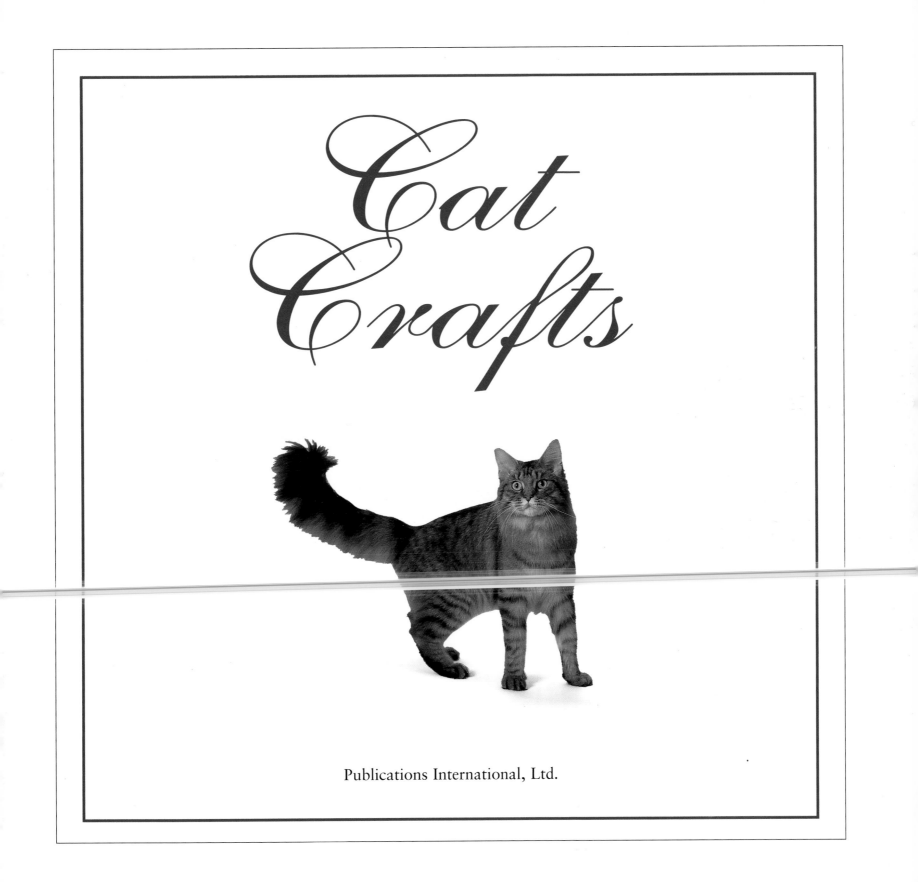

Cat Crafts

Publications International, Ltd.

Craft designers: Lori Blankenship (pages 44, 53, 62, 130); Darla Fanton (pages 85, 95); Gay Fay of Suzann Designs (page 92); Ricë Freeman-Zachery (pages 76, 100); Janelle Hayes (pages 98, 142); Tracia Ledford (page 164); Judith Sandstrom (pages 20, 27, 111, 122, 136); Muriel Spencer (pages 23, 79, 115, 146, 160); Carol Spooner (pages 32, 34, 59, 72, 82, 89, 103); Grace Taormina/Rubber Stampede (pages 108, 120, 156); Lois Winston (pages 41, 69, 127, 154)

Contributing crafter:
Christine DeJulio (page 142)

Technical advisor:
Brenda Coppola

Photography:
Sacco Productions Limited/Chicago; Peter Dean Ross Photographs (page 95); Tetsu Yamazaki (title page)

Photographers:
Rick Tragesser; Marc A. Frisco

Production:
Paula M. Walters

Photo stylists:
Melissa J. Frisco; Paula M. Walters

Models:
Jessica Levy; Theresa Lesniak/ Royal Model Management

Cat models:
Animal Talent of Chicago

Photo site acknowledgements:
Venetta Berenz; Sweet Basil Hill Farm Bed & Breakfast, Gurnee, IL

Louis Weber, C.E.O.
Publications International, Ltd.
7373 North Cicero Avenue
Lincolnwood, Illinois 60646

Permission is never granted for commercial purposes.

Manufactured in U.S.A.

8 7 6 5 4 3 2 1

Library of Congress Catalog Card Number: 95-69693

ISBN: 0-7853-1297-8

CONTENTS

This is a craft book for ailurophiles, which is the term for cat fanciers. Mysterious and aloof, cats have fascinated their human companions for thousands of years. If you're both an ailurophile and a crafter, you'll want to bring cat designs and themes to gifts you make or items for your own home or wardrobe. And this collection of projects can inspire you to do that. You'll find cat designs in crafts of all kinds—cross-stitch, rubber stamping, quilting, decorative painting, sewing, and silk dying.

TECHNIQUES FOR CRAFTS

The projects in this book include a wide variety of techniques and methods. You'll find everything from traditional crafts to today's new materials and techniques. We've included projects for all skill levels. Each one has complete step-by-step instructions and photos to help make everything easy to understand and fun to do. However, the basic information that follows will help you get started.

Before plunging into your chosen project, read the directions thoroughly. Check to make sure you have all the materials needed. Being prepared will make your project easier and more enjoyable. Many of the items you need may be on hand already. Your local craft store will be a good source of most of the materials you'll need.

Next, read the basic information in the pages that follow for the craft you're doing. These pages will help you choose materials, will define terms, and will describe certain techniques that are essential to that craft.

USING PATTERNS

Enlarging patterns: Many of the patterns in this book are printed smaller than actual size in order to fit them on the page. You will have to enlarge them before using them. You can do this on a photocopier, copying the pattern at the percentage indicated near the pattern.

If you don't have access to a photocopier, you can use the grid method. You will need graph paper or other paper ruled in one-inch squares. The first step is to draw a grid of evenly spaced lines over the pattern in the book. (You will probably want to trace the pattern and draw the grid over the tracing rather than drawing directly in the book.) Next copy, square by square, the pattern from the smaller grid in the book to the one-inch graph paper. Using the grid ensures that the pattern is enlarged proportionately.

The size of the grid you draw on the pattern depends on the degree of enlargement you need. If the pattern is to be 200 percent of what is in the book, your grid will consist of half-inch squares. If the pattern is to be copied at 150 percent, the squares in your grid will be two-thirds of an inch.

Transferring patterns: Once your pattern is the correct size, you can use it as directed in the project instructions. To transfer a pattern to another surface, you can trace over

the lines of the pattern with an iron-on transfer pen. Follow the manufacturer's directions to iron the pattern onto the surface. You can also use transfer paper, which comes in various colors. Sandwich the transfer paper between the pattern and the surface, then trace over the lines.

A WORD ABOUT GLUE

Glue can be a sticky subject when you don't use the right one for the job. Many different glues are on the craft market today, each formulated for a different crafting purpose. The following are ones you should be familiar with.

White glue: This may be used as an all-purpose glue—it dries clear and flexible. It is often referred to as craft glue or tacky glue. Tacky on contact, it allows you to put two items together without a lot of setup time. Use for most projects, especially ones that use wood, plastics, some fabrics, and cardboard.

Thin-bodied glues: Use these glues when your project requires a smooth, thin layer of glue. Thin-bodied glues work well on some fabrics and papers.

Hot-melt glue: Formed into cylindrical sticks, this glue is inserted into a hot-temperature glue gun and heated to a liquid state. Depending on the type of glue gun used, the glue is forced out through the gun's nozzle by either pushing on the end of the glue stick or squeezing a trigger. Use clear glue sticks for projects using wood, fabrics, most plastics, ceramics, and cardboard. When using any glue gun, be careful of the nozzle and the freshly applied glue—it is very hot! Apply glue to the piece being attached. Work with small areas at a time so that the glue doesn't set before being pressed into place.

Low-melt glue: Like hot-melt glue, low-melt glue is formed into sticks and requires a glue gun to be used. Low-melt glues are used for projects that would be damaged by heat. Examples include foam, balloons, and metallic ribbons. Low-melt glue sticks are oval-shaped and can be used only in a low-temperature glue gun.

DECORATIVE WOOD PAINTING

Decorative painting is an art form that was developed by untrained artists—no artistic talent or drawing skills are necessary. All you need is the desire to create useful and beautiful items to decorate your home.

PAINTS AND SUPPLIES

Paints: Acrylic paint dries in minutes, and cleanup is easy with soap and water. Many brands of acrylic paints are available at your local arts and crafts stores. The projects in this book will work with any brand, so you can choose your favorite colors regardless of brand.

Finishes: Varnishes to protect your finished project are available in both spray or brush-on. Brush-on water-base varnish dries in minutes and cleans up with soap and water. Use it over any acrylic paint. Spray varnish can be used over any type of paint or medium. For projects with a pure white surface, choose a nonyellowing varnish. The slight yellowing of some varnishes can actually enhance certain colors for a richer look. Varnishes are available in matte, satin, or gloss finishes. Choose the shine you prefer.

BRUSHES

Foam (sponge) brushes work well for sealing, base-coating, and varnishing wood. They can be cleaned with soap and water when using acrylic paints and mediums, but when using paints or mediums that require mineral spirits to clean up, you will have to throw the disposable brush away.

Synthetic brushes work well with acrylic paints for details and designs. Use a liner brush for thin lines and details. Round brushes fill in round areas, stroke work, and broad lines. An angle brush is used to fill in large areas and to float, or side-load, color (see "Basic Painting

Techniques" below). A large flat brush is used to apply base coat and varnish. Small flat brushes are for stroke work and base-coating small areas. Specialty brushes, including a stencil brush and a fabric round scrubber, can be used for stencil painting.

WOOD PREPARATION

Properly preparing your wood piece so it has a smooth surface to work on is important to the success of your project. Once the wood is prepared, you are ready to proceed with a base coat, stain, or finish.

Supplies you will need to prepare the wood are: sandpaper (#200) for removing roughness; tack cloth, which is a sticky, resin-treated cheesecloth to remove dust after sanding; a wood sealer to seal wood and prevent warping; and a foam or 1-inch flat brush to apply sealer.

BASIC PAINTING TECHNIQUES

Thin lines

1. Thin paint with 50 percent water for a fluid consistency that flows easily off the brush. It should be about ink consistency.

2. Use a liner brush for short lines and tiny details or a script brush for long lines. Dip brush into thinned paint. Wipe excess on palette.

3. Hold brush upright with handle pointing to the ceiling. Use your little finger as a balance when painting. Don't apply pressure for extra-thin lines.

Floating color

This technique is also called side-loading. It is used to shade or highlight the edge of an object. Floated color is a gradual blend of color to water.

1. Moisten an angle brush with water. Blot excess water from brush, setting bristles on paper towel until shine of water disappears.

2. Dip the long corner of the angle brush into paint. Load paint sparingly. Carefully stroke the brush on your palette until the color blends halfway across the brush. If the paint blends all the way to the short side, clean the brush and load again. Dilute thicker paint first with 50 percent water.

3. Hold the brush at a 45 degree angle and, using a light touch, apply color to designated area.

Stenciling

A stencil is a design or shape cut out of a sheet of thin, strong plastic. You can paint perfect designs by simply applying paint inside the shape with a stencil brush. A sponge or old brush with bristles cut short will also work.

1. Use a precut stencil pattern or make your own by drawing a design on a sheet of plastic and cutting it out with a craft knife. Tape the stencil onto the surface you are painting.

2. Don't thin the paint. Dip the tip of a stencil brush in the paint color. Blot almost all paint off on a paper towel. Too much paint or too watery paint can bleed under the stencil and cause uneven edges. Practice on paper first.

3. Hold the brush in an upright position and pounce repeatedly inside the cutout area. Make color heavy on the edges and sparse in the center for a shaded look.

Dots

Perfect, round dots can be made with any round implement. The size of the implement determines the size of the dot. You can use the wooden end of a brush, a stylus tip, a pencil tip, or the unused eraser end of a pencil.

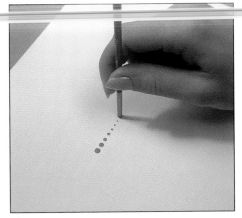

1. Use undiluted paint for thick dots or dilute paint with 50 percent water for smooth dots. Dip the tip into paint and then place the tip on the surface. For uniform dots, you must redip in paint for each dot. For graduated dots, continue dotting with same paint load. Clean tip on paper towel after each group and reload.

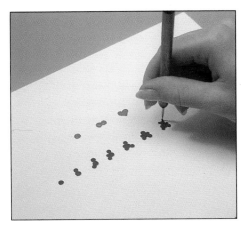

2. To create hearts, place two dots of the same size next to each other. Then drag down paint from each dot to meet in a point for the bottom of the heart. You can also use sequences of dots to create teddy bears or other designs.

Knob-and-Pole Printing

This is one of the simplest ways for the beginner to create decorative printing. Letters are made up of thin lines and dots. The letters can have a slight variation in size and still be pleasing to the eye. Always practice on paper first.

1. Print letters lightly on the surface with pencil. Line the letters with the desired paint color. Use undiluted paint for thick lines or thin paint with 50 percent water for thin lines.

2. Add a dot to the end of each line of a letter. For O, place dot on top, a bit to the left of center.

RUBBER STAMPS

With rubber stamps, you can create your own greeting cards, stationery, wrapping paper, fabric designs— even jewelry! All you need to start are a few stamps, ink pads, papers, and accessories.

SUPPLIES

Stamps: The variety of images available in rubber stamps is enormous. Most rubber-stamp projects use a number of stamps to create a unique picture.

Inks: The standard, dye-based ink used in some ink pads is water-soluble ink. Never use permanent inks for a rubber-stamp project; they will ruin your stamps. Dye-based inks are easy to use, and the ink dries quickly. This type of ink pad is sold everywhere and comes in dozens of colors.

Pigment ink is thick, opaque, and slow-drying—not good for slick surfaces, but perfect for embossing. Pigment ink also works well when stamping on colored paper, because the color of the paper won't show through or alter the color of the overlying ink. For stamping in metallic colors, pigment inks are unequalled.

Papers: Suitable types of paper for stamping have smooth surfaces and are white or light-colored. Dark or textured paper is suitable only in rare cases—for example, when stamped with metallic ink and embossed. Glossy, matte, and coated stocks come in a range of colors and weights. Some work better with dye-based ink; others work better with pigment ink.

Tools: Rubber-stamp projects use many of the following items: colored pencils, water-based brush markers, embossing powders and embossing gun, glitter glue, scissors, pinking shears, glue gun, craft knives and cutting mat, brayer, fabric ink and marking pens, eraser carving material and carving tools, stamp positioning tool, and cosmetic sponges.

TECHNIQUES

No matter what stamping project you've chosen, you need to understand the basics before you begin. Keep these tips in mind:

1. Know the fundamental stamping variables. The stamp, ink, and paper are most important, and each affects the other. Experiment every time you get a new stamp to see how it takes ink and leaves an impression. Check out its resiliency, and observe how it stamps on different papers or surfaces. Test new ink pads and papers as well.

2. Learn the correct way to ink a stamp. Tap the stamp gently two or three times on a pad. Never pound or rock a stamp when inking. Turn the stamp over to see how well it has inked. Stamp it on scrap paper to get a feel for applying the right amount of ink to a stamp. Too little ink causes details to be lost and colors to look pale, whereas too much ink obscures details. The image on a new stamp usually needs heavier

inking because the fresh surface is so porous.

3. Perfect your general stamping technique. Make a stamp impression by gently and evenly applying the inked stamp to the paper. Do not grind or rock the stamp.

4. Always work with clean stamps. Clean off each stamp before you switch from one color to another and after you are finished using it. Prepare a cleaning plate by moistening a paper towel, sponge, or small rag under warm running water, then wringing it out. Place it on a waterproof plate or in a shallow bowl. After using a stamp, tap it several times on scrap paper to remove as much ink as possible, then tap it onto the cleaning plate. Finally, tap it onto a clean paper towel or rag to remove moisture. Never use alcohol-based solvents or other harsh cleansing agents—they can ruin a stamp.

5. Protect your stamps when they're not in use. Store with the die side down, out of direct sunlight and away from dust. Line your stamp storage container with thick construction paper.

Inking and coloring stamps: You can ink a stamp in several ways. The easiest is to tap it onto a pad. Another way is to ink it with a felt-tip marker. This method lets you color various parts of an image in different hues. To do this, hold your stamp in one hand with the die facing you, and color it directly with one or more markers. Work swiftly to keep the ink from drying out. When done, breathe gently on the stamp for moisture, then stamp.

Embossing: This technique creates a stunning look. Use only pigment or embossing ink and use an embossing gun as your heating tool. Embossing thickens the line, so don't expect sharp images. To emboss, ink the image on a pigment-ink pad and stamp it. Cover your work area with a sheet of paper. Hold the stamped image over the sheet and dust the image liberally with embossing powder. Tilt the image so that the excess powder falls onto your catch sheet. (You can return the excess to your powder bottle later.) With the stamped image about six inches away, direct the hot-air flow of the embossing gun back and forth across the image until the powder melts.

CROSS-STITCH

Cross-stitch is traditionally worked on an even-weave cloth that has vertical and horizontal threads of equal thickness and spacing. The cloth can have as few as five threads to the inch or as many as 22. The most common even-weave fabric is 14-count Aida cloth, meaning it has 14 threads to the inch. Designs can be stitched on any fabric count—the resulting size of the project is the only thing that will be affected. The smaller the count number of the fabric, the larger the design will be, since the count number refers to the number of stitches per inch. Thus a design worked on 14-count fabric will be half the size of the same

design worked on 7-count fabric. Most of the projects in this book are worked on prefinished products that include even-weave cloth for cross-stitching.

Six-strand embroidery floss is used for most stitching. Many other beautiful threads, particularly metallic threads, can be used to enhance the appearance of the stitching.

BASIC SUPPLIES

Needles, hoops, and scissors: A blunt-end or tapestry needle is used for counted cross-stitch. The recommended size for most stitching is a #24 needle. You can use an embroidery hoop while stitching—just be sure to remove it when not working on your project. A small pair of sharp scissors is a definite help when working with embroidery floss.

Floss: Six-strand cotton embroidery floss is most commonly used, and it's usually cut into 18-inch lengths for stitching. Thread your needle with two of the six strands unless the directions for that project tell you otherwise. Also use two strands for backstitching.

PREPARING TO STITCH

Directions for the cross-stitch projects in this book will tell you the stitch dimensions of the pattern area. It will also tell you the size in inches of the finished pattern.

Position the center of the design in the center of the fabric. To locate the center of the fabric, lightly fold it in half and in half again. Find the center of the chart by following the arrows on the side and top.

Reading the chart is easy—each square on the chart equals one stitch on the fabric. Near each chart you will find a color key listing the colors used and showing a representative square of each color. Select a color and stitch all of that color within an area. Begin by holding the thread ends behind the fabric until secured or covered over with two or three stitches. You can skip a few stitches on the back of the material to get from one area to another, but do not run the thread behind a section that will not be stitched in the finished piece—it will show through the fabric.

If your thread begins to twist, drop the needle and allow the thread to untwist. It is important to the final appearance of the project to keep an even tension when pulling stitches through so that all stitches will have a uniform look. To end a thread, weave or run the thread under several stitches on the back side. Cut the ends close to the fabric.

Horizontal rows:

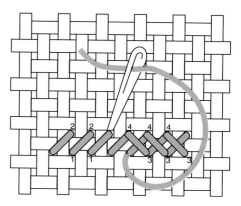

Cross all stitches in the same direction. Work the stitches in two steps—first do all the left-to-right stitches (bringing your needle up at 1 and down at 2), and then go back over them to do all the right-to-left stitches (bringing your needle up at 3 and down at 4).

Vertical rows:

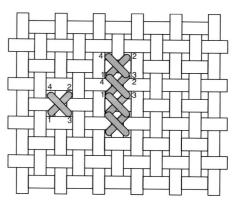

Work each complete stitch before going on to the next, bringing your needle up at 1, down at 2, up at 3, and down at 4.

Three-quarter stitches:

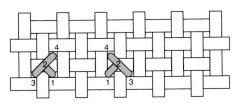

These are often used when the design requires two colors in one square or to allow more detail in the pattern. The first stitch is half as long as normal, and the crossing stitch is the normal length.

Backstitch:

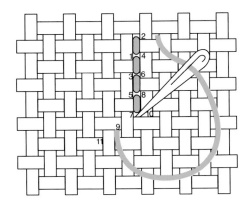

Outlining or creating letters is often done in backstitch, which is shown by bold lines on the patterns. Your needle comes up at 1 and all odd-numbered holes and goes down at 2 and all even-numbered holes. Backstitch is usually worked after the pattern is completed.

Satin stitch: This stitch is used to create a solidly filled figure. Make stitches side by side, increasing or decreasing the length of the stitches to fit into the outline desired.

PLASTIC CANVAS

Plastic canvas allows for three-dimensional stitchery projects to be constructed. Stitching on plastic canvas is easy to do, easy on the eyes, and easy on the pocketbook.

BASIC SUPPLIES

Plastic canvas: Canvas is most widely available by the sheet. Stitch all the pieces of a project on the same brand of plastic canvas to ensure that the meshes will match when you join them together.

Plastic canvas comes in several counts, or mesh sizes (number of stitches to the inch). Specialty sizes and shapes such as circles are also available. Most canvas is clear, although up to 24 colors are available. Colored canvas is used when parts of the project remain un-stitched. Seven-count canvas comes in four weights—standard; a thinner, flexible weight; a stiffer, rigid weight; and a softer weight made especially for bending and for curved projects.

Needles: Needle size is determined by the count size of the plastic canvas you are using. Patterns generally call for a #18 needle for stitching on 7-count plastic canvas, a #16 or #18 for 10-count plastic canvas, and a #22 or #24 for stitching on 14-count plastic canvas.

Yarns: A wide variety of yarns can be used. The most common is worsted weight, or 4-ply, yarn. Wool yarn can be used, but acrylic yarns are less expensive and are also washable. Several companies produce specialty yarns for plastic canvas work. These cover the canvas well and will not pill as some acrylics do. Sport-weight, or 3-ply, yarn and embroidery floss are often used on 10-count canvas. Use six strands of embroidery floss for stitching on 14-count canvas and 12 strands, or double the floss thickness, for 10-count canvas. Many of the specialty metallic threads made for cross-stitch can be used to highlight and enhance your project.

PREPARING TO STITCH

Cut your yarn to a 36-inch length. Begin by holding the yarn end behind the fabric until secured or covered over with two or three stitches. To end a length, weave or run the yarn under several stitches on the back side. Cut the end close to the canvas.

As in cross-stitch, if your yarn begins to twist, drop the needle and allow the yarn to untwist. It is important to the final appearance of the project to keep an even tension when pulling your stitches through so that all your stitches have a uniform look. Do not pull your stitches too tight, since this causes gaps in your stitching and allows the canvas to show through between your stitches. Also do not carry one color of yarn across too many rows

of another color on the back—the carried color may show through to the front of your project.

Do not stitch the outer edge of the canvas until the other stitching is complete. If the project is a single piece of canvas, overcast the outer edge with the color specified. If two or more pieces are used, follow the pattern instructions to assemble the project.

Continental stitch:

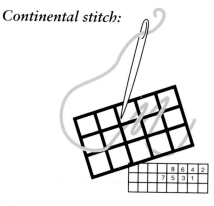

This is the most commonly used stitch to cover plastic canvas. Bring your needle up at 1 and all odd-numbered holes and down at 2 and all even-numbered holes.

Cross-stitch:

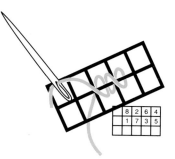

Work the plastic canvas cross-stitch just as you do a regular cross-stitch.

Backstitch:

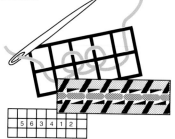

Work the plastic canvas backstitch just as you do a cross-stitch backstitch.

Gobelin stitch:

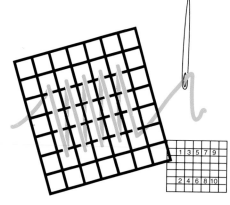

Bring your needle up at 1 and all odd-numbered holes and down at 2 and all even-numbered holes.

Slanting Gobelin:

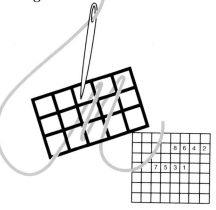

Bring your needle up at 1 and all odd-numbered holes and down at 2 and all even-numbered holes.

French knot:

Bring your needle up through a hole and wrap yarn clockwise around needle. Holding the yarn, insert needle in the hole to the right and slowly pull yarn.

Overcast stitch:

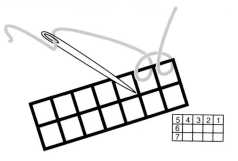

Bring your needle down at the numbered holes, wrapping the yarn over the edge of the canvas. Make sure to cover the canvas completely.

CLEANING YOUR PROJECT

Projects stitched with acrylic yarn can be washed by hand using warm or cool water and a mild detergent. Place the item on a terry-cloth towel

to air-dry. Don't dry-clean plastic canvas or dry it in a dryer.

FABRIC PAINTING

You'll find fabric painting fast, easy, and fun. With the latest development in fabric paints, using basic dimensional paints is almost as easy as writing with a ballpoint pen.

PAINTS

Only dimensional and embellished paints, that are especially formulated to use on fabric are used. For specific instructions for each paint, follow the instructions on the packaging or bottle.

BASIC GUIDELINES FOR FABRIC PAINTING

1. Prewash fabric items without using any softeners. Softeners prevent the paint from bonding completely with the fibers. Press out any wrinkles.

2. If you're right-handed, work on your project from the upper left-hand corner to the lower right-hand corner; if you're left-handed, work from the upper right-hand corner. Paint all colors as you go. This will prevent you from accidentally smearing the paint with your elbow or hand.

3. Each time you use a tube of dimensional paint, pick up the tube with the cap on and shake the paint down into the tip to remove any air

bubbles. Set a paint bottle down on its side between uses.

4. Hold your dimensional paint bottle like a ballpoint pen. Squeeze gently to push out paint. Work quickly and smoothly. Moving too slowly often creates bumps and uneven spots in your work.

5. When using dimensional glitter paint, be sure to draw a paint line thick enough to carry the glitter.

6. Allow paints to dry at least six to eight hours before touching. Allow 36 to 48 hours for paint to be completely cured before using.

CARING FOR PAINTED FABRIC

Hand or machine wash in lukewarm water—NOT COLD!—in the delicate/knit cycle. Cold water will crack the paint. Tumble dry on low for a few minutes to remove wrinkles, then remove and lay flat to dry. Use a mild, pure soap, not a detergent. Regular detergents, including cold-water washing formulations for delicate washables, contain "lifting" agents to lift the dirt and stains from the garment. Eventually they will also lift the decoration.

SEWING

Before starting a sewing project, read through the directions and study the photographs to make sure you understand how the project is put together.

MATERIALS

Fabrics: The type of fabric best suited to the project is given in the list of materials. But don't hesitate to make substitutions, taking into consideration your preferences in colors and patterns. Keep in mind the scale of a pattern relative to the size of the project. The weight of the fabric is an important consideration: Don't substitute a heavy, stiff fabric for a delicate fabric.

It is worth investing in the best materials you can afford. Many inexpensive fabrics are less likely to be colorfast. Avoid the regret that goes with choosing a fabric that isn't quite perfect but is less expensive than the fabric you really love.

Thread: Have mercerized sewing thread in the colors needed for the project you have chosen. Using the proper shade and strength (about a 50 weight) of thread avoids having the stitching show more than is necessary, and the item will have a finished look.

Fusible webbing (or adhesive): This lightweight fusible iron-on adhesive makes easy work of attaching fabric cutouts to your garment. The webbing is placed paper side up on the wrong side of the material. Place the iron on the paper side of the adhesive and press for one to three seconds. Allow the fabric to cool. Your design can then be drawn or traced onto the paper side and cut out. To transfer patterns to fusible

webbing, place pattern piece right side down on the paper backing. Trace around the pattern piece and cut out. Remove the paper and place the material right side up in the desired position on your project and iron for three to five seconds. If desired, you may machine-stitch a zigzag stitch around the attached fusible adhesive pieces to secure the edges.

TOOLS

Scissors: For cutting fabric, you'll need sharp scissors eight to ten inches long with a bent handle. This style of scissors allows you to cut through the fabric while the fabric lies flat. These scissors should be used only for fabric: Paper and plastic quickly dull the cutting edges of scissors. You'll also need a smaller pair of scissors, about six inches, with sharp points, for smaller projects and close areas.

Straight pins: Nonrusting dressmaker pins will not leave rust marks on your fabric if they come in contact with dampness or glue. And dressmaker's pins have very sharp points for easy insertion.

Ironing board and steam iron: The iron is just as important to a sewing project as the sewing machine. Keeping your fabrics, seams, and hems pressed saves valuable time and produces a professional look. You also use the iron to adhere fusible interfacing. Be sure your ironing board is well padded and has a clean covering. Keep the bottom of your iron clean and free of any substance that could mark your fabric.

A steam-or-dry iron is best. The steam iron may be used directly on most fabrics with no shine. Test a small piece of the fabric first. If it causes a shine on the right side, try the reverse side.

CUTTING OUT PATTERNS

Some of the patterns in this book are smaller than actual size in order to fit them on the page. Instructions for enlarging patterns are on page 4. Many pattern pieces indicate that two pieces should be cut from the pattern. Fold the fabric in half, right sides together, lengthwise with the selvages together. Adjust one side to the left or right until the fabric hangs straight. The line created by the fold is parallel to the fabric's straight of grain. Place the pattern pieces right side up on the fabric with the arrow on the pattern lying along the grain line. On a pattern piece, a solid line indicates a cutting line, and a dashed line indicates a line that should be placed on the fold. To make sure you have enough fabric, arrange and pin all pattern pieces on the fabric before you start to cut.

Once the pieces are cut out, transfer any markings from the patterns to the fabric. Handy marking tools include colored pencils designed for marking on fabric. Tailor's chalk or chalk wheels are helpful for marking patterns just before you sew. The chalk brushes off fabric easily. Disappearing-ink pens may be tempting because they make a mark that is easy to see, but a permanent stain can result from heating fabric that contains residue from the ink.

Stitching: Sewing patterns include a seam allowance of ¼ inch. The lettered dots on pattern pieces will help you fit pattern pieces together. A dot lettered A on one piece, for example, must be placed against the A dot on another piece. Pin fabric pieces right sides together before stitching.

QUILTING

Modern time-saving techniques for quilting allow even the busiest person to make quilts that can be used on beds or hung on a wall.

MATERIAL SELECTION

Fabric: The considerations for selecting fabrics for sewing projects apply to quilting as well. Try to select only 100 percent cotton fabrics for the face and back of the quilt. Cotton is easy to cut, mark, sew, and press. It is also widely available. Fabrics that contain synthetics, such as polyester, are more difficult to handle and are more likely to pucker.

The backing fabric should be similar in fiber content and care instructions to the fabrics used in the quilt top. Some wide cottons (90 and 108 inches) are sold specifically for quilt backings. They eliminate the need to piece the back.

Batting: Many types of batting are available to meet the needs of different projects. In general, use polyester batting with a low or medium loft. Polyester is better if the quilt will be washed frequently. All-cotton batting is preferred by some quilters for a very flat, traditional-looking quilt. For a puffier quilt, you can use a high-loft batting, but it is difficult to quilt.

Thread: Old, weak thread tangles and knots, making it frustrating to work with. Buy 100 percent cotton thread or good long-staple polyester thread for piecing, appliqué, and machine quilting. Cotton quilting thread is wonderful for hand quilting, but it should not be used for machine quilting because it is stiff and will tend to lie on the surface of the quilt.

For piecing by hand or by machine, select a neutral color of thread that blends in with most of the fabrics in the quilt. For most projects, either khaki or gray thread works well. Use white thread for basting; do not risk using colored thread, which could leave color behind. For appliqué, the thread should match the fabric that is being applied to the background. The color of quilting thread is a personal design choice. If you want your quilting to show up, use a contrasting color of thread.

MATERIAL PREPARATION

Prewashing: Always wash fabrics first. This will remove some of the chemicals added by the manufacturer, making the fabric easier to quilt. Also, cotton fabric does shrink, and most of the shrinkage will occur during the first washing and drying. Be sure to use settings that are as hot as those you intend to use with the finished quilt.

Dark, intense colors, especially reds, tend to bleed or run. Wash these fabrics by themselves. If the water becomes colored, try soaking the fabric in a solution of three parts cold water to one part white wine vinegar. Rinse thoroughly. Wash again. If the fabric is still losing its color, discard the fabric and select another. It is not worth using a fabric that may ruin the other fabrics when the finished quilt is washed.

Marking and cutting fabric: Some of the patterns in this book are smaller than actual size in order to fit them on the page. Instructions for enlarging patterns are on page 4. To cut fabric the traditional way for piecing or appliqué, place the pattern right side down on the wrong side of the fabric.

Trace around the pattern with a hard-lead pencil or a colored fabric-marking pencil. Cut around each piece with sharp fabric scissors.

In many cases, it is faster and easier to cut fabric using a rotary cutter. This tool, which looks and works like a pizza cutter, must be used with a self-healing mat and a see-through ruler. Always use the safety shield of the rotary cutter when it is not in use.

Fold the fabric as described on page 14. Keeping this fold in place, lay the fabric on the mat. Place a see-through ruler on the fabric. Align one of the ruler's grid lines with the fold and trim the uneven edge of the fabric. Apply steady, even pressure to the rotary cutter and to the ruler to keep them and the fabric from shifting. Do not let the cutter get farther away from you than the hand that is holding the ruler. Stop cutting and reposition your hand.

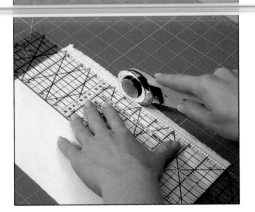

Reposition the ruler so that it covers the width of the strip to be

cut and the trimmed edge is on the markings for the appropriate measurement on the ruler.

After cutting the strip, hold it up to make sure it is straight. If it is angled, refold the fabric and trim it again. Continue cutting strips, checking frequently that the strips are straight.

TOOLS

A sharp pair of scissors is essential for cutting fabric. Keep another, separate pair of scissors for nonfabric uses.

To cut fabric quickly and easily, invest in a rotary cutter, see-through ruler, and self-healing mat. These tools let you cut strips of fabric efficiently.

The needles used for hand piecing and hand appliqué are called sharps. For hand quilting, use the needles called betweens. Use the smallest needle you can to make the smallest stitches. Generally, start with a size 8 and work toward using a size 10 or 12.

Always use a sharp needle on your sewing machine; a dull needle will tend to skip stitches and snag the threads of your fabric, which will create puckers. Use size 9/70 or 11/80 for piecing and appliqué and size 11/80 (in most cases) or 14/90 (for a thick quilt) for machine quilting.

Use fine, sharp straight pins (such as silk pins) for piecing and holding appliqué pieces in place before

basting or stitching. Long quilter's pins are used to hold the three layers (top, batting, and backing) before they are basted together or quilted.

MACHINE APPLIQUÉ

Use fusible webbing to hold the pattern piece firmly in place. Follow the manufacturer's instructions to bond the webbing to the back of the pattern piece, remove the protective paper, and then bond the pattern piece to the background fabric. Stitch around the piece using a ⅛-inch- to ³⁄₁₆-inch-wide zigzag stitch. The stitches should be close together, but not so close that the fabric does not feed smoothly through the machine.

QUILTING

Quilting, stitching that goes through all three layers of the quilt, is both functional and decorative. It holds the batting in place. It is also an important design element, greatly enhancing the texture of the finished quilt. For a traditional look, outline important elements of the design with quilting. A grid of stitching works well in background areas. Fancier design elements that complement the theme of the quilt can also be incorporated.

Spread out the backing (right side down) on a table or other flat surface. Use masking tape to secure it after smoothing it out. Place the

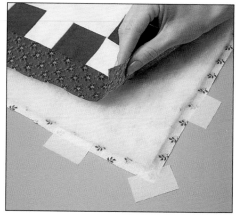

batting on top of the backing, smoothing it out also. Finally, place

the assembled quilt top on the backing, right side up. Stretch it out so it is smooth and tape it.

For hand quilting, baste the layers together using long stitches. For best results, start basting at the center of the quilt and work toward the

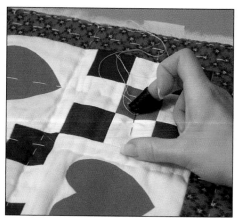

edges. Create a grid of basting by making a line of stitching approximately every four inches.

HAND QUILTING

Hand quilting has a beautiful, classic appearance that cannot be

duplicated by machine. To outline-quilt design areas, stitch ¼ inch away from each seam line. Simply decide where to stitch by eye or use ¼-inch masking tape placed along each seam as a guide. Masking tape can also be used as guides for straight lines and grids. Stitch beside the edge of the tape; avoid stitching through the tape, because you will get the adhesive on the needle and thread. Do not leave the masking tape on the fabric when you are finished stitching each day, however, because it can leave a sticky residue that is difficult to remove.

Some quilters hold their work unsupported in their lap when they quilt. Most quilters, however, prefer to use some sort of quilting hoop or frame to hold the quilt stretched out. This makes it easier to stitch with an even tension and helps to prevent puckering and tucks.

Use betweens (quilting needles) for hand quilting. The smaller the needle (higher numbers like 11 and 12), the easier it will be to make small stitches. A quilting thimble on the third finger of your quilting hand will protect you from needle sores.

Use no more than 18 inches of quilting thread at once. Longer pieces of thread tend to tangle, and the end gets worn as it is pulled through the fabric. Knot the end of the thread and slip the needle into the quilt top and batting about an inch from where the first stitch

should start. Pull the needle up through the quilt top at the beginning of the first stitch. Hold the thread firmly and give it a little tug. The knot should pop into the batting and lodge between the quilt top and backing.

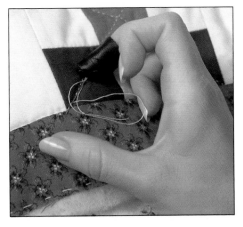

The quilting stitch is a running stitch. Place your free hand (left hand for right-handed people) under the quilt to feel for the needle as it pokes through. Keep your stitches small and evenly sized, and make sure you are going through all three layers.

Tying Quilts

The fastest way to secure the layers of a quilt (top, batting, and backing) together is to tie a thread through all three layers. Thread a needle with a long piece of embroidery floss, yarn, or pearl cotton. At regular intervals (every four inches, at most) take a single stitch through the three layers of quilt. Tie the thread in a double square knot and

trim the thread to a consistent length, usually ½ or 1 inch.

Making a Hanging Sleeve

To make a sleeve for hanging a quilt, cut a strip of fabric (muslin or a scrap of backing fabric) 6 inches wide and as long as the quilt is wide. To finish the ends of the strip, roll under the ends to the wrong side of the fabric and slip-stitch (or machine stitch). Fold the fabric lengthwise with wrong sides together. Stitch a ⅜-inch seam the length of the sleeve. Turn the sleeve wrong side out and press the seam. Stitch a ⅝-inch seam over the first seam. Turn the sleeve right side out and press. Stitch the sleeve to the top of the quilt and insert a dowel to hang the quilt.

HOME

A cat lover can decorate the home with all manner of cat designs. Sew a paisley draft dodger, cross-stitch a cat eyeing its fishbowl prey, or stencil a country clock and matching lamp shade.

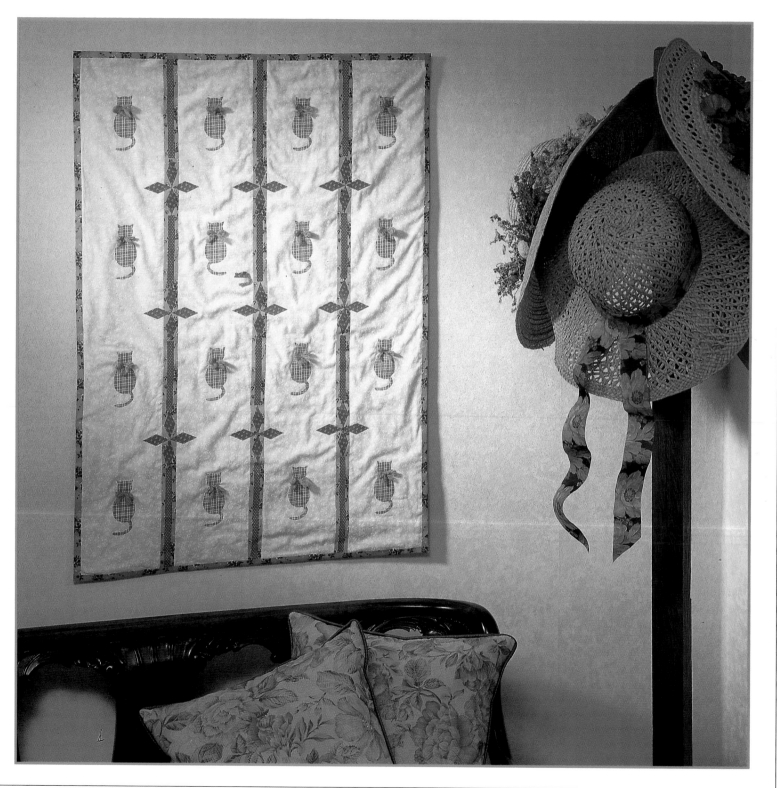

CAT AND MOUSE QUILT

A charming, 22×30-inch quilt depicting a mouse's worst nightmare—alone with 16 cats, with one cat's twitching tail pointing to the mouse for all the other cats to see.

What You'll Need

- ⅞ yard muslin or light background fabric (enough for the top and backing)
- 2 yards tan plaid or print fabric ribbon, 1⁷⁄₁₆ inches wide
- 5½ yards floral print ribbon, ⅞ inch wide
- 1¼ yard rose print ribbon, ⅝ inch wide
- 1¾ yard teal ribbon, ⅜ inch wide
- 1 roll fusible webbing, ⅞ inch wide
- 1 roll fusible webbing, ⅝ inch wide
- 1 roll fusible webbing, ⅜ inch wide
- 1 skein polyester yarn
- 1 package quilting fleece
- Small, sharp scissors
- Rotary cutter and board
- Transparent ruler with 45-degree angle marking
- Yarn darner needle
- Iron, pencil, yardstick, straight pins

Note: If the desired colors and patterns of fabric ribbon are not available, ¼ yard of cotton fabric can be substituted for each ribbon and will yield identical results if properly trimmed. Iron fusible webbing to the wrong side of the fabric instead of ribbon, and carefully cut along the edge of the fusible webbing, trimming off any tiny threads along the bonded edge.

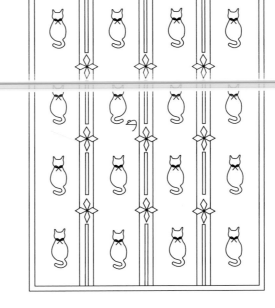

1. See pages 14–17 for basic techniques for quilting. Cut the muslin into two 22×30-inch pieces. Set one aside for the backing. Mark dots 5½ inches apart at the edges of both 22-inch ends of the top piece. Using yardstick, lightly draw three vertical lines connecting the dots.

2. Cut 5 pieces 30 inches long and 2 pieces 22 inches long from both the floral ribbon and the ⅞-inch fusible webbing. Iron a piece of fusible webbing to the wrong side of each ribbon piece, following manufacturer's directions. Remove paper backing.

3. Cut a 1¼-yard piece from both the rose ribbon and the ⅝-inch fusible webbing. Iron fusible webbing to wrong side of ribbon. Follow directions on page 14 to trace and cut patterns on page 22. Place mouse pattern piece right side down on paper backing; trace and cut out. Remove paper backing from mouse and from remainder of ribbon strip. Using the 45-degree-angle marking on transparent ruler,

cut at the ⅝-inch mark, making a diamond. Continue in the same manner to cut a total of 36 diamonds.

4. Cut a 2-yard piece of the tan ribbon and two 2-yard pieces of the ⅝-inch fusible webbing. Iron the two pieces of fusible webbing side by side to wrong side of ribbon. Place cat pattern piece right side down on paper backing; trace 15 cats. Place pattern piece wrong side down and trace 1 cat. Cut out the cats and remove paper backing.

5. Cut a 1¾-yard piece of ⅜-inch fusible webbing and iron to wrong side of teal ribbon. Cut 6 pieces 6 inches long and 6 pieces 4 inches long; remove paper backing.

6. Cut 1 piece of yarn 1¼ inches long and 16 pieces 9 inches long. Cut a 22×30-inch piece of quilting fleece.

7. Center a 30-inch piece of floral ribbon over each of the lines drawn on the background fabric. Iron in place. Place a pin every 7½ inches along each floral ribbon strip. Arrange 4 rose diamonds, points meeting at the pin as in placement diagram on page 21, and iron in place. Repeat at every pin placement. Remove pins.

8. Center 4 cats in each row, starting 2½ inches from top and placing cats 4¼ inches apart. The cat facing the opposite direction is the second down in the panel second from the left. Refer to placement diagram. Place mouse slightly under the tail of this cat. For mouse's tail, position the 1¼-inch piece of yarn under mouse so that ¼ inch of the yarn is anchored under the mouse body and 1 inch hangs down. Iron on all cats.

9. Center teal strips on top of floral ribbons, placing 6-inch strips at the ends and 4-inch strips in the middle. Iron in place.

10. Sandwich the quilting fleece between the top and backing with edges even. Pin around perimeter.

11. Fold the 4 remaining ribbon strips in half lengthwise. Encase one long side of quilt with a long folded ribbon strip. Iron from the top side, removing pins just prior to ironing. Turn over and iron from the backing side. Repeat to bind the other long side and the two shorter sides.

12. Thread yarn darner needle with a 9-inch piece of yarn. Stitch through all thicknesses at the neck of a cat. Knot twice and tie yarn in a bow. Evenly trim off the yarn ends. Repeat for all cats.

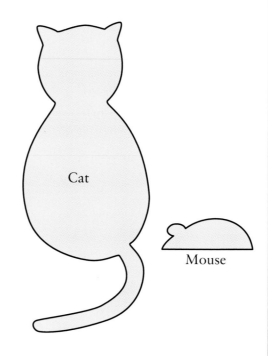

Cat

Mouse

Photocopy patterns at 100%

Folk Art Cat Pillow

This colorful cat will brighten an alcove with gay colors. Try enlarging or reducing the pattern to make a mama cat and her kittens. Vary the faces and flower colors so that each cat is a little different, though they all belong to the same litter.

What You'll Need

- Neutral-color linen fabric, 32 count, 13×26 inches
- Cotton quilt batting, 13×13 inches
- Textile paints: black, white, apple green, maroon, opaque orange, and opaque pink
- Tracing paper, 13×13 inches
- Pencil
- Masking tape
- Heat-resistant tape
- Iron-on transfer pen
- Brown wrapping paper
- White nylon brushes: #1 and #5 round, #2 flat stain
- Polyester stuffing
- Sewing machine, sewing pins, sewing needles, scissors, thread, iron, ruler, pencil

1. For best results, prewash linen in cold water and without fabric softener. Hang to dry. Follow directions on page 4 to trace pattern on page 26.

2. Trace over pencil lines on tracing paper with iron-on transfer pen.

3. Cut linen in half to make two 13×13-inch squares. Press with iron. Place pattern facedown in center of one linen piece. Adhere with heat-resistant tape. Iron until pattern is transferred. Remove pattern and tape.

4. To protect work area while painting, use masking tape to attach the linen with design on it to brown paper cut a little larger than linen. You will be able to move your work around easily without getting wet paint on the back of your work. Paint will flow through to paper.

5. Use the smallest brush for small areas and the larger brushes for the larger areas. Using apple green, paint the forehead dots, iris of eyes, mane, leaves, flower centers and curled lines on tail. Use maroon for middle and outer ear centers, nose, dots, second flowers of top and bottom rows, and triangular tail markings. Mix one part white with one part opaque pink and paint the rest of the ears, face, fourth flower on top row, and first flower on bottom row.

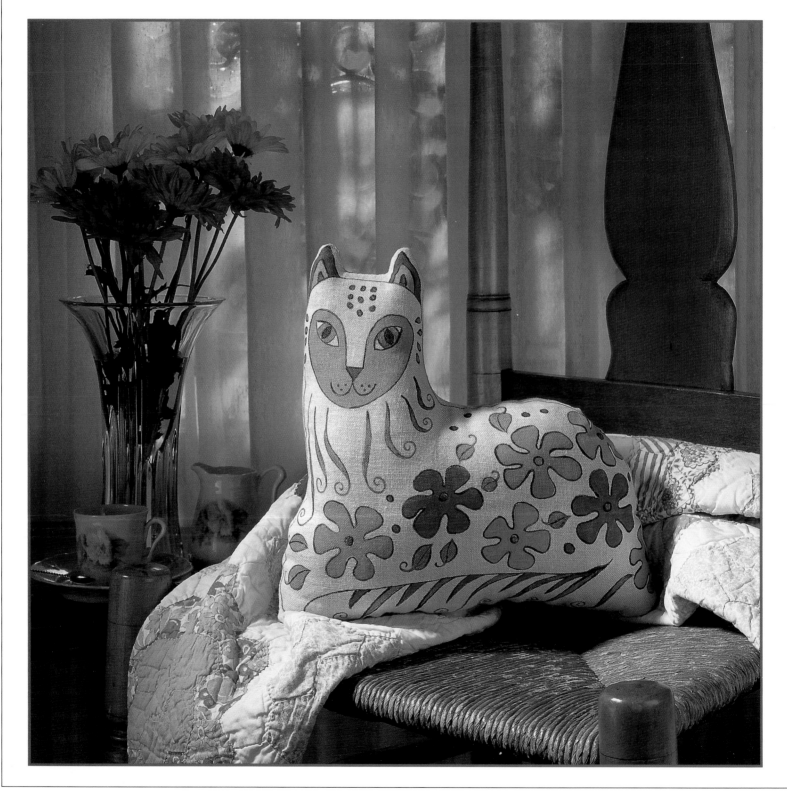

6. Use opaque orange for dots on head sides and remaining flowers. Use black paint for eye pupils, whisker dots, and mouth line. Outline with black around cat shape and each color, except curled green lines. Allow to dry. Heat-set using paint manufacturer's directions.

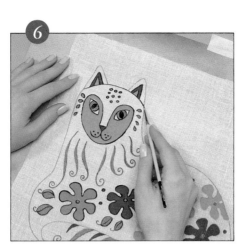

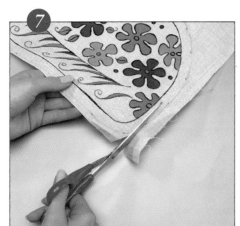

7. Measure and draw a pencil line ½ inch around cat shape. Cut on this line. Turn facedown on second piece of linen; pin the two pieces together. Cut back to fit front. Stitch the two pieces together, leaving a 4-inch opening at bottom for turning. Trim seams and clip curves.

8. Iron batting. Position batting under wrong side of front. Pin together. Cut batting about 1 inch from cat shape. Stitch batting to linen over previous seam. Trim batting even with pillow edges.

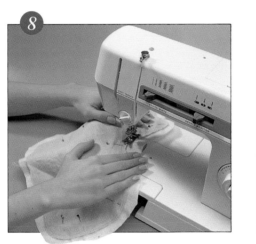

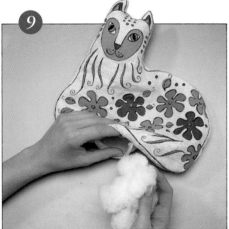

9. Turn pillow right side out. Pull stuffing into small pieces to make it fluffy—large clumps will make lumps that show on the outside. Stuff pillow between batting and back, starting with ears. Use the points of the scissors for a stuffing tool. Hand-sew opening closed.

Photocopy pattern at 150%

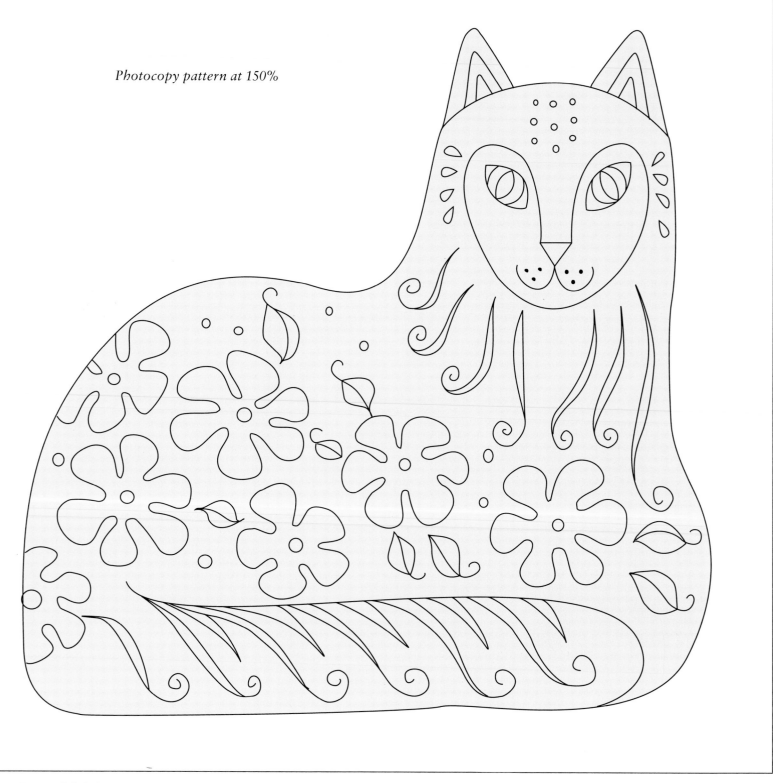

SCAREDY CAT WALL HANGING

This three-panel picture tells a story—the cat serenely gazing at the moon in the first panel becomes frightened when the witch arrives to carve the pumpkin. This 14×20-inch no-sew hanging is a perfect Halloween decoration.

What You'll Need

- ½ yard royal blue solid or print fabric (enough for top and backing)
- ⅛ yard solid black fabric
- ¼ yard brown pin-dot or solid fabric
- ⅛ yard green fabric
- ⅛ yard or scraps of light orange fabric
- ⅛ yard or scraps of light gold fabric
- 3 yards fabric ribbon, 1⁷⁄₁₆ inch wide (for sashing and binding)
- ⅝ yard fusible webbing
- 6 yards fusible webbing strip, ⅜ inch wide
- Low-loft polyester batting, 14×20 inches
- Fine-point black pen
- Iron, scissors, ruler, basting needle and thread, straight pins, pencil
- Optional: 2 small rings for hanging

1. Cut two 14×20-inch pieces of royal blue fabric. Set one aside for the backing.

2. Follow directions on page 14 to trace and cut patterns on pages 30–31. Iron a 4½×17-inch piece of fusible webbing to wrong side of black fabric, following manufacturer's directions. Place pattern pieces for cats and witch's hat right side down on paper backing. Trace around each piece and cut out. Remove paper backing.

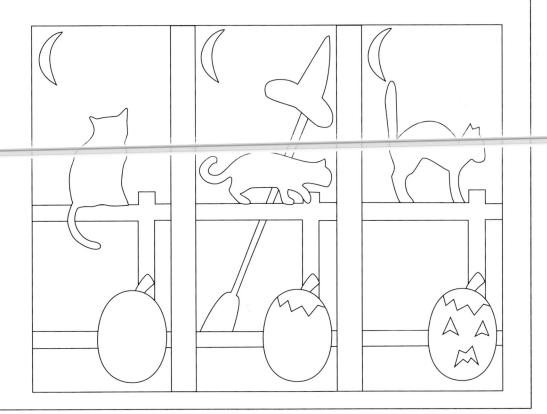

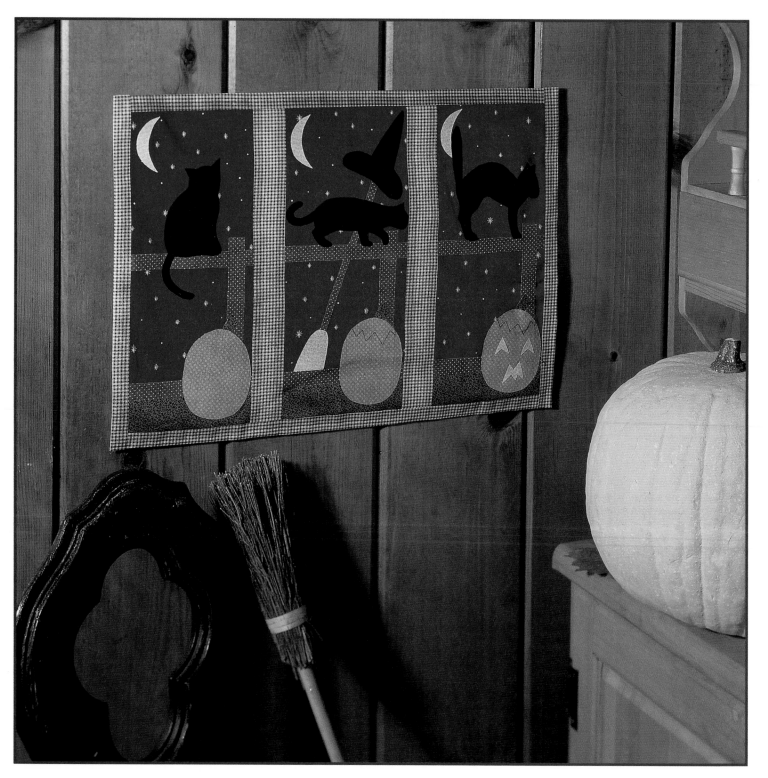

3. Iron a 9×17-inch piece of fusible webbing to wrong side of brown fabric. Place pattern pieces for fence and broom handle right side down on paper backing. Trace, cut out, and remove paper backing.

4. Cut a 2×20-inch piece of green fabric. Iron a small piece of fusible webbing to wrong side of leftover green fabric. With pattern piece right side down on paper backing, trace and cut pumpkin stems. Remove paper backing.

5. Iron a 4½×10-inch piece of fusible webbing to wrong side of light orange fabric. With pattern piece right side down on paper backing, trace and cut 3 pumpkins. Set 1 aside as is. Lightly transfer in pencil the zigzag top marking onto 2 pumpkins; transfer the eyes and mouth onto 1 of these. Go over the zigzag line on 2 pumpkins in pen.

6. Iron a 4½×7-inch piece of fusible webbing to wrong side of light gold fabric. With pattern pieces right side down on paper backing, trace and cut moons, broom, pumpkin mouth, and eyes. Remove paper backing.

7. Cut ribbon into 2 pieces 20 inches long and 4 pieces 14 inches long.

8. Place royal blue background top on an ironing board or flat padded ironing surface that can accommodate pins put into it. Place the 2×20-inch piece of green over bottom edge of royal blue background, matching raw edges, and push pins straight down to hold it in place. Use this pinning method to keep all pieces in place before fusing pieces.

9. Cut ⅜-inch fusible webbing into 4 pieces 2 inches long and 8 pieces 14 inches long. Iron 2 fusible webbing pieces of corresponding length, side by side, to wrong side of ribbon pieces. Remove paper backing.

10. Line up all appliqué pieces, using placement diagram on page 27 as a guide. The horizontal fence edges overlap the green by ⅛ inch. The broom and broom handle go under the middle fence section. All outer appliqués must be slightly more than ⅜ inch from the outer edge of the background. Be sure to have all pieces, including ribbon sashing, lined up perfectly and pinned before ironing in place. Remove pins as you iron the appliqué and ribbon pieces into place.

11. Sandwich batting between fused top and backing. Pin and loosely hand-baste the three layers together at perimeter edge.

12. Fold remaining ribbon pieces in half lengthwise and crease folded edge. Encase one side of quilt with ribbon and iron. Turn over and iron on the back. Repeat for remaining sides. Sew two small rings on the upper back for hanging if desired.

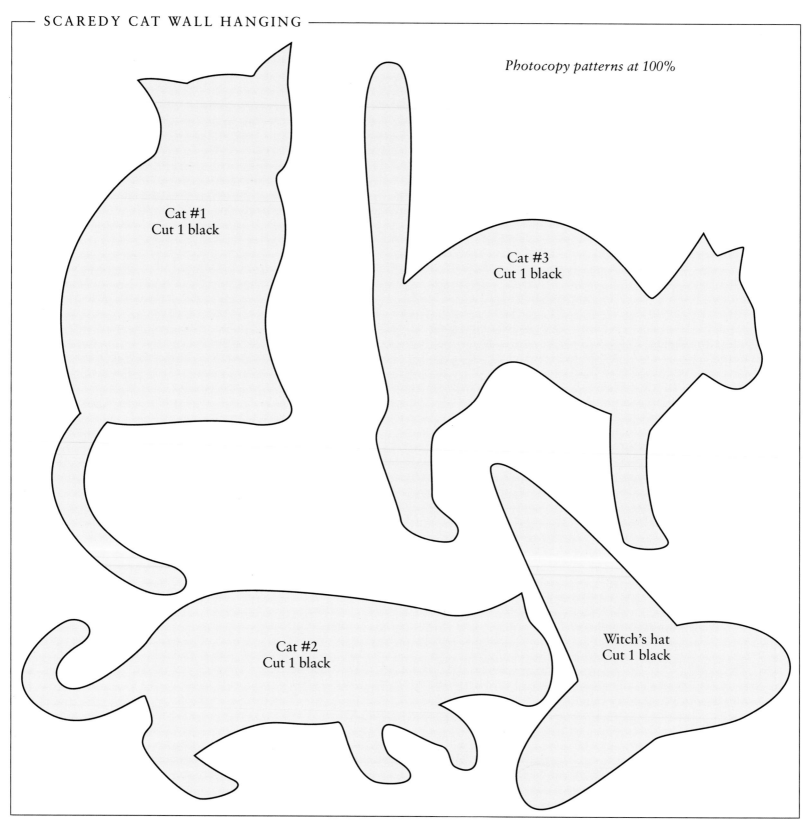

Photocopy patterns at 100%

Cat #1
Cut 1 black

Cat #3
Cut 1 black

Cat #2
Cut 1 black

Witch's hat
Cut 1 black

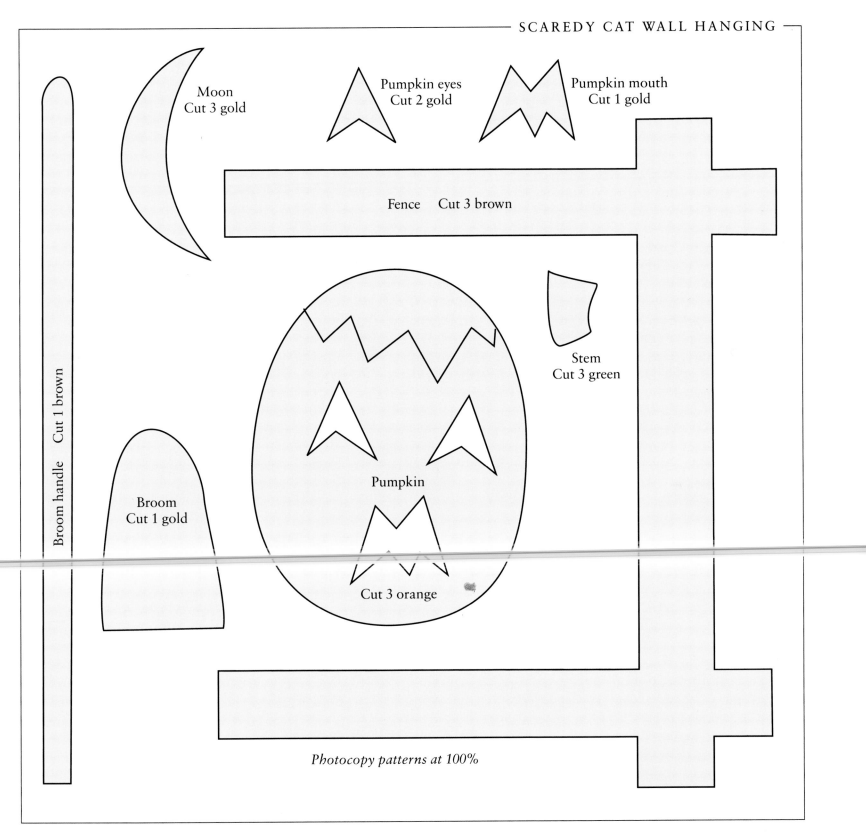

Moon
Cut 3 gold

Pumpkin eyes
Cut 2 gold

Pumpkin mouth
Cut 1 gold

Fence Cut 3 brown

Broom handle Cut 1 brown

Stem
Cut 3 green

Pumpkin

Broom
Cut 1 gold

Cut 3 orange

Photocopy patterns at 100%

Country Cat Clock and Lamp Shade

Cats and hearts stenciled onto these decorator pieces create an appealing country ambience that will add charm to any room.

What You'll Need

- Unfinished wood mantle clock and clockworks
- Small lamp with flat-surface shade
- Small piece of card stock, such as the back of a business card
- Cat stencil
- Brushes: ½-inch flat brush, small stencil brush
- Acrylic paint: tapioca, heartland blue, Amish blue, calico red
- Acrylic matte-finish spray
- Hot glue gun, craft knife

1. Use ½-inch flat brush to base-coat clock entirely with tapioca. Allow to dry. Mix equal parts heartland blue and Amish blue for blue mix. Base-coat router edge of clock with blue mix.

2. Cut out heart shape from border of cat stencil. Arrange cats and hearts across front of clock; check for evenness. Using cat stencil, stencil brush, and blue mix, practice stenciling on a separate surface. Take care not to move stencil. If brush is too wet, bleeding will occur. Stencil the cats. Remove and clean stencil and brush; allow clock to dry. If blue paint has bled around cats, touch up with tapioca.

3. Using calico red, stencil hearts.

4. For lamp shade, bleeding under stencil cannot be corrected. Practice on separate cloth. Stencil cats and hearts in the same way, beginning at the seam in the back of the shade. (Shades differ in circumference; by beginning and ending in the back, any unevenness is minimized.)

5. Lamp shade will not need an additional finish. Spray mantle clock with acrylic matte-finish spray. Allow to dry. Assemble clockworks according to manufacturer's directions.

6. Paint a 1×2-inch area of the card with calico red. Allow to dry. Spray with acrylic matte spray; allow to dry. Lay heart stencil over red area; trace 2 hearts and cut out. Apply a dot of hot glue to the back of a paper heart and attach to tip of minute hand. Attach remaining heart to hour hand.

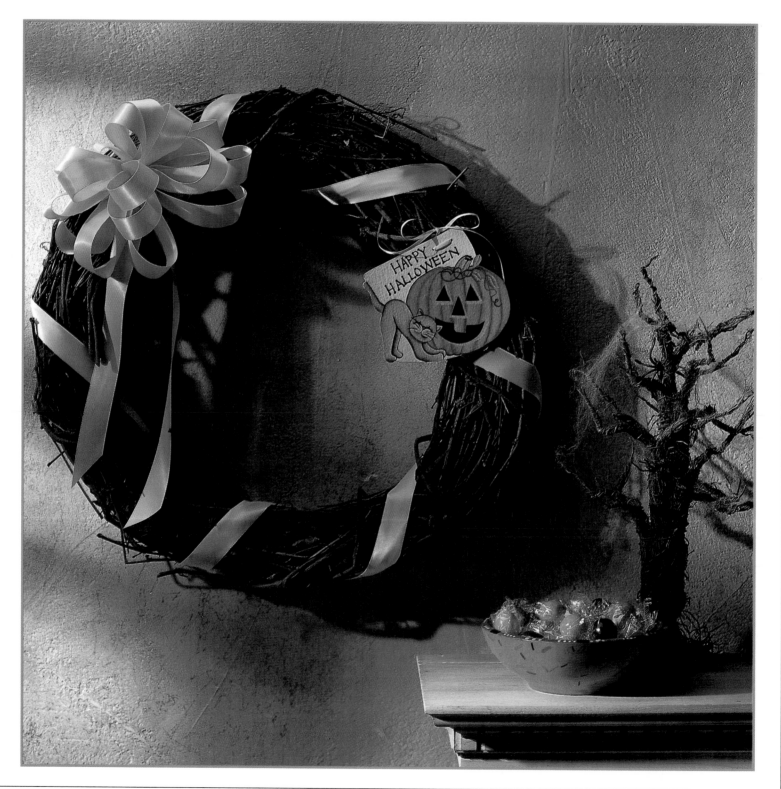

ALL-SEASON HOLIDAY WREATH

Our friendly cat welcomes each holiday with its own wreath ornament. The ornaments are easily changed so that one wreath remains festive all year round.

What You'll Need

- Grapevine wreath, medium size
- Cold-press watercolor paper, 300#
- Acrylic paint: dove grey, shading flesh, ebony black, dark chocolate, calico red, buttermilk, mint julep, cadmium yellow, taffy cream, kelly green, snow white, flesh tone, sapphire blue, pumpkin, red iron oxide, light avocado, French grey-blue, baby blue, antique gold, glorious gold
- Brushes: #2 flat, ⅜-inch angle, 10/0 liner
- 3 yards ribbon, ¾ inch wide
- 4⅔ yards ribbon, ⅛ inch wide
- Acrylic matte-finish spray
- Craft knife, scissors

1. Follow directions on page 4 to trace patterns on pages 38–40. For each ornament, trace pattern and transfer to watercolor paper. Use scissors to cut out basic shape; clean out corners and cut holes for ties with craft knife. See pages 5–8 for basic techniques for decorative painting.

HALLOWEEN

2. Use flat brush to base-coat the sign with snow white paint. Base-coat cat with dove grey and cat nose with shading flesh. Base-coat background with buttermilk. Base-coat pumpkin with pumpkin paint and base-coat pumpkin eyes and mouth with ebony black. Base-coat

pumpkin stem and leaves with mint julep. Allow to dry. Apply detail pattern.

3. Contour pumpkin ridges by floating with red iron oxide, using angle brush. Float the dimensions of pumpkin face with cadmium yellow. Float stem and leaves with light avocado. Float contours of cat with ebony black and line features with ebony black.

4. Use liner brush to line pumpkin with ebony black. Paint in "HAPPY HALLOWEEN" with black and add dots. Paint vine with light avocado. Allow to dry. Spray with acrylic matte-finish spray.

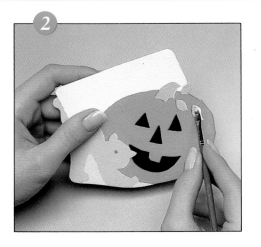

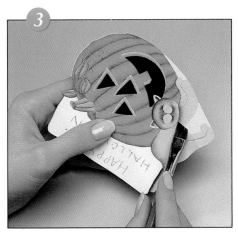

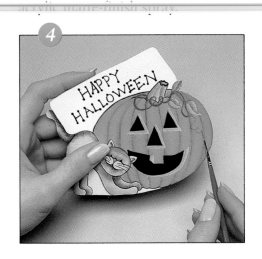

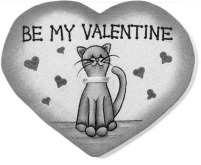

WELCOME

5. Use flat brush to base-coat cat dove grey and cat nose shading flesh. Paint rug colors baby blue, flesh tone, mint julep, and taffy cream. Allow to dry. Apply detail pattern for stitching on rug.

6. Use angle brush to float shading on rug with French grey-blue, shading flesh, light avocado, and dark chocolate. Float highlights on each rug color with snow white. Float edge of cat with ebony black.

7. Use liner brush to paint rug details with snow white. Line cat and "WELCOME" with ebony black. Dot letters with ebony black. Allow to dry. Spray with acrylic matte-finish spray.

VALENTINE

8. Use flat brush to base-coat heart with flesh tone. Paint cat with dove grey and cat nose with shading flesh. Allow to dry. Apply detail pattern for hearts.

9. Use angle brush to float floor with dark chocolate. Float shading on cat with ebony black. Use liner brush to paint floorboards with dark chocolate. Line cat and "BE MY VALENTINE" with ebony black. Dot the letters with ebony black. Follow directions on page 7 for creating hearts with calico red.

10. Float the entire outer edge with calico red. Allow to dry. Spray with acrylic matte-finish spray.

SPRING BUNNY

11. Use flat brush to base-coat the bunny costume with buttermilk and the cat face with dove grey. Paint cat nose with shading flesh. Allow to dry. Apply detail pattern.

12. Use angle brush to float inside of bunny ears with shading flesh. Float costume shading with dark chocolate. Use liner brush to paint legs, paws, and bow under chin with dark chocolate. Create a dashed line for inner ears. Use angle brush to float contours of cat face with ebony black and line features with ebony black. Allow to dry. Spray with acrylic matte-finish spray.

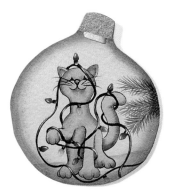

FOURTH OF JULY

13. Use flat brush to base-coat entire flag with snow white. Base-coat cat with dove grey and cat nose with shading flesh. Allow to dry. Apply detail pattern.

14. Base-coat star area with sapphire blue, leaving heart area white. Paint alternating stripes with calico red.

15. To create shading on the flag, use angle brush to float red stripes under the folds with calico red mixed with a touch of ebony black. Float down the first fold and on the right edge with snow white. Float the white stripes under the folds with sapphire blue.

16. Float contours of cat with ebony black and use liner brush to line features with ebony black. Line heart with ebony black. Allow to dry. Spray with acrylic matte-finish spray.

THANKSGIVING

17. Use flat brush to base-coat the background with buttermilk. Paint the letters with pumpkin. Base-coat cat with dove grey and paint cat nose with shading flesh. Base-coat turkey with antique gold, leaf garnish with mint julep, and plate with snow white. Allow to dry. Apply detail pattern.

18. Create shading on the letters by floating and then lining with red iron oxide. Use angle brush to float stem and leaves with light avocado. Float contours of cat with ebony black and use liner brush to line features with ebony black. Float and line turkey with dark chocolate; float and line garnish with light avocado. Float plate with French grey-blue. Allow to dry. Spray with acrylic matte-finish spray.

CHRISTMAS

19. Use flat brush to base-coat the ornament with buttermilk. Paint cat with dove grey and cat nose with shading flesh. Allow to dry. Apply detail pattern.

20. Use angle brush to float contours of cat with ebony black. Use liner brush to line features with ebony black. Line wire and bulb sockets with ebony black. Base-coat the bulb colors with calico red, cadmium yellow, pumpkin, kelly green, and sapphire blue. Float the floor with dark chocolate.

21. Create shading and highlighting on bulbs by floating with ebony black and buttermilk. Float a highlight on bulb sockets with buttermilk and line highlights on wire with buttermilk. Reline highlights on bulbs and wire with buttermilk.

22. Line pine branches with kelly green and add a few additional lines with sapphire blue. Float calico red around the entire ornament. Base-coat ornament top with glorious gold. Allow to dry. Spray with acrylic matte-finish spray.

23. Wrap ¾-inch-wide ribbon around wreath and tie in a decorative bow. Cut ⅛-inch-wide ribbon into 7 pieces 24 inches long. Thread 1 piece through tie holes in an ornament so that free ends are at the back. Repeat with remaining ornaments. Tie desired ornament to wreath.

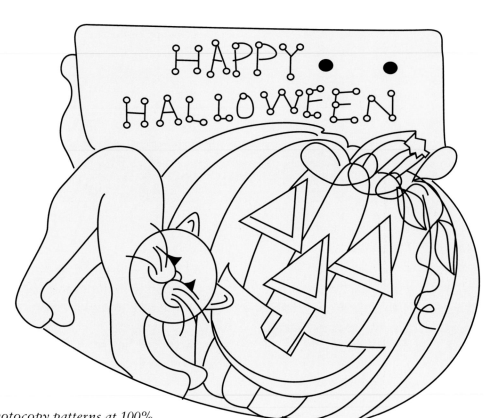

Photocopy patterns at 100%

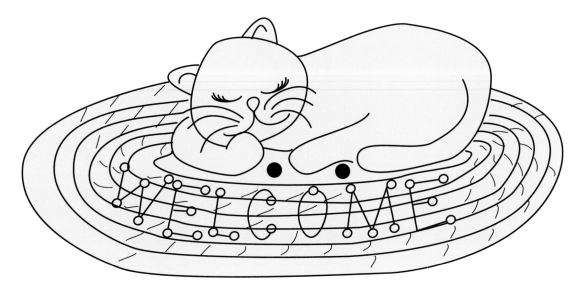

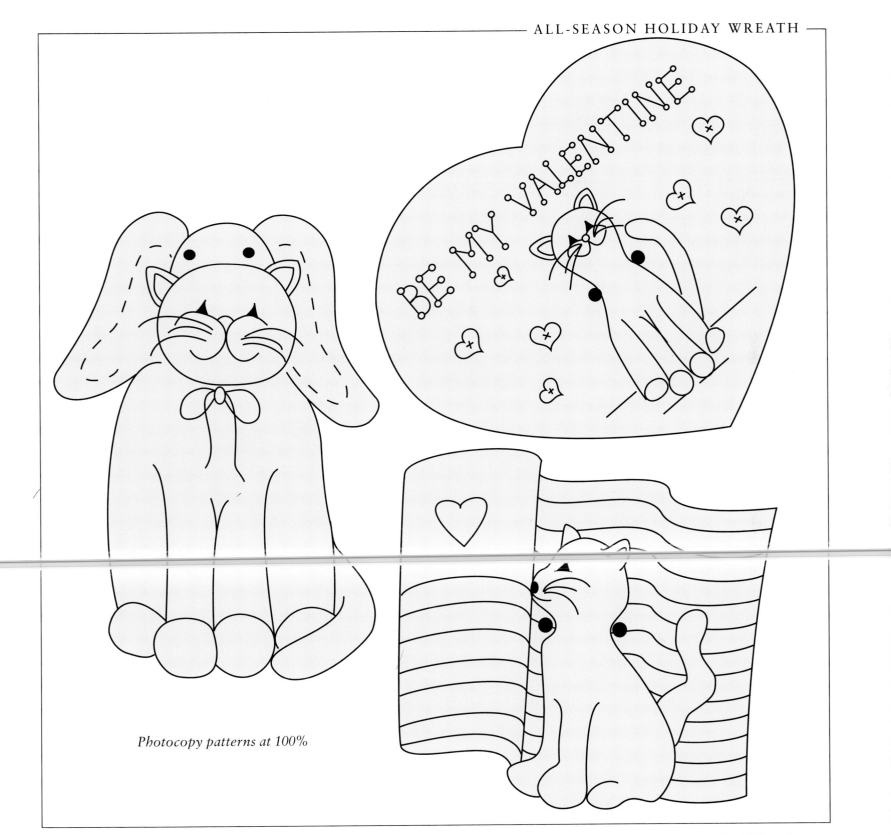

BE MY VALENTINE

Photocopy patterns at 100%

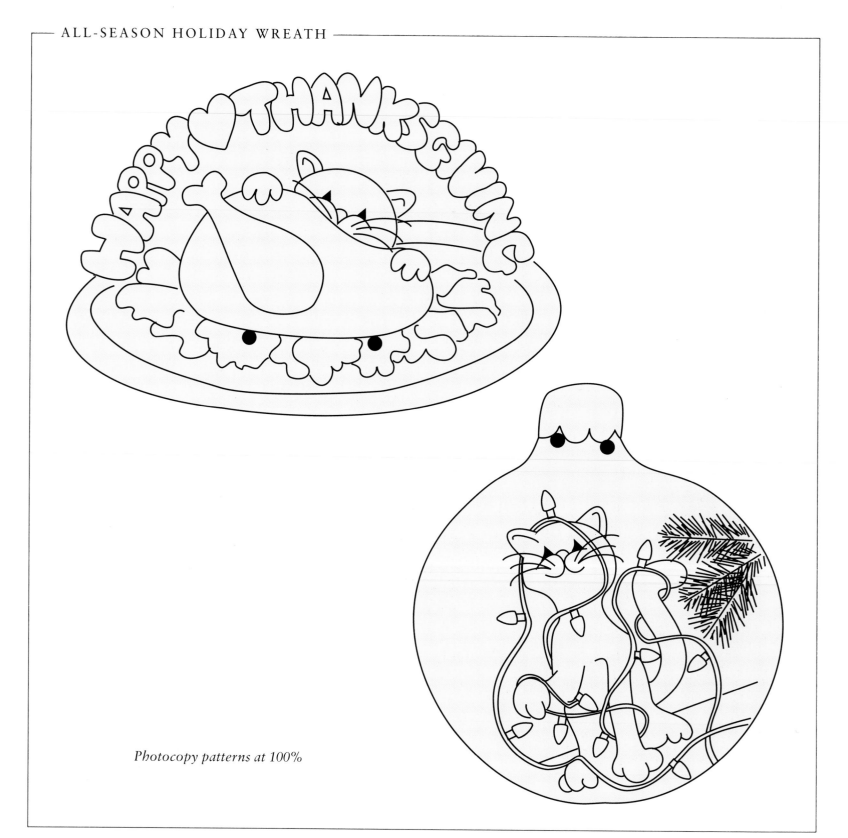

Photocopy patterns at 100%

CATNAP
CROSS-STITCHED PILLOW

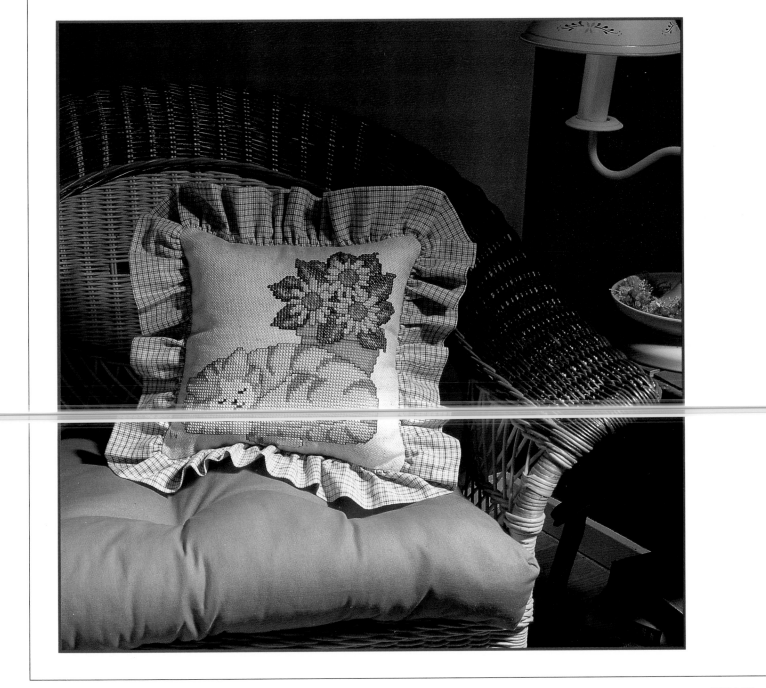

A cat loves nothing better than curling up in the warm sunshine to catch forty winks next to a pot of sunflowers. This design will stitch up quickly because it is worked over two threads of the 16-count fabric.

What You'll Need

- 16-count white birch square pillow
- 6-strand embroidery floss (see color key)
- #24 tapestry needle
- Scissors
- 12-inch square pillow form

Stitch count: 77h×76w

Size: 9½×9½ inches

Following the general cross-stitch directions on pages 9–11, stitch design centered on cross-stitch insert of pillow, working over 2 threads. Use 4 strands of floss for all cross-stitching. When all cross-stitching is done, backstitch where indicated with 2 strands of black floss. Insert pillow form into completed pillow. Zip closed.

Stitching design on 14-count Aida cloth, working over 2 threads, will produce a design 11×11 inches square, too large for a 12-inch square pillow but suitable for framing. Stitching design on 8-count Aida cloth, working over 1 thread, will produce a design the same size as pictured.

Color	DMC
Coffee brown	433
Very ultra dark topaz	435
Russet	434
Dark wheatstraw	729
Light straw	3822
Ultra dark pistachio green	890
Dark hunter green	3345
Medium yellow green	3347
Light terra cotta	920
Very light terra cotta	922
Medium pink	818
Cream	712
Medium brown	420
Mustard	3045
Light mustard	3046
Light yellow beige	3047
Black	310

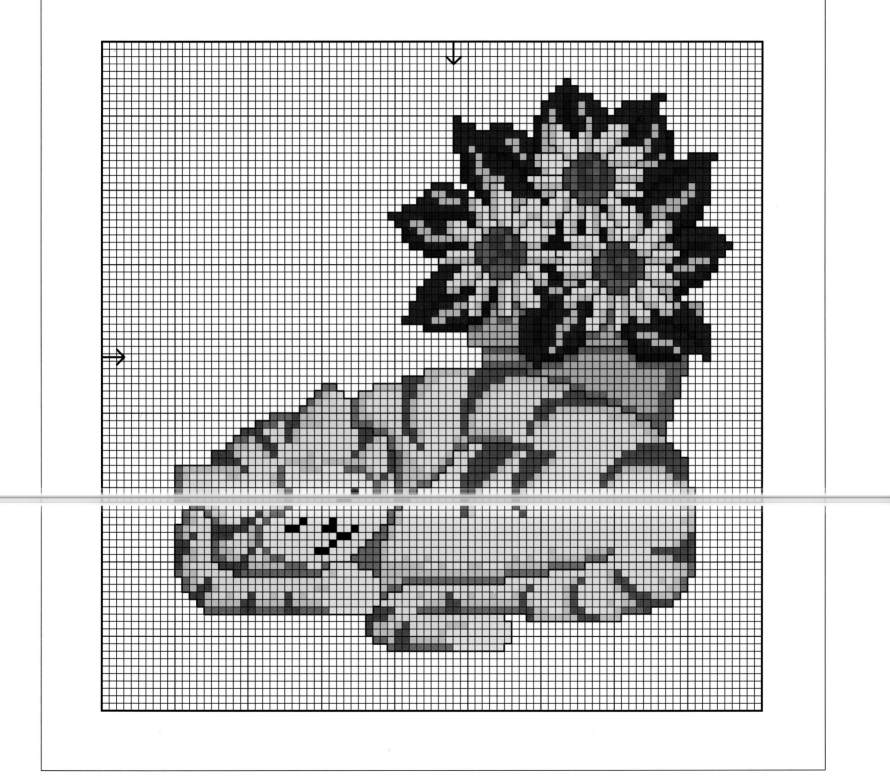

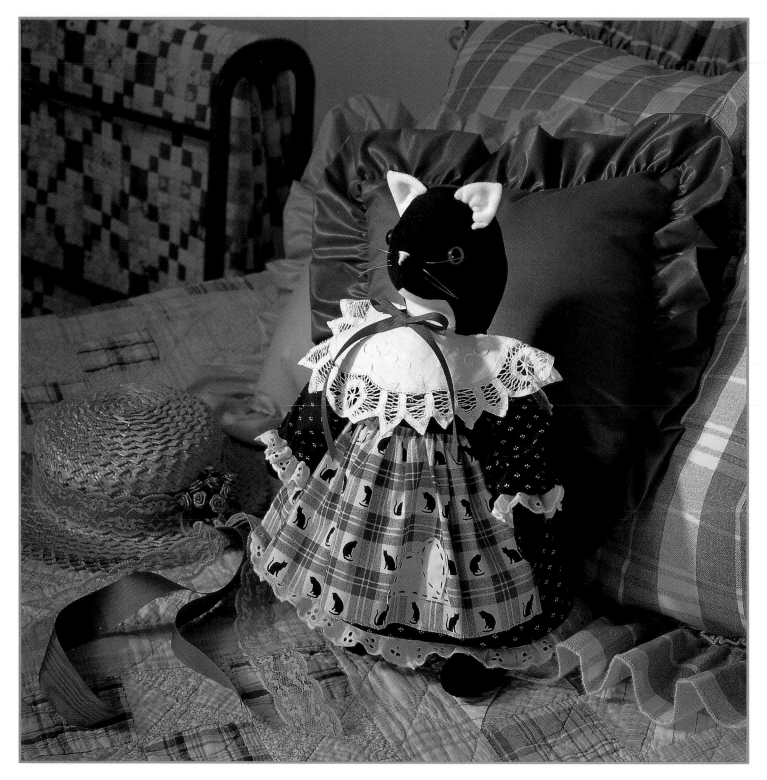

OLD-FASHIONED Cat Doll

With her calico apron and proper lace collar, this well-turned-out puss makes an unusual accent in a cozy room setting.

What You'll Need

For cat:
- ⅜ yard black velour, 60 inches wide (for main cat body)
- ⅜ yard white velour (for cat tummy, ears, chin)
- 1 bag (20 ounces) polyester stuffing
- Animal eyes, 15mm
- Animal whiskers
- 4 black buttons, ¾-inch diameter
- Pink embroidery floss
- Black fabric paint

For clothing:
- ⅜ yard fabric (for dress)
- ¼ yard fabric (for apron)
- 1¼ yard eyelet trim, 1 inch wide
- 1 yard ribbon, ⅝ inch wide (for apron sash)
- Battenburg doily, 10 inches wide
- Scrap of muslin adhered to fusible webbing (for mouse)
- Black embroidery floss
- Sewing machine, scissors, needle, coordinating thread, white chalk pencil, pencil, straight pins, ruler

1. Follow directions on page 14 to trace and cut patterns on pages 49–52. Transfer all markings from patterns to fabric. From dress fabric, cut two 8×7-inch rectangles for sleeves. From apron fabric, cut one 22×6-inch rectangle.

2. Body: Sew back seam A to B on body side pattern pieces with right sides together. Pin body front to body sides matching C and D; sew in place with right sides together. Match A, C, and center front on body base to body; pin in place. Stitch, easing in any extra fullness. Clip curves; turn and stuff firmly.

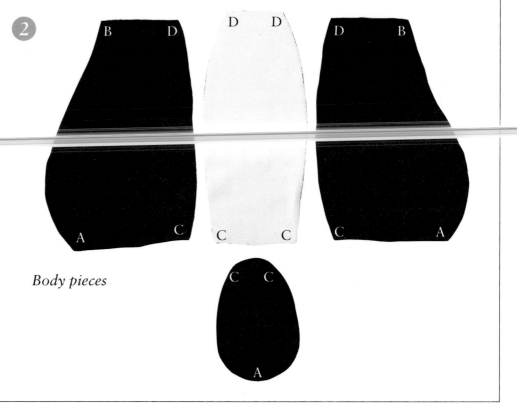

Body pieces

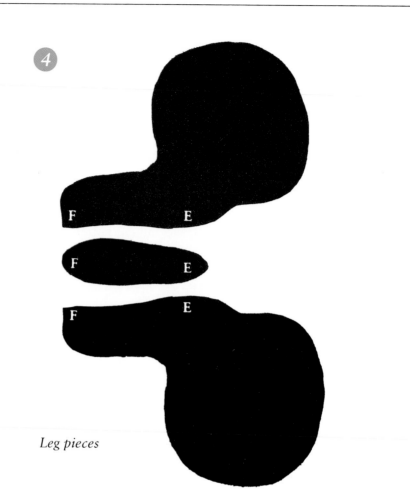

Leg pieces

3. Front arm: With right sides together, pin and stitch around entire arm. Pinch to separate the two arm pieces slightly. Clip a short slit on inside of arm for turning. Clip curves; turn and stuff firmly. Hand-stitch opening closed. Repeat for other arm.

4. Leg: With right sides together, stitch around hip, leaving E to F open. Pin hind foot bottom to opening on hip pattern, matching E and F. Stitch in place beginning at E on foot bottom pattern piece. Stitch around to F, being careful not to catch top of foot in stitching. Lift presser foot and arrange fabric so stitching can be continued around foot bottom to E without catching foot top. Pinch to separate the two

hip pattern pieces slightly. Clip a short slit on inside of hip for turning. Trim seams and clip curves; turn and stuff firmly. Hand-stitch opening closed. Repeat for other hip.

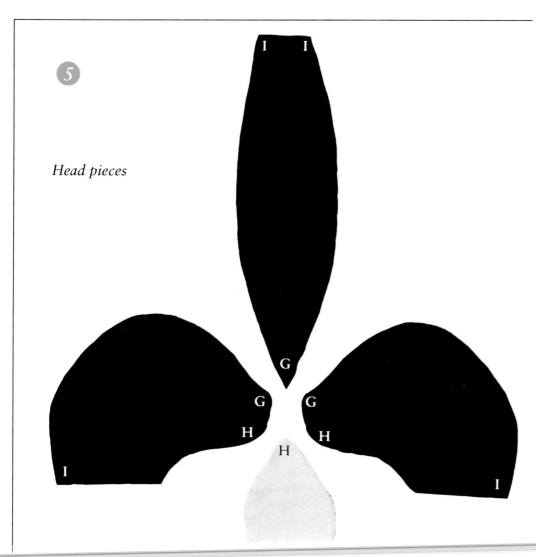

Head pieces

5. Head: Pin head side pieces with right sides together, matching G, H, and I. Stitch seam from H to G. Separate head sides and match G on head top pattern piece to G on seam just sewn, with right sides together; pin in place. Match I on head top to I on head sides; pin in place, then stitch. Pin chin pattern piece in place, matching H at chin point, with right sides together. Stitch, easing in any fullness. Clip curves and turn.

6. Referring to eye placement guide on pattern piece, pierce fabric, insert eye, and press on eye backing. Repeat for other eye. Stuff head firmly. Stitch to body by hand, matching front seams. (Stuffing may need to be added at this point.)

7. Pin right sides of ear pattern pieces together; stitch, leaving J to K open for turning. Trim seams, clip corners, and turn. Using a running stitch, gather bottom edge of ear. Pull stitching to form a slight curve and stitch in place on top of head in spot indicated on pattern piece. Repeat for other ear.

8. Tail: With right sides together, stitch around tail pattern pieces, leaving opening at base of tail for turning. Clip and trim curves. Turn and stuff very firmly. Using needle and thread, make a gathering stitch around opening ⅛ inch from edge.

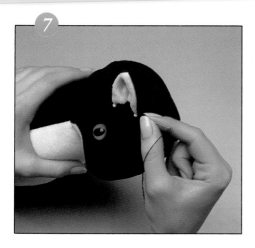

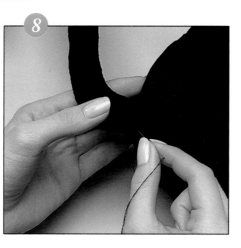

Gather tightly and secure with a knot. Attach with a tacking stitch to body at back ¼ inch above joining of seams.

9. Arm and hip joints: Following placement markings from pattern pieces, sandwich a flat button between finished body and limb. Stitch in place as follows. Anchor thread in body, sew from body through eye of button to limb and back through button to body. Repeat several times, pulling tightly on the final pass. Secure thread well. Repeat for remaining limbs.

10. With pink embroidery floss, use a satin stitch to fill in nose. With fabric paint, paint little toe and paw pads on each foot. This takes 6 hours to dry. The paint tends to flow until set, so doll should be placed head down in a box so feet and paws can be as flat as possible during drying process.

11. Dress: Sew across shoulder seams of dress pieces with right sides together. Set aside. Sew eyelet trim to end of each sleeve with right sides together. Press seam to back of sleeve, leaving trim to border edge of sleeve. Pin sleeve to arm opening with right sides together; stitch in place. Repeat for other sleeve. Stitch underarm seam down side of dress beginning at eyelet edging and ending at hemline on each side of

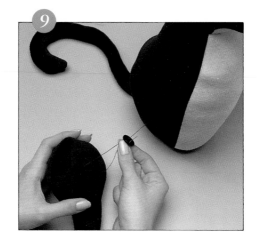

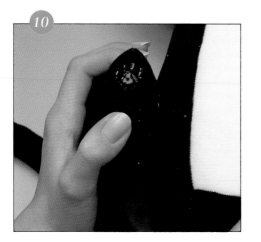

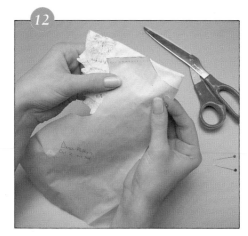

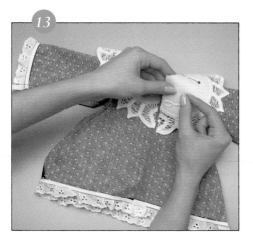

dress. Sew eyelet trim to hemline of dress with right sides together. Press seam to back of dress, leaving trim to border edge of dress.

12. Cut a 3-inch slit down center back of dress. For collar, fold Battenburg doily in half to form shoulder line, then fold again to form center front on the fold line. Using neckline of dress pattern,

match center front fold line of doily to center fold line of dress pattern and shoulder fold line to one shoulder seam. Pin in place and cut out neck opening in doily. Unfold doily and cut down center back.

13. Pin right side of doily to wrong side of dress. Begin stitching at center back opening, continuing around neckline and ending on

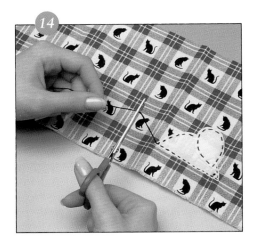

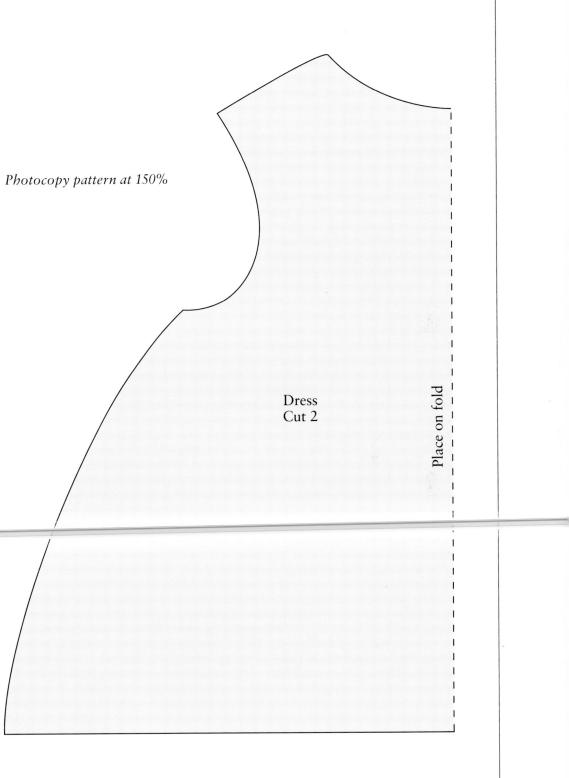

Photocopy pattern at 150%

Dress
Cut 2

Place on fold

other side of center back. Clip corners and curves. Turn collar to right side. Match cut ends of Battenburg doily with right sides together and stitch together. Press. Dress cat doll. Tack dress together at neck opening. Using a running stitch, gather sleeves around wrists, pull gathers snugly, and secure thread.

14. Apron: Turn sides under and press. Iron mouse on right side near bottom edge of apron. Use black embroidery thread to stitch mouse in place with little tacking stitches. To create tail on mouse, secure embroidery floss at back of mouse and leave about 2 inches of floss before cutting. Gather top of apron to measure 8 inches, using a running stitch. Find center of apron; match to center of ribbon. Pin ribbon along top of apron and stitch in place along edge of ribbon. Tie apron around doll's waist.

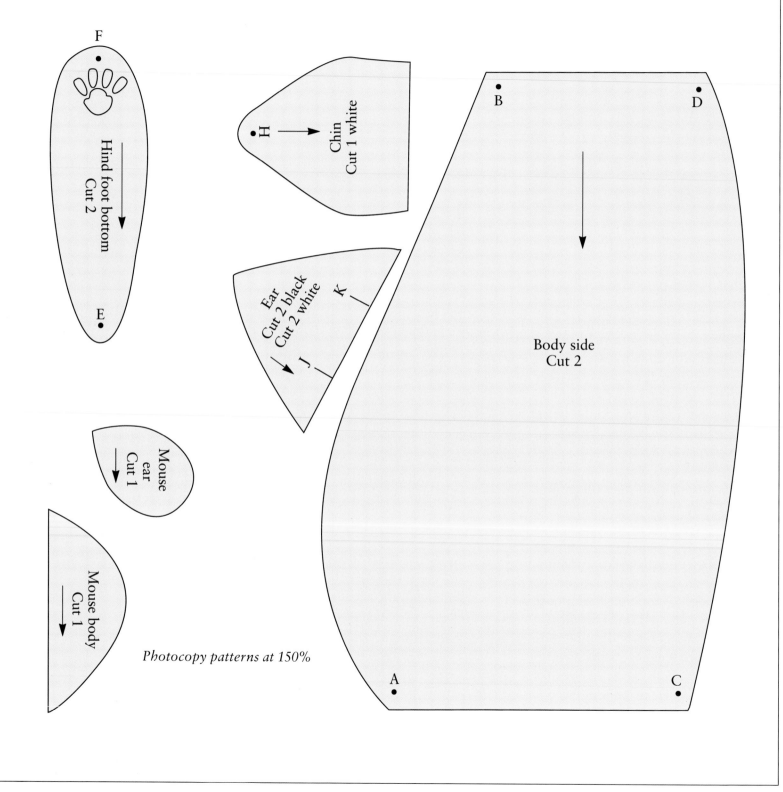

F

Hind foot bottom
Cut 2

E

H →

Chin
Cut 1 white

B

D

Ear
Cut 2 black
Cut 2 white

J ← K

Body side
Cut 2

Mouse
ear
Cut 1

Mouse body
Cut 1

Photocopy patterns at 150%

A

C

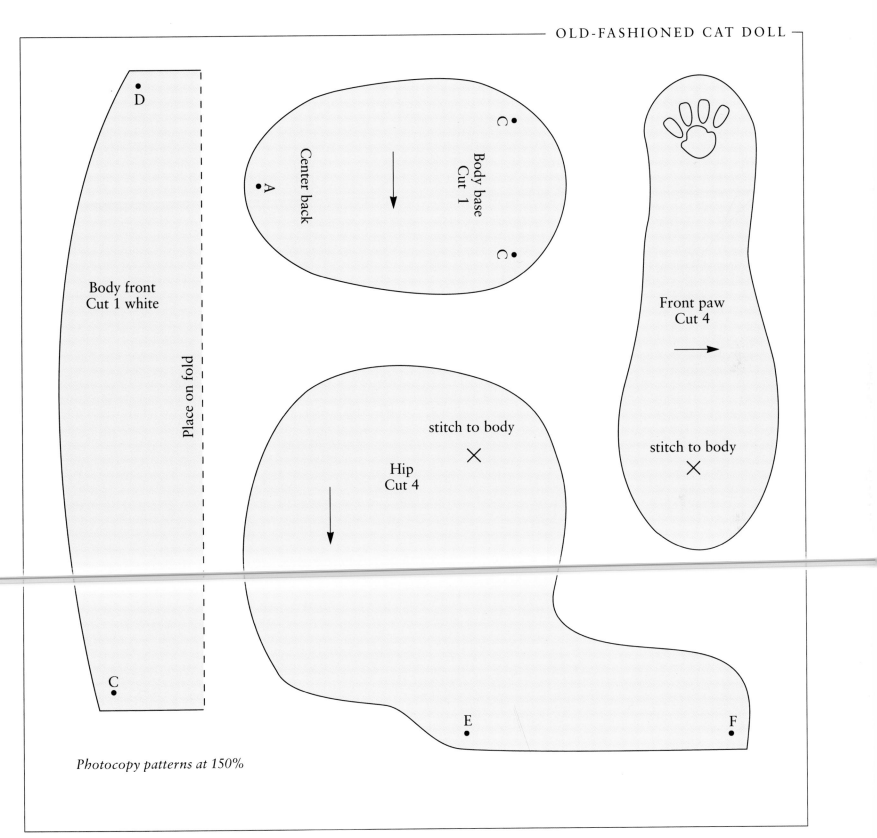

D

Body front
Cut 1 white

Place on fold

C

C

Center back

A

Body base
Cut 1

C

stitch to body

×

Hip
Cut 4

E

F

Front paw
Cut 4

stitch to body

×

Photocopy patterns at 150%

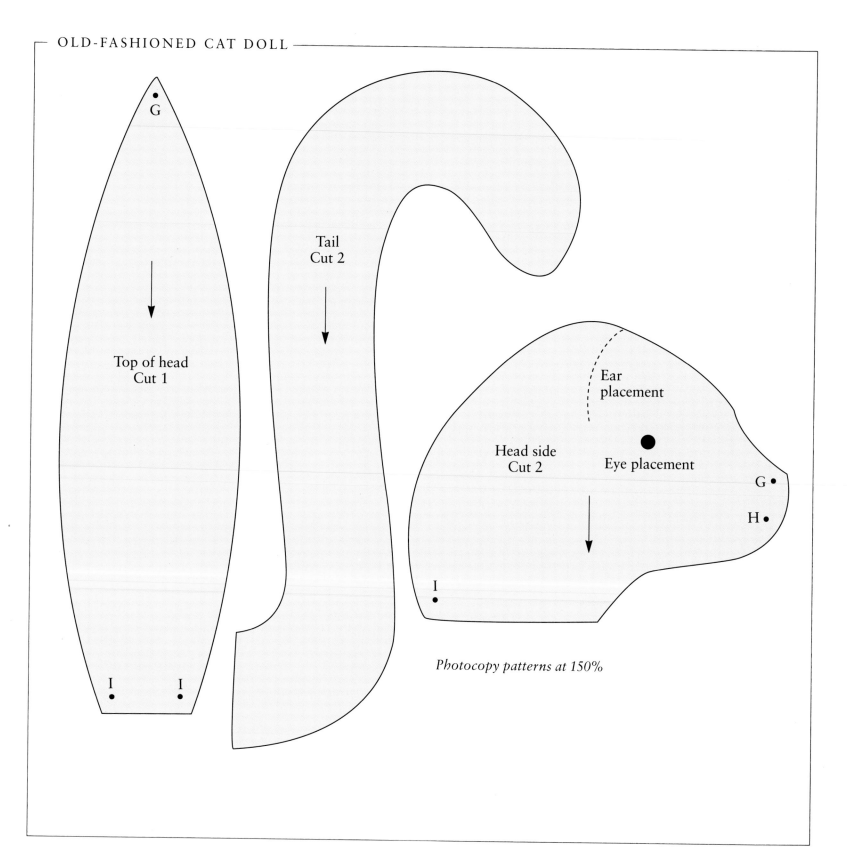

G

Top of head
Cut 1

I I

Tail
Cut 2

Ear
placement

Head side
Cut 2

Eye placement

G

H

I

Photocopy patterns at 150%

CROUCHING CAT DRAFT DODGER

Most cats gravitate toward a warm, cozy spot. But this paisley cat lies by the door, her long tail stretched out to ward off the chilly drafts.

What You'll Need

- 1 yard fabric
- ⅛ yard muslin
- Coordinating thread
- Black animal eyes or buttons, ½ inch wide
- 1 bag (20 ounces) polyester stuffing
- 6 to 8 cups sand filler
- Black embroidery floss
- 24 inches ribbon
- Sewing machine, scissors, string, needle, chalk pencil, pins, and funnel

1. Follow directions on page 14 to trace and cut patterns on pages 55–58. Follow guidelines on pattern for cutting extra tail section from muslin. Transfer all markings from pattern to fabric.

2. Stitch dart in each body side piece from A to B. Pin body pieces with right sides together and sew, leaving C to D open for turning. Trim seams and clip curves. Turn at opening.

3. Pin hip pattern pieces with right sides together and sew, leaving E to F open for turning. Trim seams and clip curves. Turn at opening. Do the same for front arm, leaving G to H open for turning, and ears, leaving I to J open for turning.

4. Stitch muslin tail using a ⅜-inch seam allowance. Turn right side out and fill with sand using a funnel. Tie top of tail with string to secure. Slide muslin tail inside cat body tail.

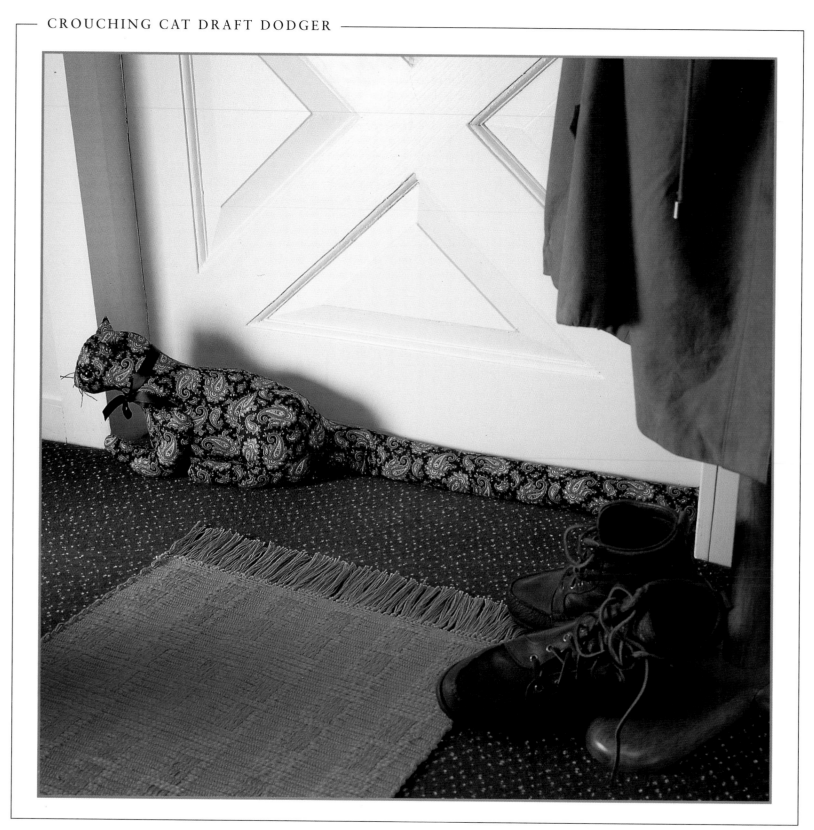

5. Insert eyes at markings and secure with backings.

6. Stuff head and body firmly; slip-stitch opening closed. Stuff arm and hip firmly; slip-stitch opening closed. Hand-sew arm and hip in appropriate place on body.

7. Using embroidery floss, stitch mouth line and create whiskers. Use satin stitch to create nose. Tie ribbon around cat's neck in a bow.

Photocopy pattern at 150%

Hip
Cut 2

E

F

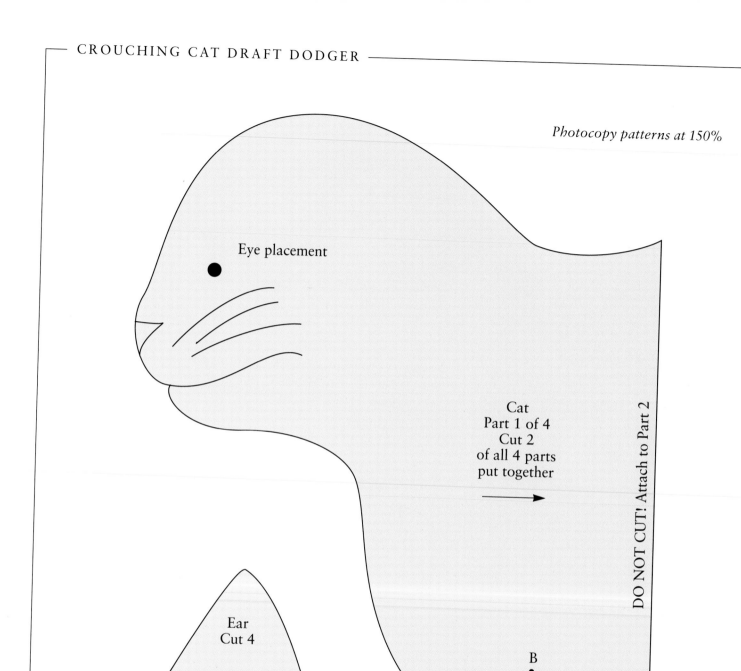

Photocopy patterns at 150%

Eye placement

Cat
Part 1 of 4
Cut 2
of all 4 parts
put together

DO NOT CUT! Attach to Part 2

Ear
Cut 4

I J

B

A

A

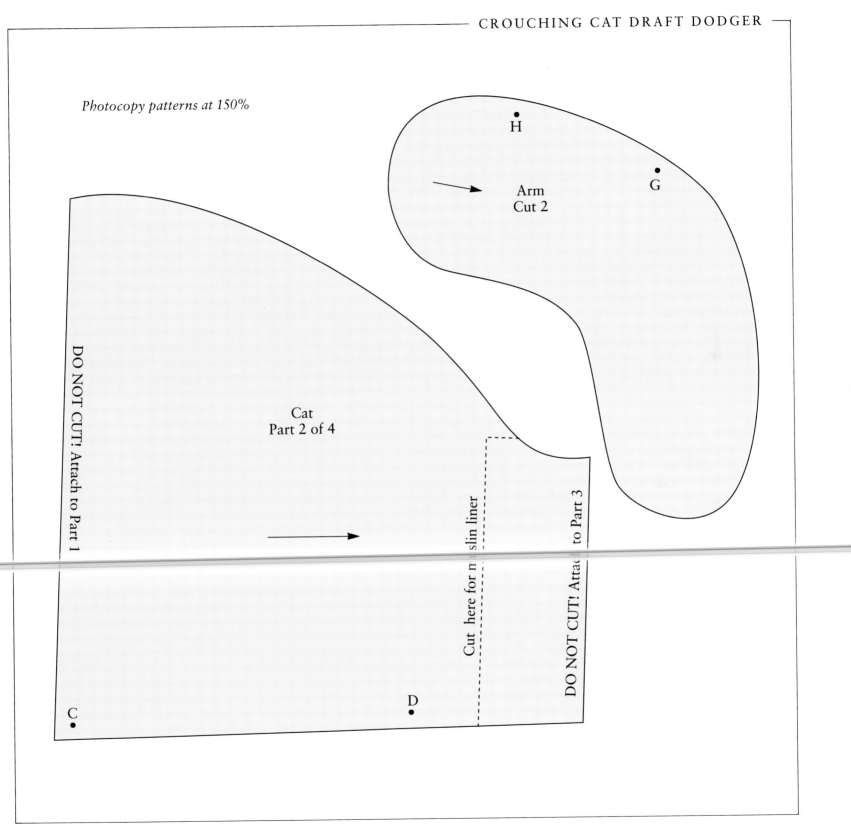

Photocopy patterns at 150%

H

G

Arm
Cut 2

DO NOT CUT! Attach to Part 1

Cat
Part 2 of 4

Cut here for muslin liner

DO NOT CUT! Attach to Part 3

D

C

DO NOT CUT! Attach to Part 4

DO NOT CUT! Attach to Part 3

Cat
Part 3 of 4

Cat
Part 4 of 4

Photocopy patterns at 150%

DO NOT CUT! Attach to Part 2

Watchful Cat Door Stop

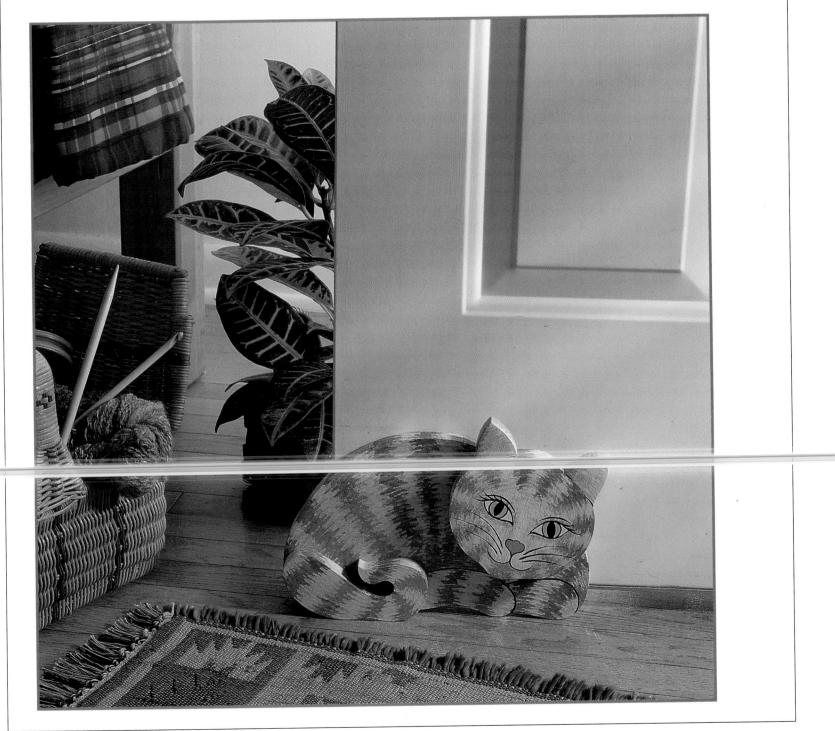

This tabby stays put right by the door to hold it open. A wooden wedge attached to the back of the cat slides under the door.

What You'll Need

- Unfinished wood cat doorstop
- Acrylic paint: yellow ochre, raw sienna, sand, gooseberry, ebony black
- Brushes: ½-inch flat, #2 flat, 10/0 liner
- Acrylic matte-finish spray

1. See pages 5–8 for basic techniques for decorative painting. Use ½-inch flat brush to base-coat body, head, and tail pieces of doorstop with yellow ochre. Allow to dry. Follow directions on pages 4–5 to trace pattern on page 61. Transfer pattern to doorstop pieces.

2. Using ½-inch flat brush, apply the dark fur with raw sienna in a zigzag tapping motion. Practice tapping on paper before applying to wood. Allow to dry.

3. In the same zigzag tapping motion, apply the light fur with sand.

4. Use #2 flat brush to paint the eyes with sand and the nose with gooseberry. Paint irises of eyes with yellow ochre. With liner brush, line paws, eyes, lashes, pupils, eyelids, nose, mouth, and whiskers with ebony black. Allow to dry. Spray with acrylic matte-finish spray. Follow manufacturer's directions for assembling doorstop.

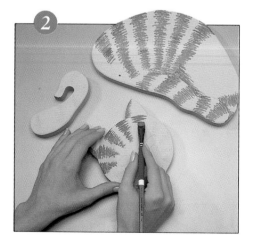

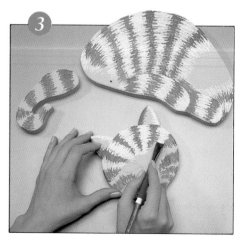

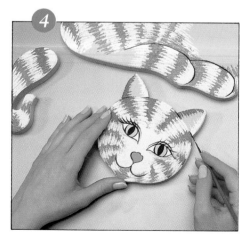

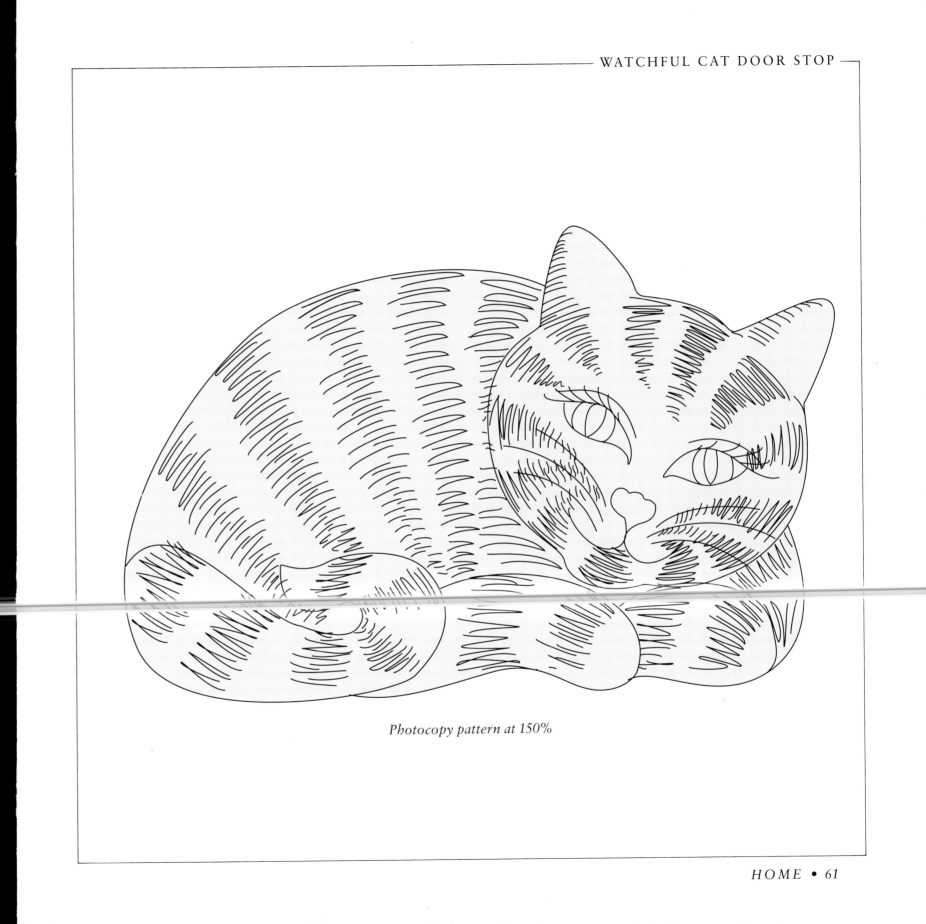

Photocopy pattern at 150%

HOLIDAY FUN
CHRISTMAS TREE SKIRT

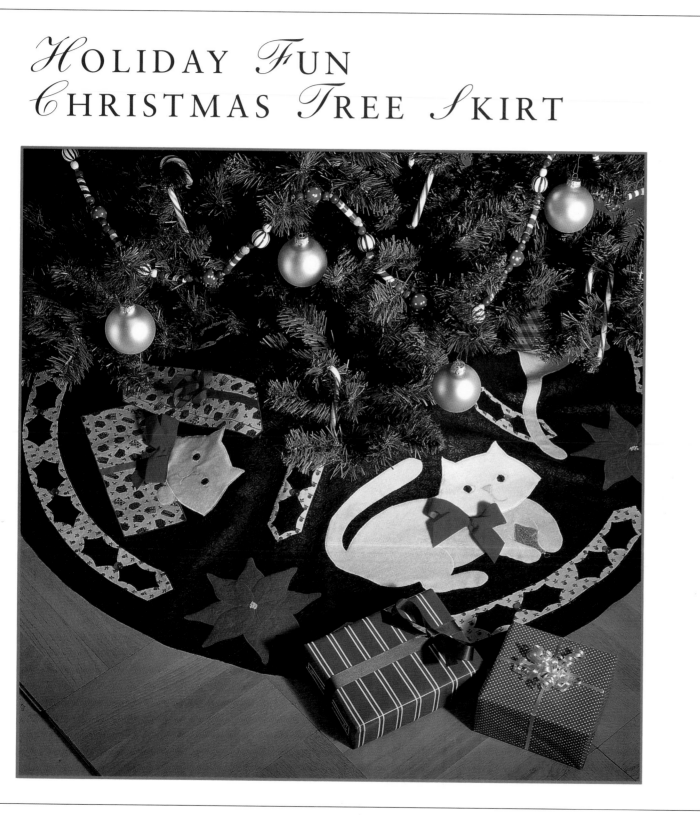

What You'll Need

- 3½ yards green felt, 54 inches wide (for skirt base and holly leaves)
- ¼ yard red felt, 54 inches wide (for poinsettia petals)
- ½ yard white fleece or velour (for cats)
- ½ yard printed fabric with white background (for section dividers)
- ⅛ yard fabric with Christmas package design (for box and lid)
- Red-and-green plaid fabric, 9×9 inches (for stocking)
- Contrasting red-and-green plaid fabric, 4×4 inches (for toe and heel patches)
- Scraps of pink, blue, and white fabric (for cat faces)
- Muslin, 3×13 inches (for ornament and lining for one divider)
- 2¾ yards fusible webbing
- 2¼ yards red velvet ribbon, 1⅜ inches wide
- 1¼ yards red grosgrain ribbon, ⅝ inch wide
- 18 red round acrylic stones, 12mm
- Fabric paint: jewel blue topaz and metal quicksilver
- Puffy fabric paint in yellow
- Animal whiskers
- Threads to match fabrics
- Brushes: #4 round, liner
- Disappearing ink marking pen
- White chalk pencil
- String, 30 inches long
- Sewing machine, iron, scissors

*K*ittens love to help with the Christmas wrapping and tree trimming. These four will play under your Christmas tree on this charming tree skirt.

1. Cut two 54-inch lengths from green felt. Fold each in half to form two 27-inch squares. Tie the 30-inch piece of string to the white chalk pencil so that the tail of string measures 27 inches. Hold string end at the corner of one felt square on the fold. Hold pencil at opposite end of folded edge. Keeping string taut, use pencil to draw a quarter circle on the felt from the fold to the selvage edges. Repeat with other 27-inch square.

2. Cut the string so that the tail measures 6 inches. Use the procedure in step 1 to mark a 6-inch quarter circle within the 27-inch

quarter circle. Repeat with other square. Cut on chalk lines. Each piece will form a half circle with a half-circle opening.

3. Cut a 14×16-inch piece of green felt. Iron fusible webbing to wrong side of felt following manufacturer's directions. Iron fusible webbing to wrong side of red felt, white velour, white print, Christmas-package print, plaid pieces, and muslin. Follow directions on page 14 to trace and cut patterns on page 66–68, using fabric recommended for each piece. Cut 6 cat faces to create double thickness.

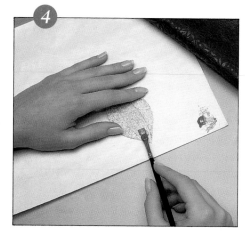

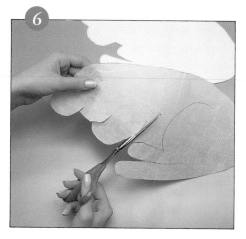

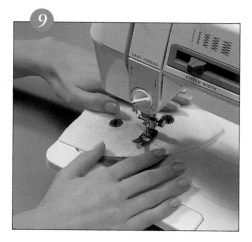

4. Paint ornament using jewel blue topaz and metal quicksilver paints. Allow to dry.

5. Find and mark midpoints on green half circles. Using placement diagram on page 65 as a guide, place all fabric pieces except the dividers and poinsettias where half circles meet. When everything is placed satisfactorily, remove and set aside cat faces, eyes, and noses. Remove paper backing from other pieces and iron in place.

6. Use paper backings to make templates for appliqué lines. Trace interior lines for cats, box lid, and stocking onto paper backings for those pieces. Carefully cut along pencil lines. Place each template on top of matching form. Using a disappearing-ink pen, draw through the cut lines onto the fabric. For cat faces, remove paper backings from 3 faces. Use disappearing-ink pen

on those 3 faces. Iron each of these faces to an unmarked face to create double thickness.

7. Cut grosgrain ribbon to match lengths on box lid and box. Iron ribbon pieces to fusible webbing, remove paper backing, and iron in place on tree skirt.

8. Appliqué all pieces in place, using coordinating threads with a medium stitch. Appliqué only ribbon ends on box lid and box; use a straight stitch for sides of ribbon. Use transparent thread for orna- ment stitching and gray thread to satin-stitch ornament holder and to outline hanger.

9. For cat faces, remove paper backing from eye, nose, and iris pieces. Iron in place. Appliqué using coordinating thread with narrow- width stitch. To make pupils for eyes, begin with narrow satin stitch

at top center of each eye, gradually widening to widest-width stitch as center of eye is reached. Taper back to narrow stitch as bottom of eye is reached.

10. Cut velvet ribbon using a diagonal cut into 1 piece 24 inches long and 3 pieces 19 inches long. Tie bows with the 19-inch pieces and stitch to cats' necks. Use the placement diagram as a guide for placing the 24-inch length. Pinch the ribbon 6 inches from each end and stitch in place at each pinch. Stitch right side of end of ribbon closest to cat's face to tree skirt.

11. Pin one edge of tree skirt halves together, right sides together; sew a ¼-inch seam. Press seam open. Put one divider and poinsettia in place over seam. Iron in place and appliqué.

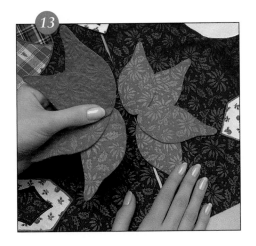

stabilizer. Remove paper for flower to fit together.

14. Apply 7 or 8 small puffs of yellow puffy fabric paint to poinsettia centers. Attach acrylic stones between holly leaf pairs using a small amount of regular fabric paint. Test on scrap fabric first to judge proper amount of paint. Allow to dry for 24 hours. Follow puffy fabric paint manufacturer's directions to make paint puff up.

12. Sew the last divider to muslin lining, leaving one side open for turning. Clip corners and turn; press. Iron holly leaves in place and appliqué. Iron fusible webbing to ½ of the muslin side, lengthwise; remove paper backing. Match the 2 open edges of tree skirt to complete circle. Position divider; iron to only 1 side of tree skirt, allowing divider to overhang the other side.

13. Match open edges of tree skirt again. Iron petals for last Poinsettia in place. Remove those petals that fall on the left side of the joined edges. Iron in place the petals on the right side. Replace the petals on the left side. Protect the overlap areas of the petals from adhering to the right side by placing paper backing between petals and other side before ironing in place. Appliqué each side individually, continuing around overhanging edges using paper backing as a

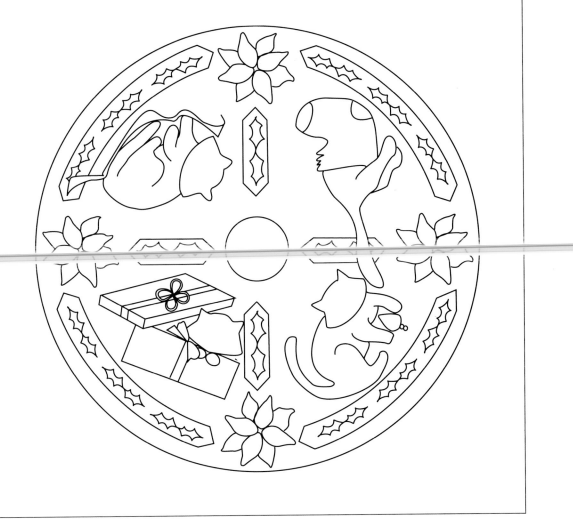

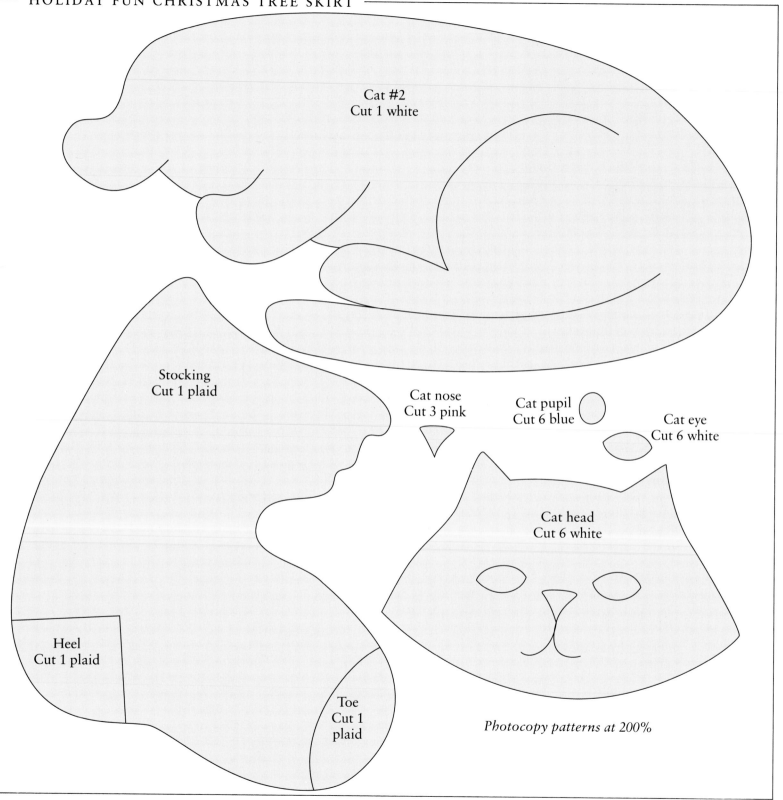

Cat #2
Cut 1 white

Stocking
Cut 1 plaid

Cat nose
Cut 3 pink

Cat pupil
Cut 6 blue

Cat eye
Cut 6 white

Cat head
Cut 6 white

Heel
Cut 1 plaid

Toe
Cut 1
plaid

Photocopy patterns at 200%

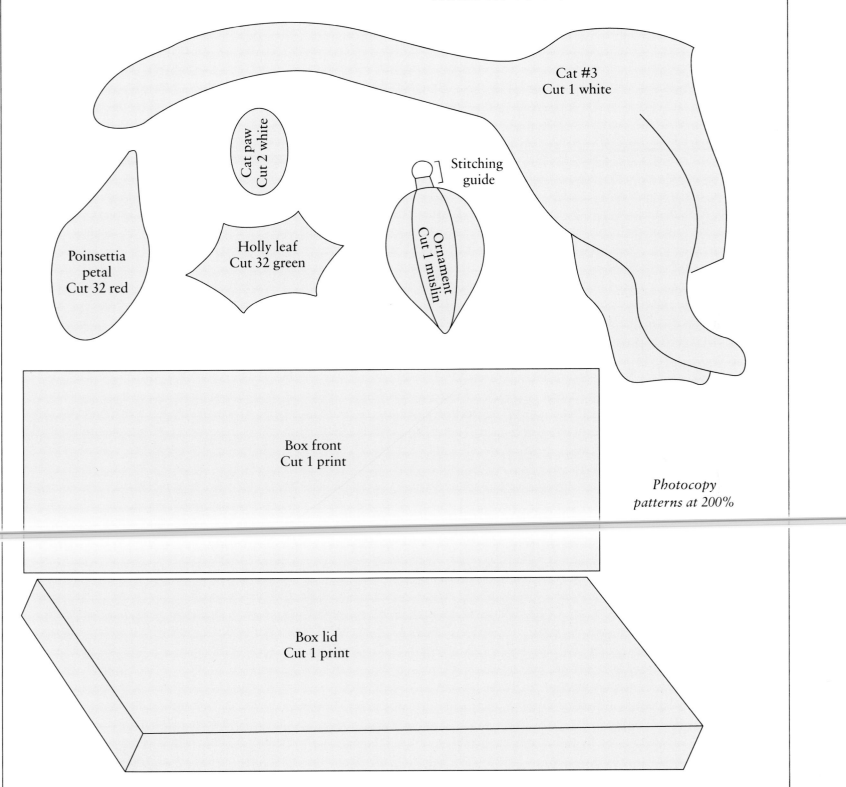

Cat #3
Cut 1 white

Cat paw
Cut 2 white

Stitching
guide

Poinsettia
petal
Cut 32 red

Holly leaf
Cut 32 green

Ornament
Cut 1 muslin

Box front
Cut 1 print

*Photocopy
patterns at 200%*

Box lid
Cut 1 print

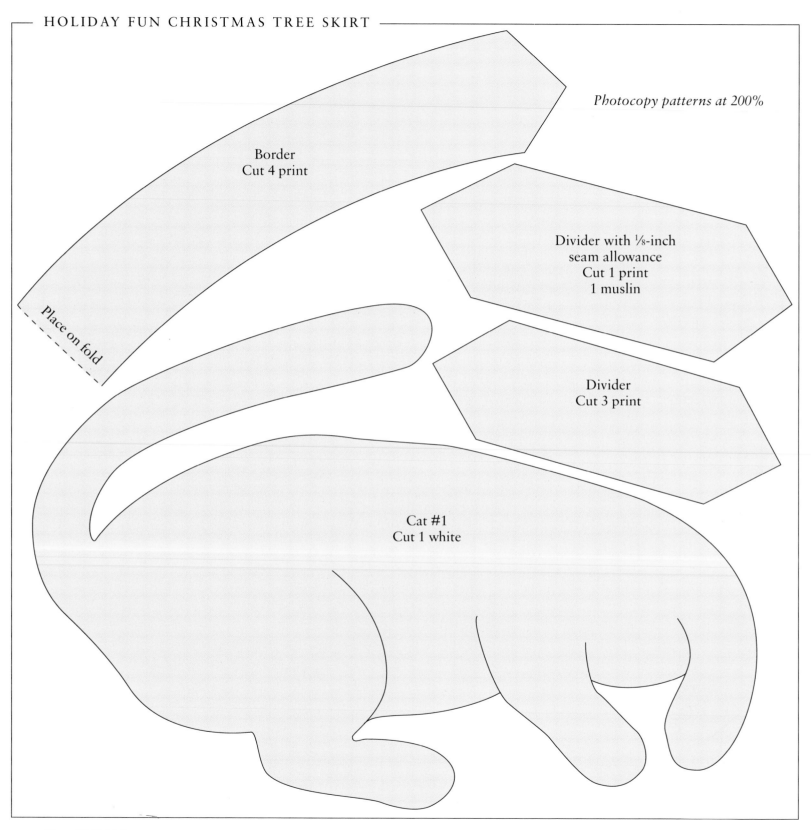

Photocopy patterns at 200%

Border
Cut 4 print

Place on fold

Divider with ⅛-inch
seam allowance
Cut 1 print
1 muslin

Divider
Cut 3 print

Cat #1
Cut 1 white

Bon Appetit Pot Holders and Kitchen Towel

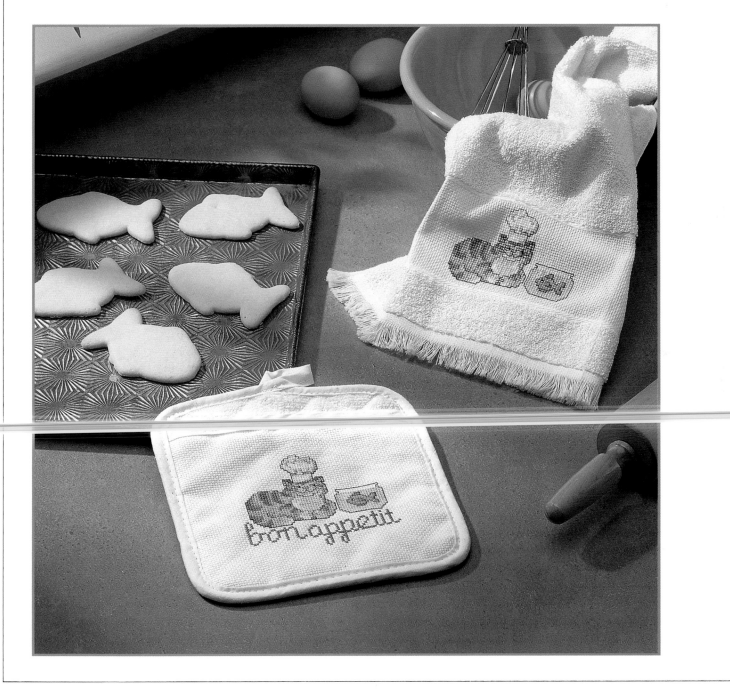

A kitty chef eyes the catch of the day—a tasty goldfish morsel, who appears worried about his fate. Once the cat has landed the hapless fish, perhaps he will use this kitchen set when preparing his feast.

What You'll Need

- Ecru terry towel and pot holders with area for cross-stitching
- 6-strand embroidery floss (see color key)
- #24 tapestry needle
- Scissors

Stitch counts: 37h×54w (towel); 51h×59w (pot holder)

Sizes: 2¾×3⅞ inches (towel); 4⅜×3¾ inches (pot holder)

Following the general cross-stitch directions on pages 9–11, stitch entire design centered on cross-stitch insert of pot holder. Cross-stitch design without words centered on cross-stitch insert of towel. When all cross-stitching is done, backstitch where indicated using 1 strand of black. Indicate cat and fish eyes with French knots worked with 1 strand of black floss.

Color	DMC
Medium pink	776
Russet	434
Very light tan ultra	739
Tan brown	436
Light tan ultra	738
Medium light blue mist	928
Dark aquamarine	992
Light sportsman flesh	3774
Light larkspur	747
Dark orange spice	720
Medium orange spice	721
Light orange spice	722
Black	310
White	White

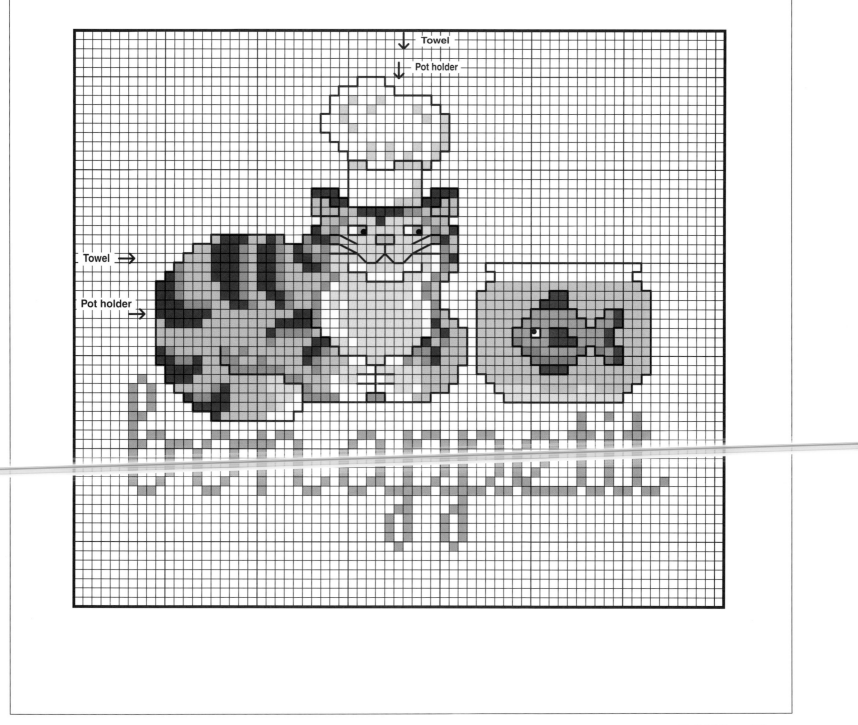

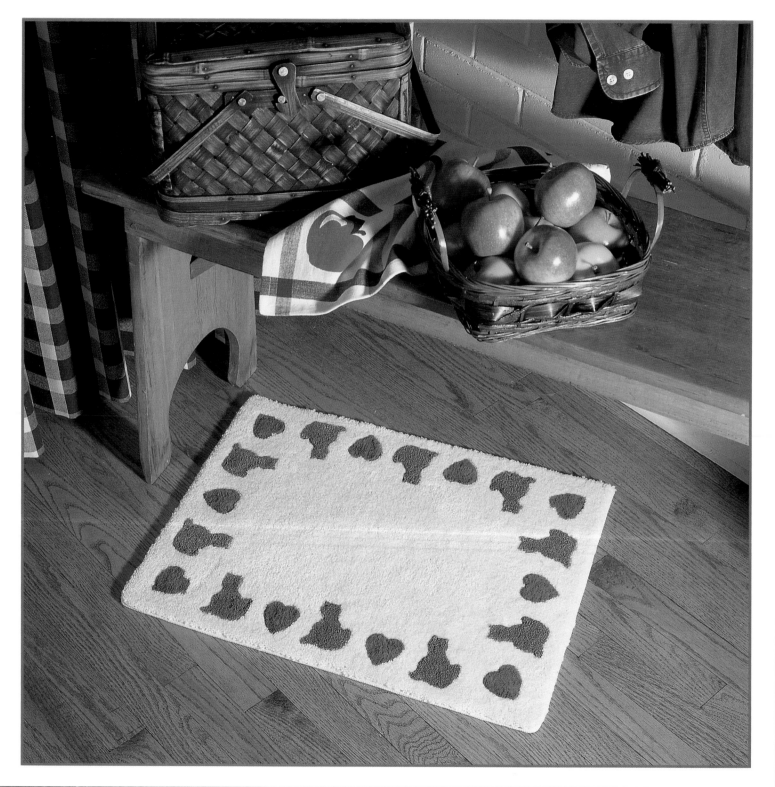

COUNTRY AREA RUG

This attractive rug gives a distinctive country look and is surprisingly easy to make. You can choose colors to match your decor, but be sure to use a light-colored rug. Paint colors will not be attractive on a darker rug.

What You'll Need

- Short-pile off-white rug, 2×1½ feet
- 2 open-top cookie cutters, 1 cat and 1 heart
- Acrylic paint: French grey-blue, country red
- #10 fabric round brush

1. Measure long side of rug to find the center. Position cat cookie cutter there, 1 inch from the edge. Gently press down, embedding cutter into pile. Lift; you will see the impression of the cutter. Alternating cats and hearts, position cookie cutters in this matter equally spaced around perimeter of rug. Position hearts in corners on an angle. You can erase the impressions by swiping your hand across the pile. Once placement is correct, you are ready to paint.

2. Replace heart cookie cutter in position on rug. Holding cutter firmly into rug, use brush to apply country red paint inside the cookie cutter. Scrub the paint gently into pile of rug. Make sure coverage is good around the edges. When painting is complete, lift cookie cutter straight up. Carefully place cookie cutter over next heart and repeat. When all hearts are painted, clean cookie cutter and brush with soap and water. Pinch-dry brush so as not to dilute next color.

3. Using French grey-blue paint and cat cookie cutter, paint cats in the same way. Allow rug to dry completely.

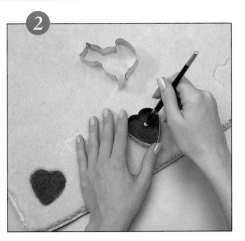
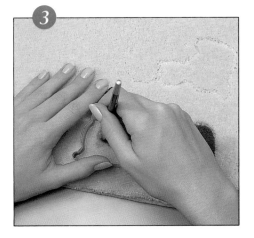

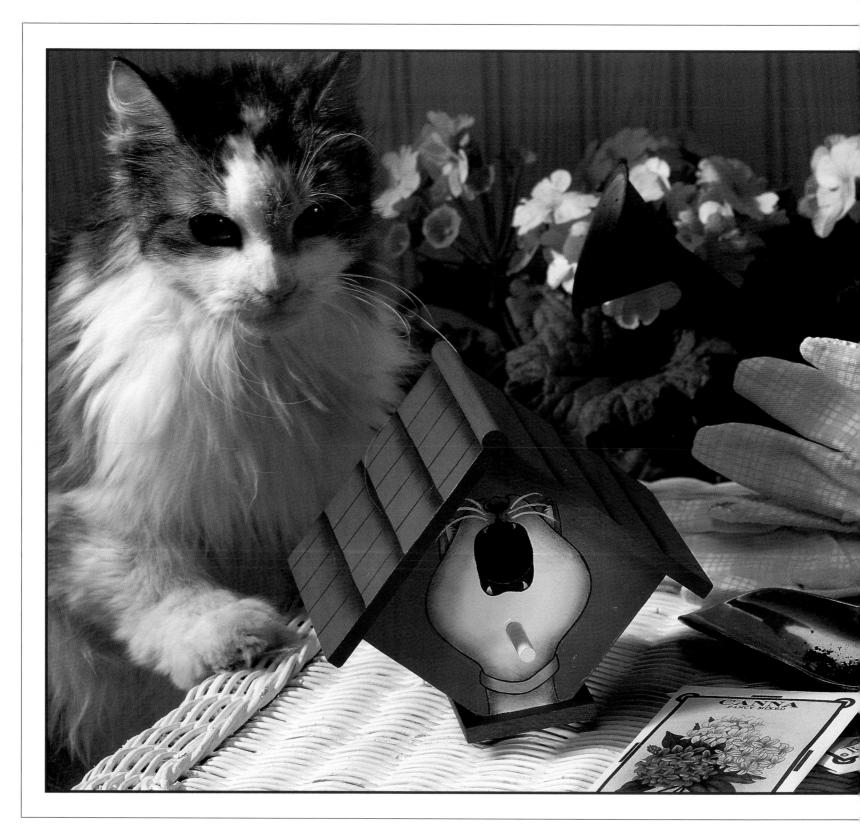

TRIFLES

Whimsical and delightful—

these appealing cat-themed

trinkets and knickknacks set a

lighthearted note. Try a striking,

cat-faced switch plate, costume

jewelry with a cat design, or a

humorous birdhouse.

CAT PAW REFRIGERATOR MAGNET PICTURE FRAMES

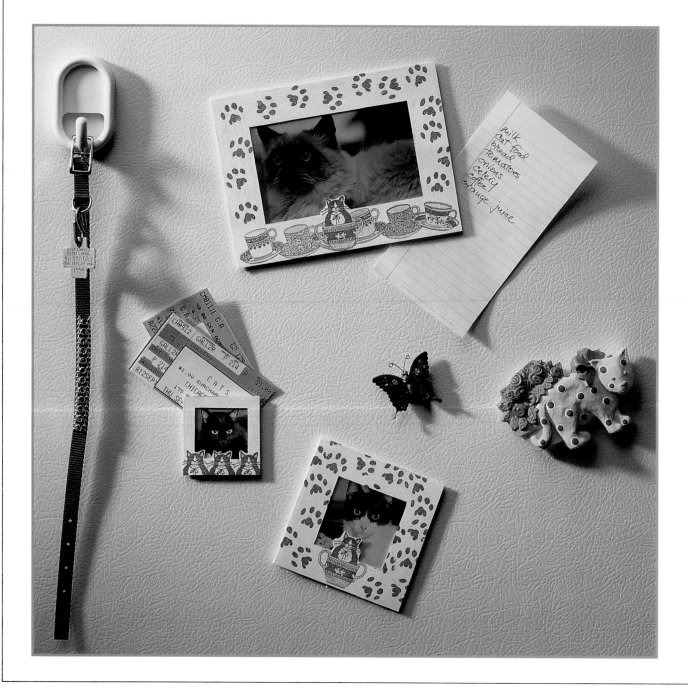

A winsome rubber stamp image—kitty peeking out of the sugar bowl—decorates this trio of frames for displaying your favorite felines.

What You'll Need

- 2 pieces smooth white card stock, 4½×6 inches
- 2 pieces smooth white card stock, 3½×3½ inches
- 2 pieces smooth white card stock, 2×2 inches
- 1 piece heavy white cardboard, 4½×6 inches
- 1 piece heavy white cardboard, 3½ ×3½ inches
- 1 piece heavy white cardboard, 2×2 inches
- 1 sheet acetate, 8½×11 inches
- Self-stick note
- Cat paw stamp
- Cat-in-sugar-bowl stamp
- Teacup stamp
- Black pigment ink pad
- Colored pencils: pink, blue, yellow, green
- Small self-adhesive magnets
- Craft knife, self-healing mat, sharp scissors, ruler, pencil, double-sided tape

1. Ink cat-in-sugar-bowl stamp with black ink pad. Stamp at bottom center of one of each of the three sizes of card stock. Reink stamp for each impression. On the smallest card, stamp off bottom edge so only the cat appears on card; repeat on either side of center image.

2. To create a mask for the image, stamp cat-in-sugar-bowl stamp on self-stick note so that top of image is over self-stick part. Cut out image. Place over image stamped on largest card.

3. Ink teacup stamp with black ink pad. Stamp teacups on either side of cat. Remove mask.

4. On largest frame, using ruler and pencil, measure and draw a line ⅞ inch from both sides and top. Cut along line with craft knife. Cut along tops of teacups and around cat's head. On medium frame, measure, draw, and cut similarly, leaving a ¾-inch border. On the smallest frame, leave a ⅜-inch border.

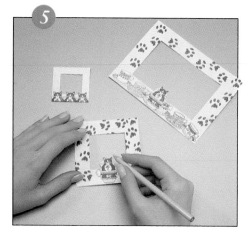

5. Ink paw print stamp with black ink pad. Stamp paw prints in borders of the two larger frames. With yellow colored pencil, lightly color borders of all three frames. Color teacups and sugar bowls with pink, blue, yellow, and green colored pencils. Color insides of cats' ears with pink pencil.

6. For each size, place second piece of card stock behind the cut-out frame and trace opening. Cut out with craft knife, making these frames slightly smaller than stamped frames.

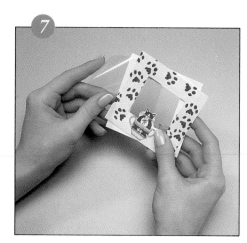

7. Cut out 3 pieces of acetate slightly smaller than outer dimensions of the 3 frames. Sandwich a piece of acetate between the 2 sections of each frame, using double-sided tape to secure.

8. Place double-sided tape along top and bottom edges of each frame and attach cardboard back. Leave sides open for inserting photograph. Insert photo, sealing edges with a small piece of double-stick tape if desired. Attach a piece of magnet to each corner of back of each frame.

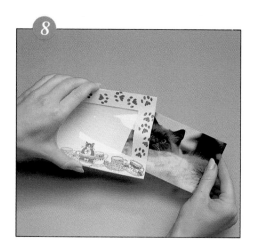

PLAYFUL CATS ETCHED GLASSES

Most cats aren't welcome on the dining table, but these cat-etched glasses will show off juice, iced tea, or soft drinks to perfection.

What You'll Need

- 4 clear glasses, 5½ inches high, 2¾-inch diameter at top
- Frisket, 6×27 inches for 4 glasses
- 3½ ounces etching cream
- Small squeegee
- Adhesive remover
- Dish detergent
- Vinegar
- Watercolor marking pen
- Fine-lined permanent marker
- Craft knife, self-healing mat, ruler, scissors, paper towels, paper

1. Remove any labels from glasses; remove residue from labels by spraying with adhesive remover. Let stand until saturated. Wash glasses in detergent and water. Rinse in water with a small amount of vinegar added and air dry.

2. For each glass, cut 2 pieces of frisket ¾×10 inches. Peel off backing and secure frisket around top and bottom of glass, overlapping ends. Cut off excess. Burnish frisket down firmly. Use watercolor marking pen to mark ¼ inch above

bottom tape. Cut a ⅜×10-inch piece of frisket and secure to glass with bottom edge at marking.

3. Mark ½ inch above narrow strip of frisket. Use this for cat placement.

4. Follow directions on pages 4–5 to trace patterns on page 81. Use permanent marker to trace both cat shapes onto one piece of frisket. Cut around shapes about ⅛ inch from tracings. Cut 2 of each cat shape for each glass.

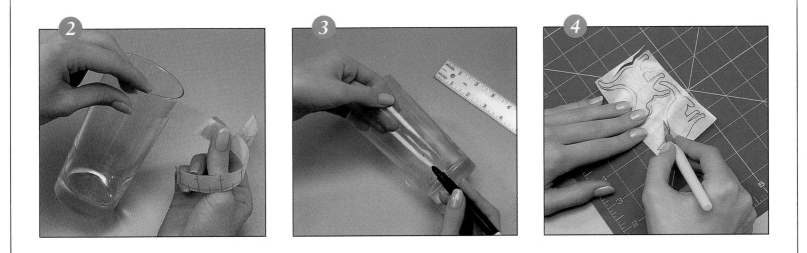

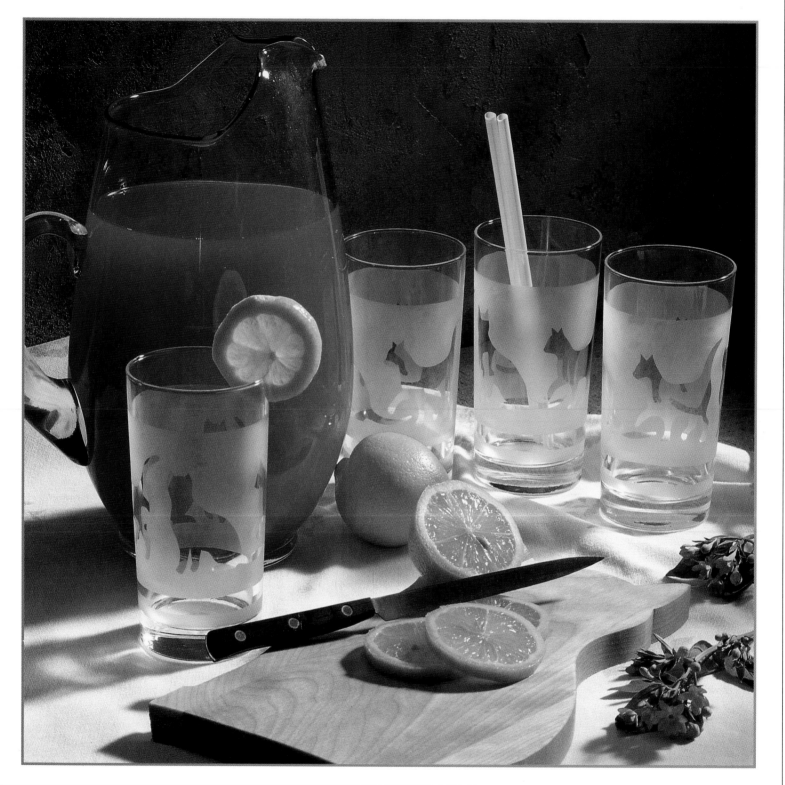

5. Peel back off one cat shape and place on glass with feet along guide line. Smooth down firmly. Position second cat shape and smooth down firmly. Repeat with 2 more cats.

6. Cut around cat shapes with craft knife held at a right angle. Apply minimum pressure. To avoid lifting or tearing the stencil, overlap the cuts slightly. Remove frisket around cats by lifting up with the knife held flat. Burnish all edges by running thumbnail or squeegee over them. Repeat for remaining 3 glasses.

7. Protect work surface with paper. Follow manufacturer's directions to apply etching cream. The glasses shown were etched for 40 minutes. Return cream to bottle. Wash glass to remove etching cream and frisket.

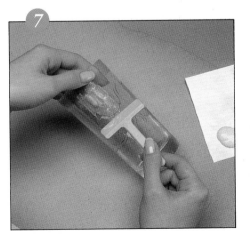

Photocopy patterns at 100%

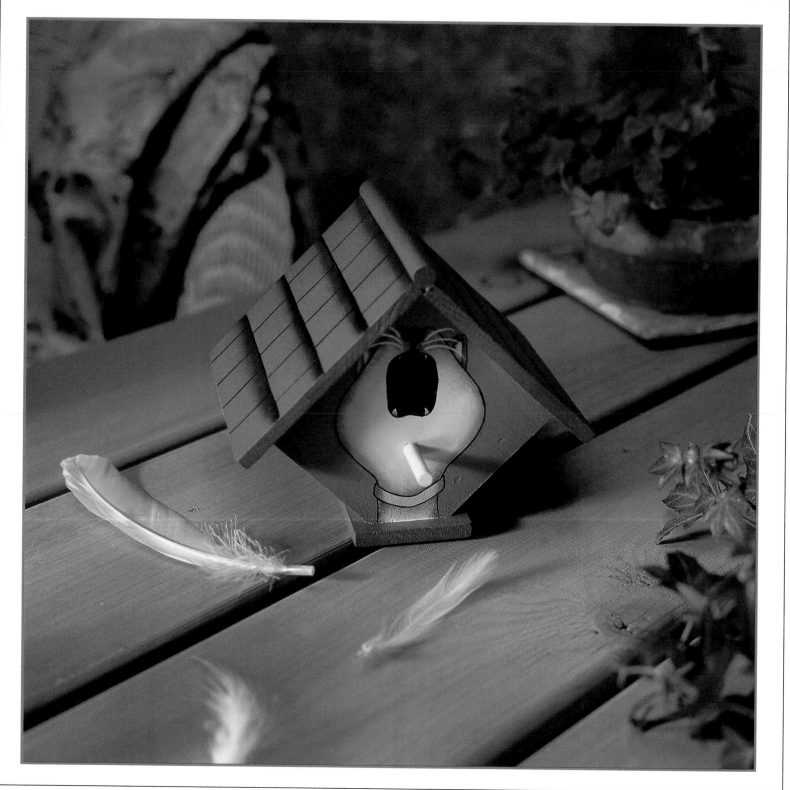

"READY AND WAITING" BIRDHOUSE

Poised for the inevitable, the open-mouthed cat on this decorative wood birdhouse provides a lighthearted accent to brighten up a room.

What You'll Need

- Unfinished wood decorative birdhouse, medium size
- Acrylic paint: country red, buttermilk, mink tan, baby blue, ebony black, dark chocolate, Victorian blue
- Brushes: ½-inch flat, #3 flat, ⅜-inch angle, 10/0 liner
- Acrylic matte-finish spray

1. See pages 5–8 for basic techniques for decorative painting. Using ½-inch flat brush, base-coat birdhouse roof and bottom with country red paint. Base-coat front and back areas and side walls with mink tan. Allow to dry. Follow directions on pages 4–5 to trace and transfer cat patterns on page 84 to front and back of birdhouse. Base-coat cats with buttermilk.

2. Using #3 brush, paint neck ribbon of both cats and eye irises of back cat with baby blue. Paint nose, mouth, inside mouth opening of front cat, and eye pupils of back cat with ebony black.

3. Use angle brush to float cat fur with dark chocolate. Float nose and left side of eye irises on back cat with buttermilk. Float irises and neck ribbon with Victorian blue.

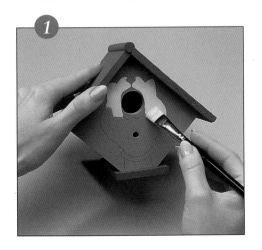

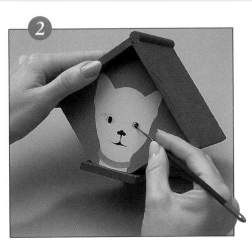

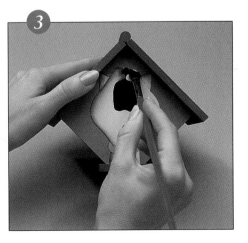

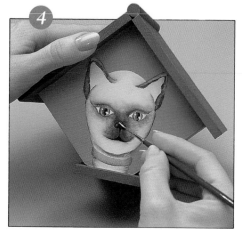

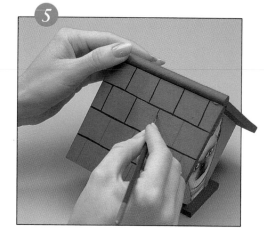

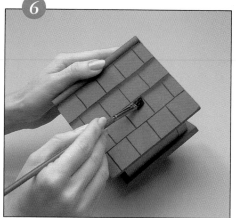

4. Base-coat teeth of front cat with buttermilk. Highlight eyes and nose of back cat with buttermilk.

5. Measure 1-inch stripes across both sides of roof; mark 1-inch squares across top row. For next row, offset squares ½ inch. Repeat for remaining rows. Using liner brush, line roof squares and cats with ebony black. Line cat whiskers with buttermilk.

6. Float roof tiles with black. When birdhouse is thoroughly dry, varnish with acrylic matte-finish spray.

Photocopy patterns at 100%

Front

Back

Swinging Cats Tree Ornaments

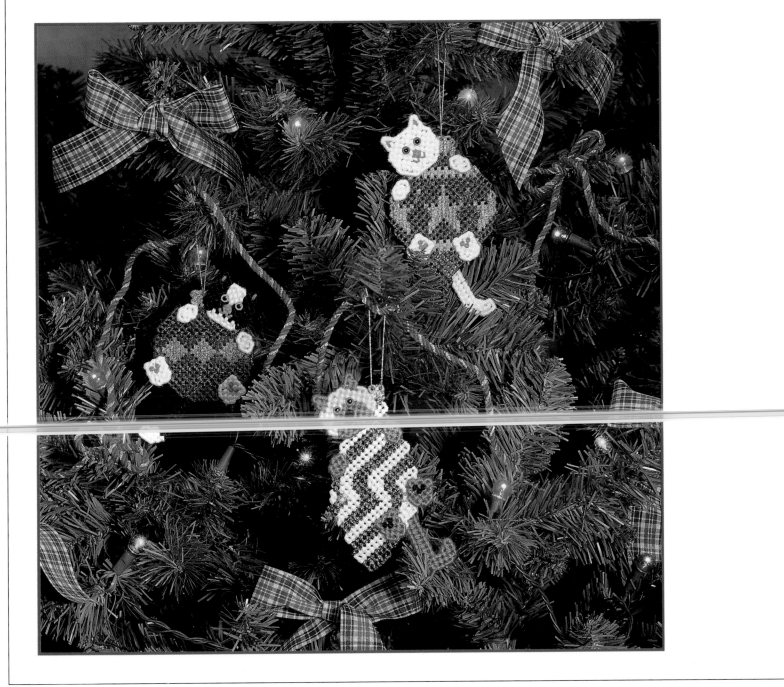

*T*hese three cats became so intrigued with the glittering glass tree ornaments that they each jumped right up to swing from one. The three plastic canvas ornaments make an amusing touch for your Christmas tree.

What You'll Need

- 1 sheet clear plastic canvas, 7 count
- 2 yellow-and-black animal eyes, 6mm
- 4 blue-and-black animal eyes, 6mm
- 24 inches fine (#8) gold braid
- Metallic ribbon, ⅛-inch (see color key)
- Plastic canvas yarn (see color key)
- #16 tapestry needle
- Craft glue
- Scissors

1. Cut all pieces from plastic canvas as indicated on charts on pages 87–88. Following the general plastic canvas directions on pages 11–13, stitch cat parts according to charts in continental stitch using yarn. After all stitching is done, cross-stitch noses and backstitch mouths (dark pink for white and black-and-white face; black for Siamese face). Overcast all edges with corresponding colors.

2. Stitch ornaments according to charts using metallic ribbon. For round ornament, stitch gold in slanting Gobelin stitch, green in reverse continental stitch, and red in continental stitch. For diamond-shaped ornament, stitch gold and light blue in slanting Gobelin stitch and dark blue in continental stitch. Stitch two gold cross-stitches between the star motifs as shown. For oblong ornament, stitch gold in slanting Gobelin stitch and green and white in continental stitch. Overcast all edges with corresponding colors.

3. Using photograph as a guide, glue faces, paws, and tails to ornaments. Attach yellow-and-black eyes to black-and-white face and remaining eyes to remaining faces, following chart. Cut gold braid into 3 equal pieces. Thread braid through top of each ornament and tie in a knot for a hanging loop.

Plastic canvas yarn

	Color	Amount	Spinrite
☐	White	4 yards	1
▨	Medium brown	3 yards	20
▨	Dark pink	2 yards	25
☐	Tan	1 yard	56
■	Black	3 yards	28

Metallic ribbon

	Color	Amount	Kreinik
■	Dark blue	4 yards	051h1
☐	Gold	3 yards	002h1
■	Red	3 yards	003h1
■	Green	5 yards	008h1
▨	Light blue	1 yard	094
☐	White	3 yards	032

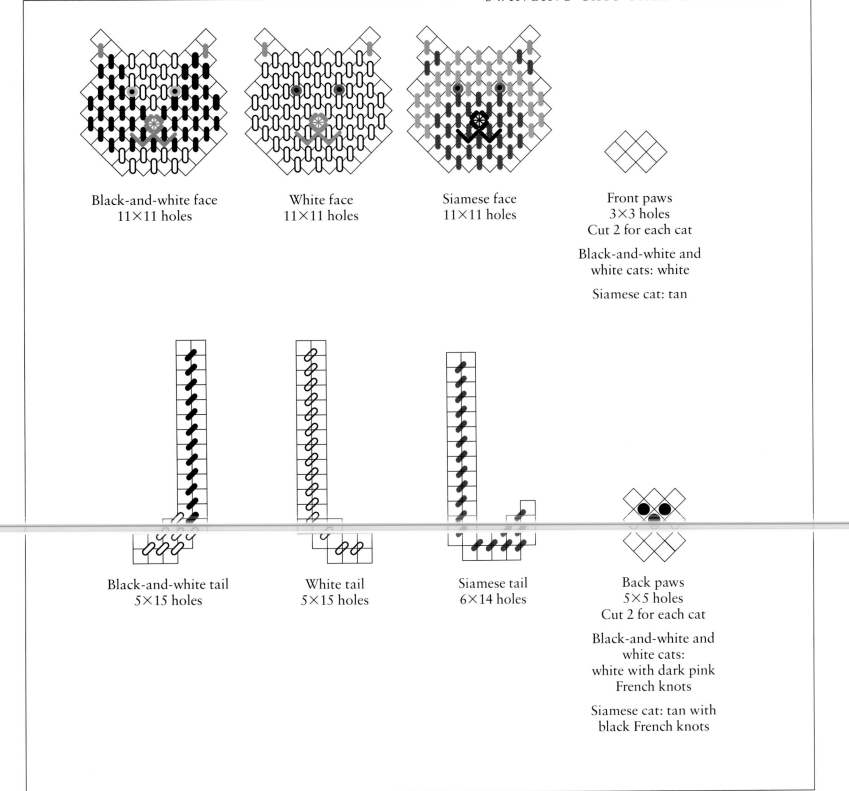

Black-and-white face
11×11 holes

White face
11×11 holes

Siamese face
11×11 holes

Front paws
3×3 holes
Cut 2 for each cat

Black-and-white and
white cats: white

Siamese cat: tan

Black-and-white tail
5×15 holes

White tail
5×15 holes

Siamese tail
6×14 holes

Back paws
5×5 holes
Cut 2 for each cat

Black-and-white and
white cats:
white with dark pink
French knots

Siamese cat: tan with
black French knots

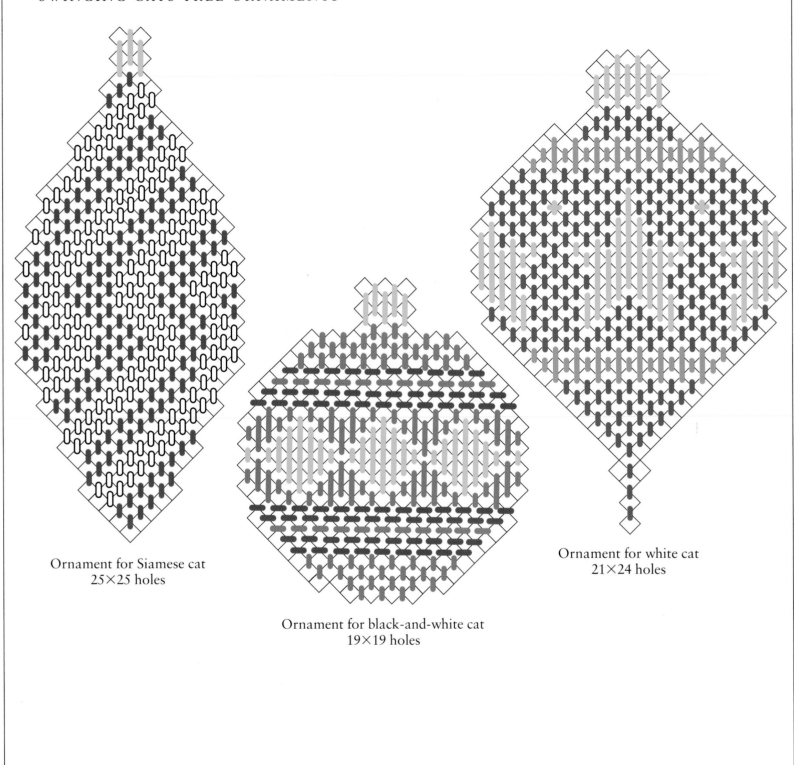

Ornament for Siamese cat
25×25 holes

Ornament for black-and-white cat
19×19 holes

Ornament for white cat
21×24 holes

CAT CLOSE-UP SWITCH PLATE

This striking cat seems to gaze intensely at you, almost as if he were peering out from behind the light switch. He makes a dramatic accent that will be noticed.

What You'll Need

- Unfinished wood single-toggle switch plate
- Acrylic paint: snow white, terra cotta, ebony black, dark chocolate, mistletoe
- Brushes: ½-inch flat, #2 flat, ⅜-inch angle, 10/0 liner
- Acrylic matte-finish spray

1. See pages 5–8 for basic techniques for decorative painting. Use flat brush to base-coat switch plate with snow white. Multiple coats may be needed for complete coverage. Allow to dry.

2. Follow directions on pages 4–5 to trace pattern on page 91. Transfer pattern to switch plate.

3. Thin terra cotta paint to the consistency of ink. Using liner brush and thinned terra cotta, line the fir. Hold brush in upright position to create fine lines.

4. Further dilute terra cotta paint with water. Use this as a wash over entire switch plate except eyes. Allow to dry.

5. Use liner brush to line fur over top of eyes, muzzle, chin, and lower right spot with diluted snow white paint. Line mouth, nose, and eyes including pupil and iris with ebony black paint.

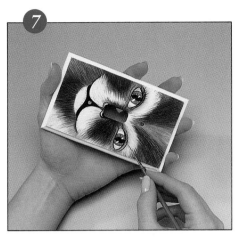

Photocopy pattern at 100%

6. Line dark fur areas with diluted ebony black paint. Line brown areas and all black fur edges with diluted dark chocolate paint. Reline the white areas with snow white paint diluted to the consistency of milk.

7. Use flat brush to wash irises of eyes with mistletoe paint. Allow to dry. Float outer edges of eyeballs, eyelids, and under muzzle with dark chocolate paint darkened with a touch of ebony black. Float snow white on nose with snow white wash. Highlight dots in eyes and nose with snow white. Line eyelashes with ebony black.

8. Repaint outside edge of switch plate with snow white if necessary. Allow to dry. Spray with acrylic matte-finish spray; allow to dry and spray again.

CAT AND FISHBOWL
PIN AND EARRINGS

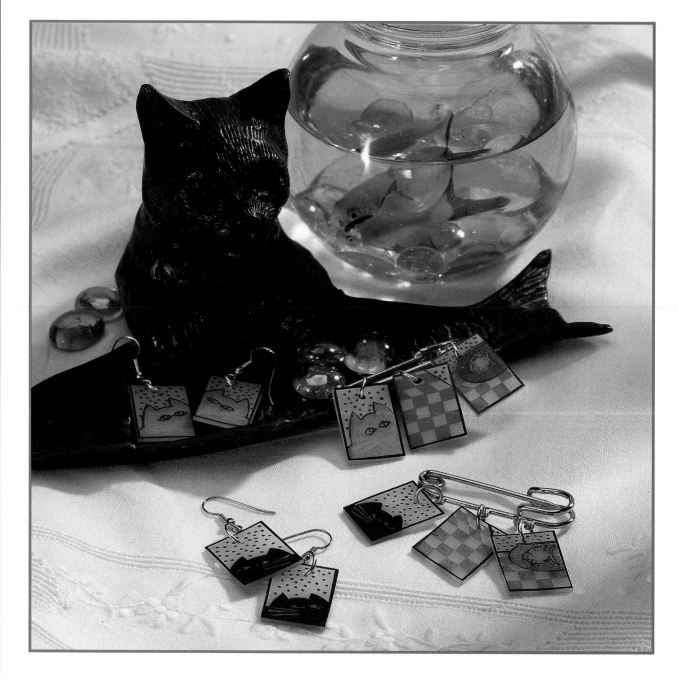

The temptation facing a cat is the story shown in this perky pin with matching earrings made of shrinkable plastic. Try a variation with a black cat on silver-tone jewelry findings.

What You'll Need

- 1 sheet shrinkable plastic film
- 1 kilt pin with 3 loops
- 3 large jump rings
- 1 pair ear wires or clips
- Permanent markers: orange, blue, black, red, turquoise, yellow
- Kraft paper or brown paper grocery bag
- Plain white paper
- Scissors, hole punch, cookie sheet, oven or toaster oven, spatula, needle-nose pliers

1. Place plastic film over designs on page 94. Using permanent markers, first trace and fill in colored areas; then trace black lines and areas. Make two tracings of the cat facing right. Be accurate, but at this point don't worry about small missed spots.

2. Cut pictures apart without cutting them out. Lay pictures over white paper and inspect them carefully one at a time. Fill in any missed areas.

3. Carefully cut out each rectangle. Punch a hole in top center of each picture about ⅛ inch from top edge.

4. Preheat oven to 275 degrees F. Line cookie sheet with kraft paper. If you are using a grocery bag, cut bag so paper has no printing or seams. Make sure paper lies flat in pan. Place pictures on paper so they are not touching. Bake 3 to 5 minutes. The pieces will be soft and should be the thickness of a nickel and lying flat, not curling up. If you have taken them out too soon, cool them slightly, nudge them with a spatula to make sure they aren't sticking to the paper, and return to oven. After pieces have been baked, allow to cool about 30 seconds, or until pieces don't bend or wrinkle when lifted with spatula. Remove pieces to clean, flat surface to finish cooling.

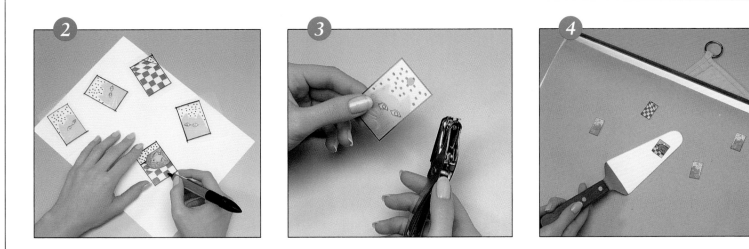

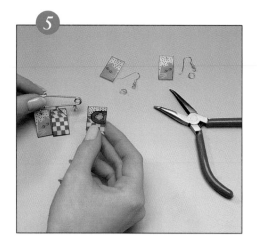

5. Use needle-nose pliers to open jump ring. Insert through hole in one of the pictures of the cat facing right. Hang in left loop of kilt pin and close loop. In center loop, hang picture of checked tablecloth. Hang picture of fish in right loop. Hang remaining pictures in loops of ear wires.

Siamese Cat Checkbook Cover

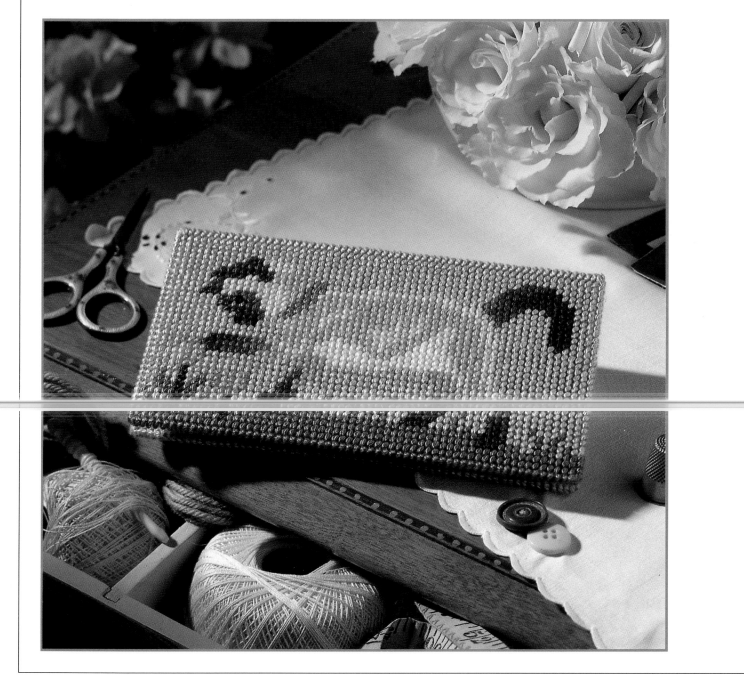

Let this curious little Siamese cat remind you, every time you pay your bills, that the important things in life are right under your eyes.

What You'll Need

- 1 sheet clear plastic canvas, 10 count
- #3 pearl cotton (see color key)
- #18 tapestry needle
- Scissors

1. Cut 2 pieces of plastic canvas 33×63 holes for front and back. Cut 1 piece 5×63 holes for spine. Cut 2 pockets, each 20×63 holes (these pieces are left unstitched).

2. Following the general plastic-canvas directions on pages 11–13, stitch front, working in continental stitch or reverse continental stitch, according to the chart. When all stitching for front is done, back-stitch mouth with black. Use French knot for eye.

3. Stitch spine in continental stitch with sky blue. Stitch back with sky blue in slanting Gobelin stitch, working in vertical rows covering two bars.

4. To assemble checkbook cover, join top edge of front and back to long edges of spine using overcast stitch in sky blue. To form pockets, place unstitched pocket pieces to wrong sides of front and back, matching lower edges and sides. Working through both thicknesses where necessary, overcast around entire piece with colors to correspond to previous stitching.

Color	Amount	DMC
Sky blue	36 yards	3325
Very dark brown	2 yards	938
Dark brown	2 yards	801
Brown	1 yard	434
Ivory	1 yard	712
Very light tan	2 yards	739
Tan	3 yards	738
Dark tan	1 yard	436
Black	1 yard	310
Blue	1 yard	799
Light green	1 yard	502
Green	4 yards	911
Dark green	1 yard	500
Light pink	1 yard	605
Medium pink	1 yard	603

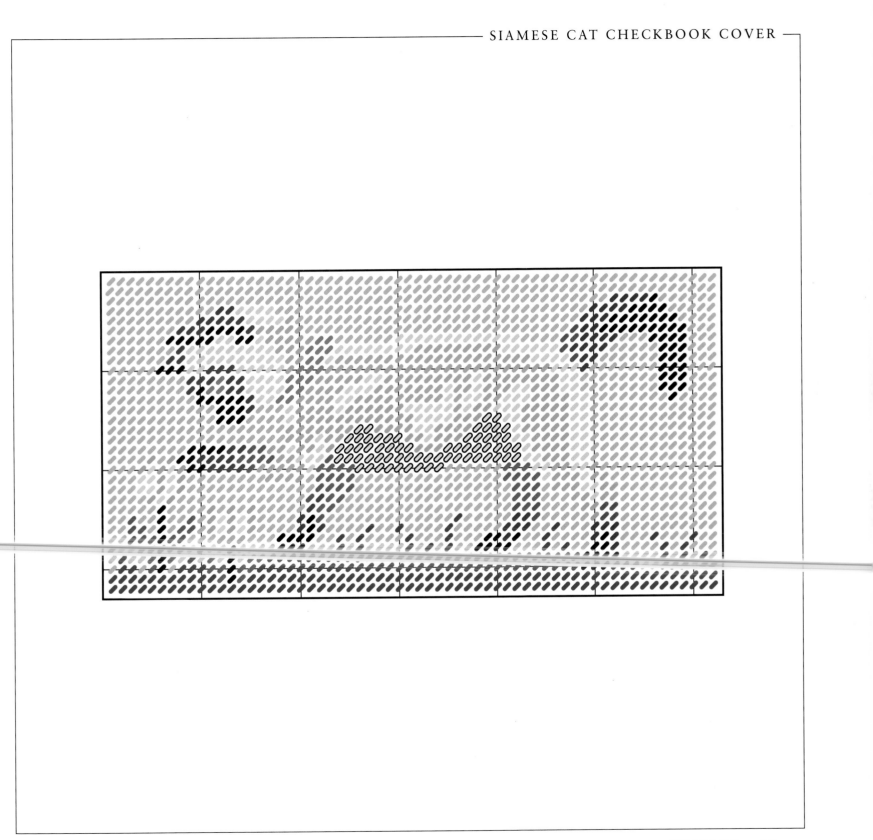

Fast and Fun Trinket Box

*T*hese cats, taking their ease by setting up residence on the furniture, come from a sticker set. Just decoupage them onto a painted box for a bright little storage container.

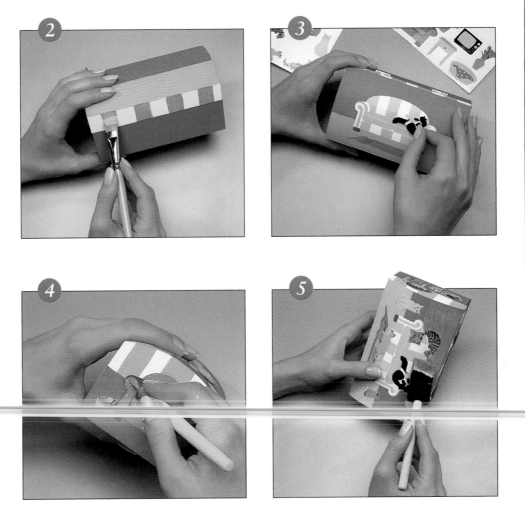

What You'll Need

- Unfinished wood box
- Acrylic paint: white, straw, fuchsia, and laguna blue
- Furniture and cat stickers
- Decoupage finish
- Brushes: 1-inch sponge and ½-inch flat
- Waxed paper
- Pencil, ruler, craft knife

1. Lightly draw a pencil line on box top to separate the painted floor and the wall. Place box on waxed paper. Use foam brush to paint sides of the box lid with white. Paint floor area with straw, wall area and lower box sides with fuchsia, and lower box front and back with laguna blue. Box may need several coats. Allow to dry between coats.

2. When paint is dry, use flat brush and straw paint to paint stripes on sides of box lid. Allow to dry.

3. Arrange stickers on box.

4. If some stickers extend from lower box to lid, use sharp craft knife to cut stickers where the lid and lower box join.

5. Working on one area of the box at a time, use sponge brush to spread a light coat of decoupage finish over entire area. To prevent large stickers from wrinkling, carefully pull up one side of the sticker at a time and spread finish under sticker. Smooth sticker down and cover with more finish. When dry and clear, apply another coat of finish. Repeat with at least one more coat.

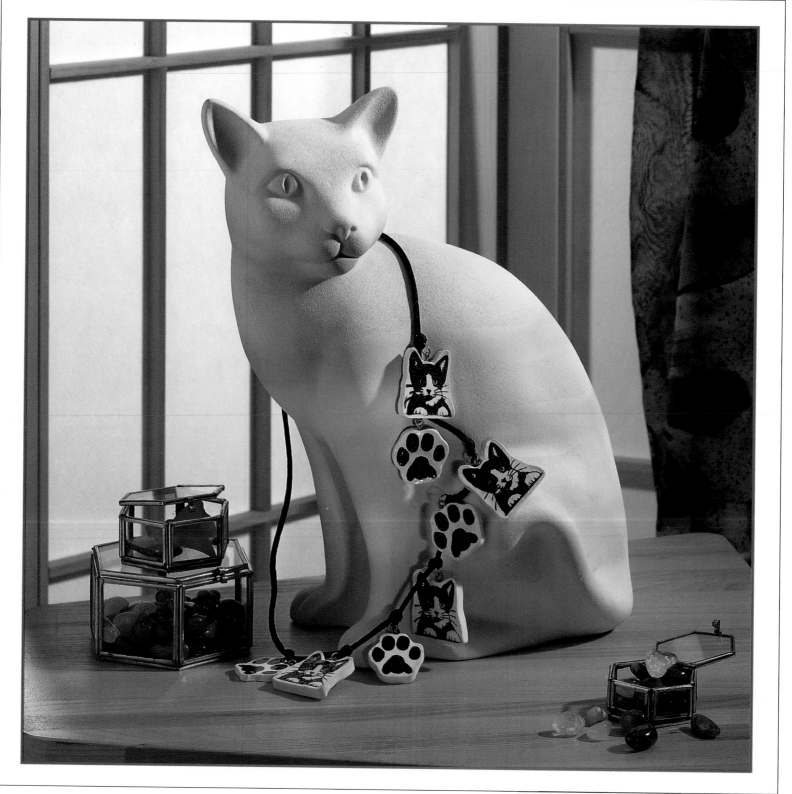

Kitty Necklace

A cute little kitten and its paws decorate this whimsical charm necklace made of polymer clay. It's the perfect casual accessory for a cat lover.

What You'll Need

- 1 package white polymer clay
- Lucky kitten stamp
- Paw-print stamp
- Black pigment-ink pad
- 8 small gold-tone screw eyes
- 8 gold-tone jump rings, 6mm
- Black rattail cord, 4 feet long
- Waxed paper
- Aluminum foil
- Facial tissues
- White glue
- Spray fixative
- Water-based varnish, clear
- Rolling pin, craft knife (#11 blade), baking sheet, emery board, small foam brush, snout-nosed pliers, scissors

1. Preheat oven to 250 degrees F. Follow manufacturer's instructions for using polymer clay. Knead a 3-inch ball of clay until soft. Use rolling pin to roll out on waxed paper to ⅛-inch thickness. Lift up and turn over so clay doesn't stick to waxed paper.

2. Ink kitten stamp with black pigment ink. Press stamp against clay (avoid pushing hard enough to leave an indentation). Repeat to make 4 impressions. Repeat with paw-print stamp.

3. Use craft knife to cut out each image close to the outside line. Be careful not to pull the clay or cut through waxed paper. After all images are cut out, carefully transfer them to baking sheet lined with aluminum foil. Avoid smearing the ink or stretching the clay. Lay facial tissues over images and press gently to remove excess ink.

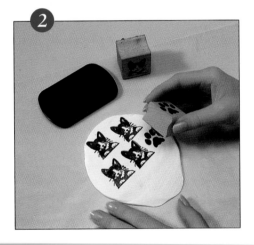

4. Carefully insert 1 screw eye into top of each kitten head and paw print.

5. Bake polymer clay for 15 to 20 minutes. Allow to cool before handling. If needed, smooth edges with emery board.

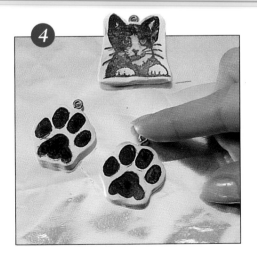

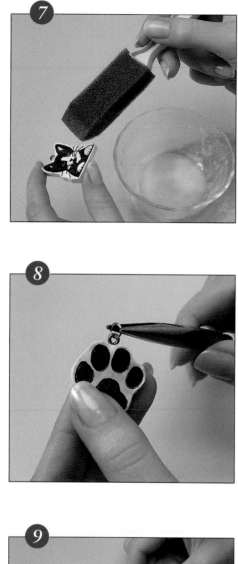

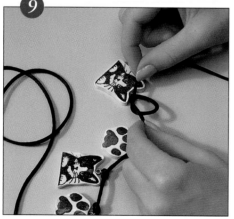

6. Check screw eyes by pulling gently on them. If any are loose, remove them and add a drop of white glue before reinserting.

7. In a well-ventilated area, place charms faceup on waxed paper and spray with fixative. Allow to dry about 30 minutes. Apply a thin coat of water-based varnish to the front of each charm, using the small foam brush. Allow to dry, then apply a second coat. Apply several coats of varnish to the sides and edges of the charms, allowing to dry between applications. Apply varnish to the front of the charms until glossy. Allow to dry between coats.

8. When charms are dry, attach a jump ring to each screw eye using the snout-nosed pliers.

9. String a kitten about a foot from one end of the black rattail cord and secure it with a knot. Alternating kittens with paw prints, string remaining charms 1½ inches apart and knot to secure. Trim any excess length of cord with scissors. Tie ends of necklace together with a double knot.

"Meow-y Christmas" Wall Plaque

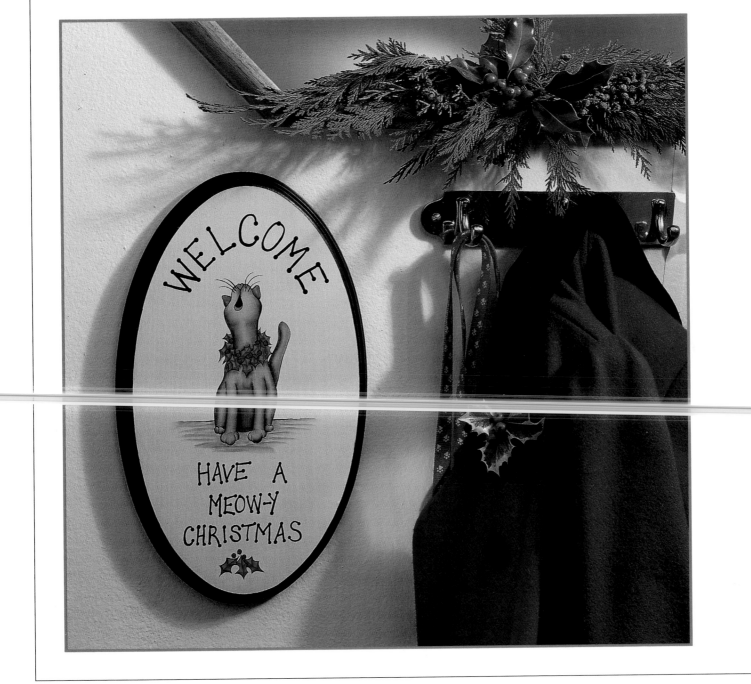

Cats and humans alike are urged to enjoy the holiday season when they're greeted by this punning welcome plaque.

What You'll Need

- Unfinished wood plaque, 8×13½ inches
- Acrylic paints: buttermilk, Black Forest green, dove grey, ebony black, bright green, calico red, gooseberry, dark pine, dark chocolate
- Brushes: ½-inch flat, ⅜-inch angle, #2 flat, 10/0 liner
- Acrylic matte-finish spray

1. See pages 5–8 for basic techniques for decorative painting. Use ½-inch flat brush to base-coat top of plaque with buttermilk; base-coat the router edge with Black Forest green. Allow to dry. Follow directions on pages 4–5 to trace pattern on page 105 and transfer to plaque.

2. Use ½-inch flat brush to paint cat with dove grey. Use #2 flat brush to paint holly leaves with bright green and nose and lip of cat with gooseberry. Use end of brush to dot berries with calico red.

3. Use angle brush to float inside the cat's ear with gooseberry and float the cat's body with ebony black. Float the holly with dark pine.

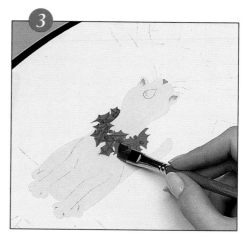

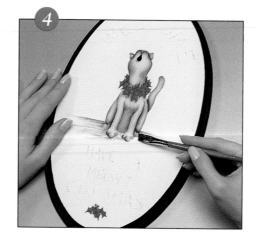

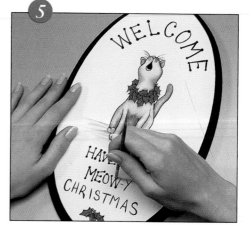

4. Use angle brush to float the floor with dark chocolate.

5. Using the liner brush, line the cat and cat's features, the berries, and letters with ebony black. Dot letters with ebony black, using wooden brush end. Allow to dry. Spray with acrylic matte-finish spray.

WELCOME

HAVE A MEOW-Y CHRISTMAS

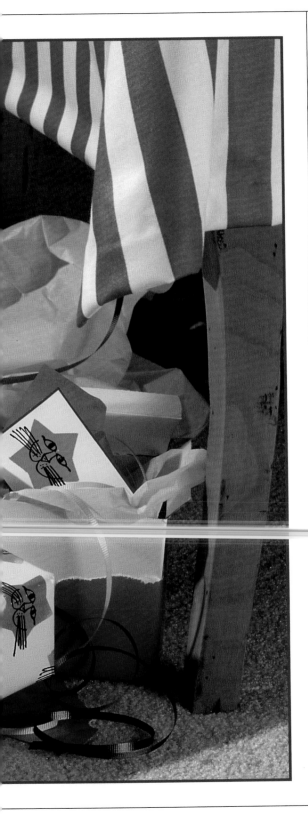

GIFTS

Here is a selection of catly

items to make as gifts for your

favorite cat lover—and a few

for your favorite cat! Choose

wearable arts, rubber stamp

projects, or quilts—your gift is

sure to be a hit.

PLAYFUL KITTEN
BOOKMARK AND NOTE CARD

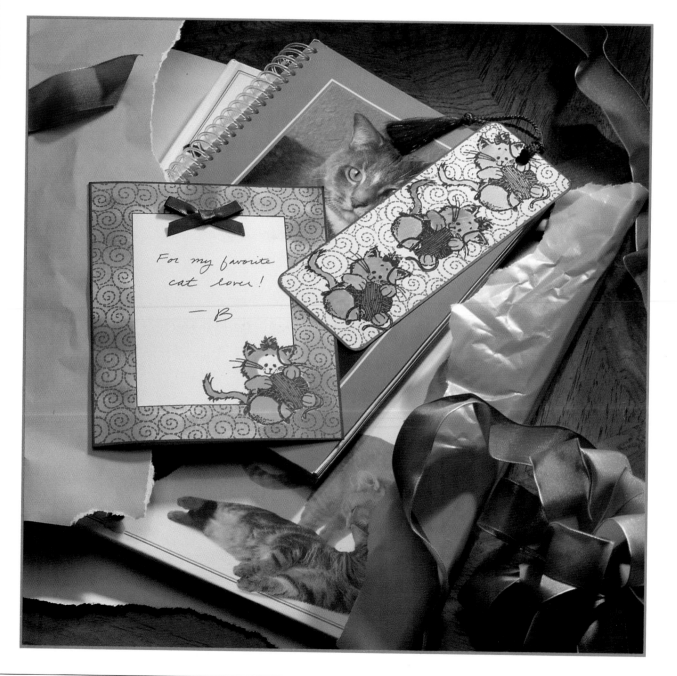

A thoughtful little gift for a book lover, this rubber-stamp project features a cute little kitty holding a ball of yarn.

What You'll Need

- White glossy note card
- White glossy bookmark with tassel
- Kitten with yarn stamp
- Swirl stamp
- Wedge sponges
- Dye-based ink pads: purple and turquoise
- Felt-tip markers in assorted colors
- 6 inches purple ribbon, ¼ inch wide
- Self-stick notes
- Craft glue
- Straightedge, scissors

1. For card, ink kitten stamp with purple ink pad and stamp in lower right-hand corner. To create a mask for the image, stamp kitten on self-stick note so that top of image is over self-stick part. Cut out image. Place over image stamped on card.

2. Place 2 self-stick notes in center of note card to mask a rectangle for a personal message.

3. Use felt-tip marker to apply color to flat edge of a wedge sponge. Blot excess ink on scrap paper. Sponge color on parts of the

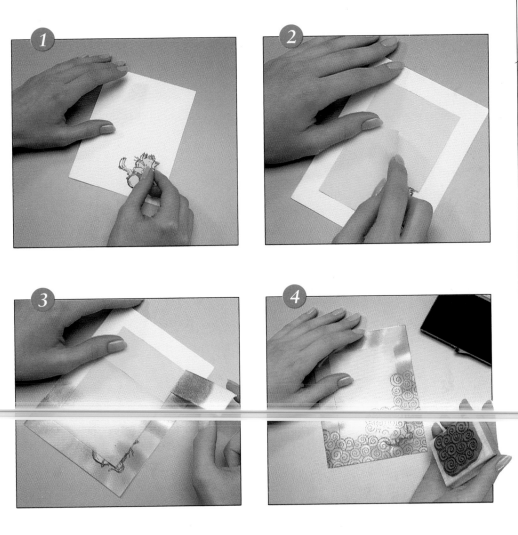

edge of the card. Repeat with different colors, filling in the edge, using a fresh wedge side for each color.

4. Ink swirl stamp with purple ink pad and stamp randomly over sponged color, overlapping masks. Remove center masks and kitten mask.

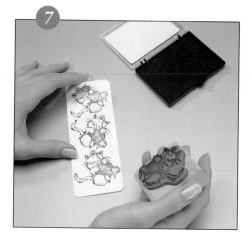

5. Using felt-tip markers, color kitten and yarn. Use straightedge and purple fine-point marker to create inside and outside borders.

6. Tie ribbon into a bow and glue to top of note area.

7. For bookmark, ink kitten stamp with purple ink and stamp 3 times.

8. To create 3 masks, stamp kitten on a stack of 3 self-stick notes so that top of image is over self-stick part. Cut out image, cutting all 3 layers at once. Place a mask on each image on bookmark.

9. Ink swirl stamp with turquoise ink pad and stamp randomly over bookmark, overlapping masks. Remove masks.

10. Use felt-tip markers to color kittens and yarn balls. Use straight-edge and blue fine-point marker to create border. Attach tassel.

LITTLE LOST MITTENS QUILT

The three little kittens who lost their mittens now have all the mittens they could ever want. Kittens and mittens are hand-appliquéd onto this 42×50-inch machine-pieced, hand-quilted project.

What You'll Need

- ¾ yard blue fabric
- 1¾ yards muslin or natural tone-on-tone print fabric
- 1½ yards fabric 45 inches wide (for backing)
- ⅜ yard fabric (for binding)
- ⅛ yard or fabric scraps of 17 fabrics (for mittens) (fabrics may be repeated if desired)
- ¼ yard tan or gray fabric (for cat faces)
- ⅛ yard or scraps of light blue (for cat eyes)
- Scraps of black fabric
- Crib-size package low-loft polyester batting
- Black embroidery floss
- Thread to match cat faces, light blue, black, mitten, and binding fabrics
- Needles: small appliqué and hand-quilting
- Hand-quilting thread
- Large basting needle and thread
- Pencil, small scissors, straight pins, ruler

1. See pages 14–17 for basic techniques for quilting. Wash and iron all fabrics before cutting. Cut 10 strips 2½×45 inches from blue fabric. Cut 8 strips 2½×45 inches from muslin. Stitch strips together lengthwise in groups of threes, making 4 blue-muslin-blue sections and 2 muslin-blue-muslin sections. Press seams open.

2. Cut each strip across into 2½-inch sections of 3 squares each. Cut 60 sections of the blue-muslin-blue combination and 30 sections of the muslin-blue-muslin.

3. Cut 20 squares 6½×6½ inches, 9 squares 6¾×6¾ inches, and 1 square 7½×7½ inches of muslin. Cut the 6¾-inch squares in half

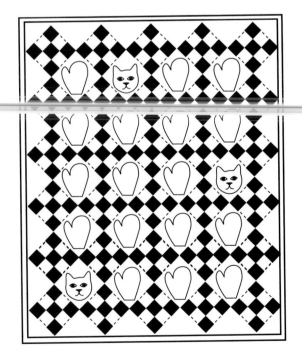

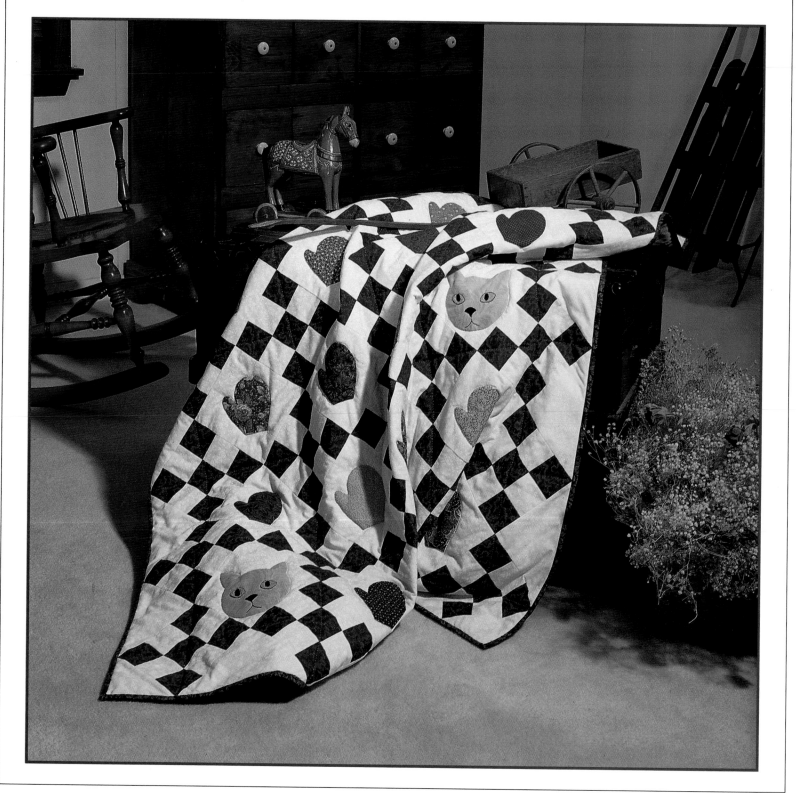

diagonally, forming 18 right triangles. Cut the 7½-inch square in half diagonally twice, forming 4 small right triangles.

4. Follow directions on page 14 to trace and cut patterns on page 114. Cut a total of 17 mittens, 3 cat faces, 6 blue eyes, 6 black pupils, and 3 black noses. When cutting, cut ¼ inch outside traced lines and clip curves and inner points to traced lines.

5. Trim batting to the same 45×54-inch size as backing. Cut 5 strips 2×45 inches from binding fabric.

6. Stitch each muslin-blue-muslin section to a blue-muslin-blue section, right sides together. Press seams open. Stitch another blue-muslin-blue section next to each muslin-blue-muslin and press seams open, making thirty 6½-inch-square blocks of 9 patches.

7. Center and pin each mitten onto a 6½-inch muslin square as shown in placement diagram on page 111. Using matching thread, hand-appliqué mitten to square, turning under clipped edges to traced line. Bring the thread up from underneath and catch about 2 threads in fabric, making stitches nearly invisible.

8. Pin and appliqué noses and eyes onto cat faces and pupils onto eyes, using pattern piece as a guide. Using 2 strands of black embroidery floss, outline eyes and embroider mouths. Center and pin cat faces onto remaining 6½-inch muslin squares as shown in placement diagram. Turn under clipped edges and hand-appliqué.

9. Using placement diagram as a guide, assemble all squares and triangles on a large flat surface. The large triangles form the outer edges, and the small triangles form the corners. Pin and stitch pieces together in diagonal rows. Pin and stitch rows together, matching seams, and press all seams open, completing the top.

10. Sandwich batting between top and backing; pin. Batting and backing will extend beyond top edges. With large needle and thread, hand-baste through all thicknesses vertically and horizontally. Baste around perimeter close to edge of top. Trim off excess batting and backing.

11. Using quilting needle and hand-quilting thread and starting at the center, outline-quilt each mitten and cat face. Quilt through each blue square, forming straight vertical and horizontal lines. When quilting is completed, remove all basting threads except those at the perimeter.

12. Stitch binding strips together to make 1 very long 2-inch strip. Fold in half lengthwise with wrong sides together. Place raw edge of binding onto raw edge of quilt top, right sides together. Leaving 3 inches of binding free at the beginning, stitch binding to quilt, starting in the middle of one of the sides. Stop stitching ¼ inch from the corner. Reposition binding onto next side and stitch. Continue around quilt. Stop stitching 2 or 3 inches from the start. Stitch together binding ends, trim excess fabric, and finish stitching binding to quilt top. Turn binding to back of quilt and blindstitch in place.

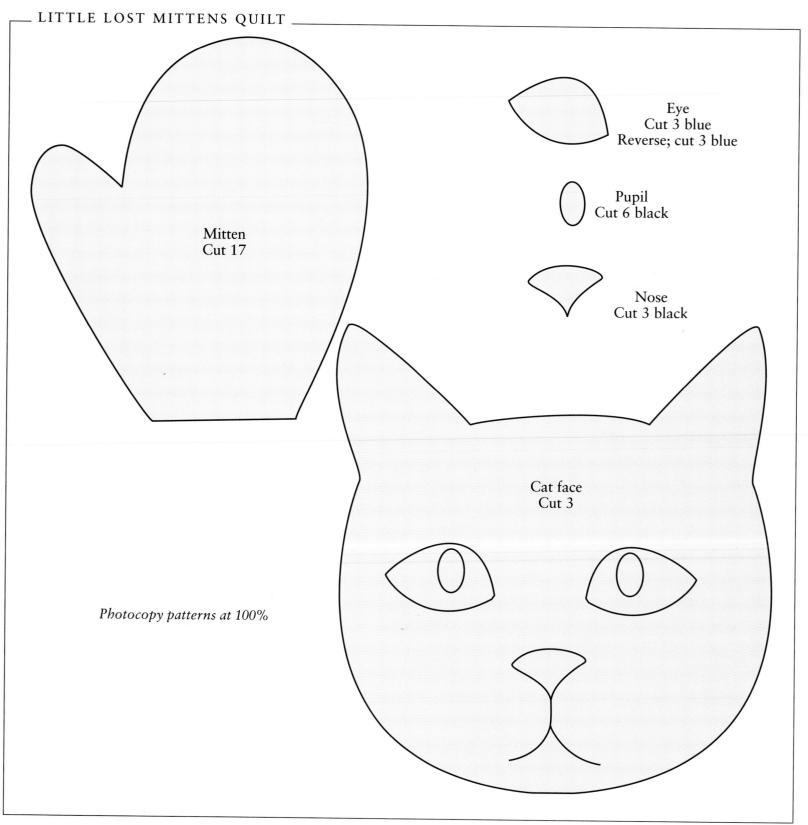

Eye
Cut 3 blue
Reverse; cut 3 blue

Pupil
Cut 6 black

Nose
Cut 3 black

Mitten
Cut 17

Cat face
Cut 3

Photocopy patterns at 100%

COUGAR SILK SCARF

What You'll Need

- Silk scarf, 8mm weight, 14×72 inches
- Paints for silk: brown, black, brass, pewter, azure blue, sulphur green, emerald green, white, ochre, and salmon
- Water-based resist for silk painting
- Dispenser bottle and medium tip for resist
- Eyedropper (for measuring paints)
- Bamboo brushes: extra-large, small, and medium
- Bond paper, 14×36 inches
- Plain white paper
- Heavy cardboard or fiber board, 16 inches wide and at least 26 inches long
- Newsprint paper larger than cardboard
- Masking tape
- Drawing pencils, #2 and #3B
- Shampoo
- Ball pins, small glass jars, yardstick

Sleek and graceful, the jungle cat gazes through lush greenery in the design of this handsome hand-painted scarf—a treasure of a gift.

1. Wash scarf in shampoo and cool water, rinse, and hang to dry. Press with cool iron. Since each scarf is individually made, sizes differ slightly, so that pattern may need adjusting.

2. Using #2 drawing pencil and yardstick, draw a line along one short edge and both long edges of large sheet of bond paper ½ inch from paper edges. Draw another line 1 inch from the paper edges.

Draw two more lines, one 2⅝ inches from the paper edges and one 3⅛ inch from the paper edges. The 1⅝-inch area between the two sets of lines is for the fern border.

3. Follow directions on pages 4–5 to trace cougar pattern and fern border pattern on page 119 onto plain paper. Center cougar pattern within the lines drawn on bond paper and tape pattern to bond paper.

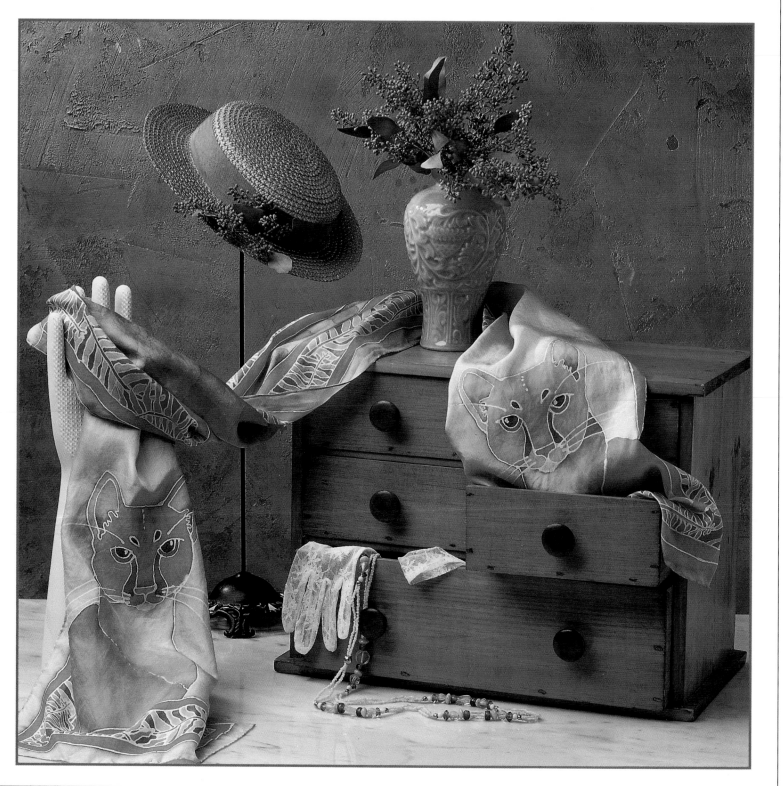

4. Place fern pattern under border area on bond paper and trace design. The pattern given will fill the short edge of the border. Continue up the right-side long edge, following the 7-inch repeat by placing A over C. Make minor adjustments for corners, rounding off the leaf tips to fit within border. For left border draw ferns facing down.

5. Tape pattern to table. Tape silk over pattern, stretching slightly. Using #3B drawing pencil, transfer pattern to fabric. Make sure lines of cougar body join border lines. Remove scarf from pattern. Turn scarf over on opposite side to tape the other end over pattern, making sure border lines are even, and trace pattern.

6. Fill any center gaps in border with shapes from fern pattern. Remove scarf from pattern and pattern from table.

7. Cover cardboard with newsprint paper. Pin scarf to cardboard by piercing through rolled hem with ball pins, stretching silk while pinning and keeping pins perpen-

dicular to cardboard. Pin as far as board allows. You will be painting the scarf in sections. Pull scarf away from board so that it rests just under pin heads.

8. Fill dispenser bottle with water-based resist. Attach applicator tip. Practice controlling the flow of the resist over scrap paper. Hold bottle upright, with applicator down, and squeeze very gently. Apply resist over pencil lines on stretched area of scarf. Make sure lines meet so that areas to be painted are completely enclosed. Allow resist to dry.

9. Use eyedropper to mix paints in small jars. Use small and medium brushes to paint the design and extra-large brush to paint the background. Before dipping brush into paint, dampen brush and wipe with paper towel to remove excess moisture. When painting, stay away from resist lines and let paint flow to them. Paint fern A with equal parts water, white, and emerald green. Paint fern B sulphur green. Paint fern C with 3 parts sulphur green and 1 part emerald green.

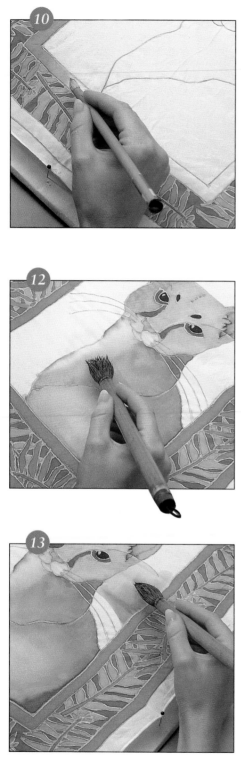

10. Paint stems brown and background around ferns azure blue. Paint border lines salmon; allow to dry, then repeat salmon.

11. For cougar, paint eye pupils and spots above eyes black. Paint ears ochre; touch black into lower parts while wet. Paint nose ochre with brown line down center and dots of brown at corners. Paint eye irises brown. Paint lines on either side of nose extending to muzzle clear water; then paint brown over it. Allow to dry. Repeat with brown on either side of nose.

12. Paint head and ears with a small amount of clear water first; then paint brass over it. Place a brown brush stroke down center dots. Paint chin clear water; place a tint of water and azure blue at top edge of mouth. Paint neck and chest with clear water followed by azure blue tint under chin and along front of chest. Paint with brass from about 1½ inches from shoulder line and with brown along lower edge and under jawline. Blend colors with brush.

13. Mix background color with 3 parts white, 3 parts azure blue, 2 parts brass, 2 parts pewter, and 15 parts water. Moisten center background with water, taking care not to moisten it too much. Apply background color on moistened silk. Silk will sag; adjust edges to prevent silk from touching the paper. Paint edges with background color. Allow to dry.

14. Repeat for second end of scarf, for border design, and for center area. Follow manufacturer's directions to heat-set colors and wash out resist.

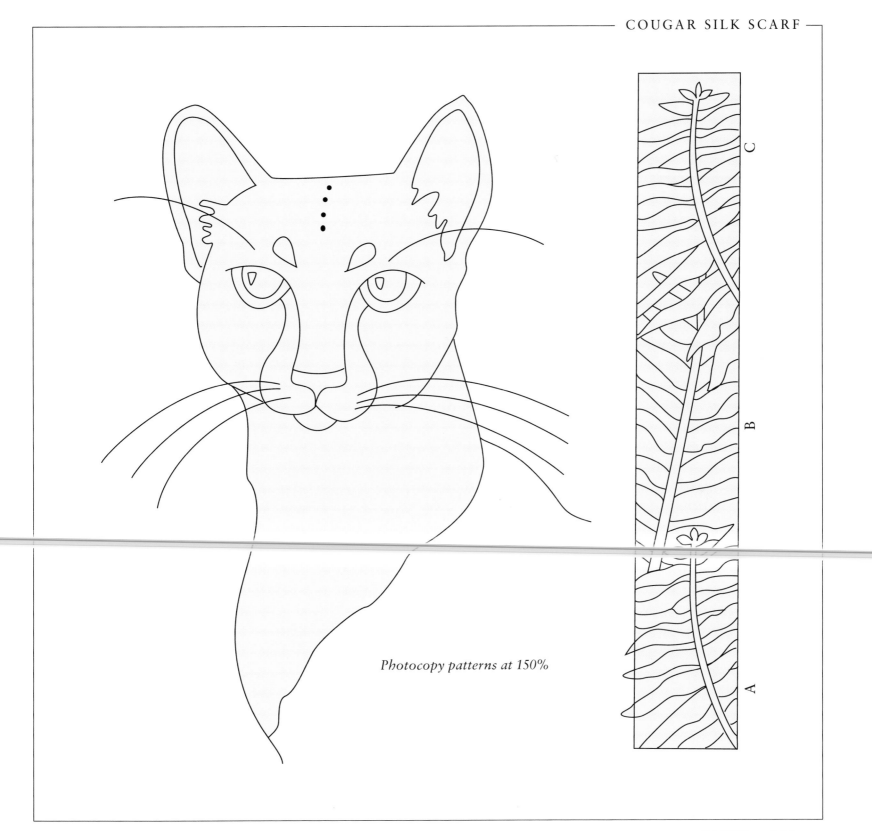

Photocopy patterns at 150%

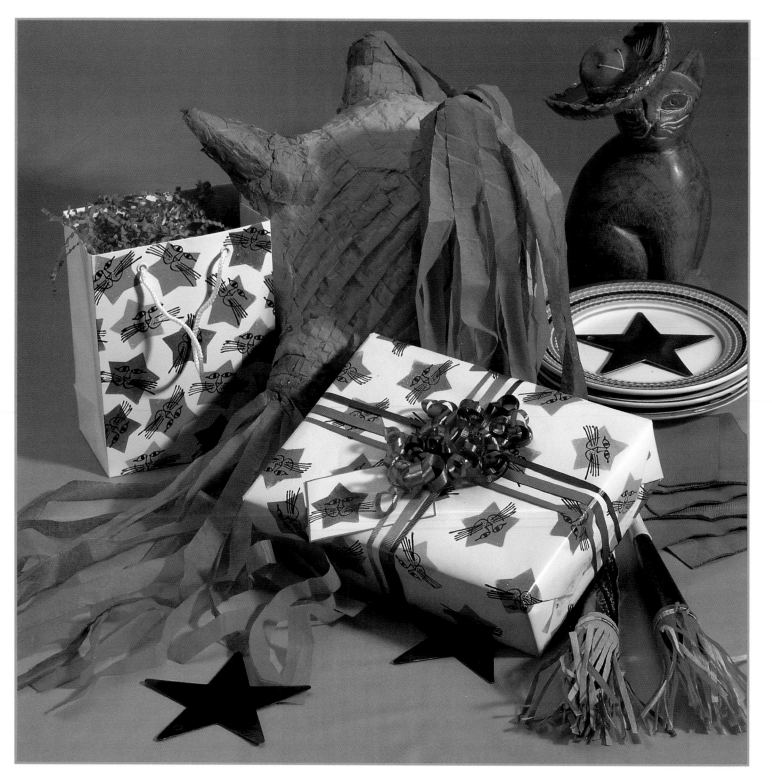

Starry Cat Gift Wrap, Bag, and Tag

If you hand-craft a gift for a cat lover, complete your project with handmade bewhiskered wrapping. It's easy to do using rubber stamps.

What You'll Need

- White glossy paper
- White glossy gift bag
- White glossy gift tags
- Star sponges
- Dye-based ink pads in assorted bright colors
- Cat face stamp
- Black pigment ink pad
- Clear embossing powder
- Heat embossing gun
- Colored felt-tip marker
- Straightedge

1. Use one side of each star sponge for each color. Ink star sponges with colored ink pads and stamp stars randomly on gift wrap and gift bag.

2. Ink cat face stamp with black pigment ink. Stamp a cat face image over a few of the stars, reinking stamp after each impression. Sprinkle cat faces with embossing powder, tap off excess, and heat with embossing gun until powder melts.

Repeat stamping cat faces on stars, stamping and embossing a few at a time.

3. Stamp a gift tag to match. Use straightedge and felt-tip marker to create border around tag.

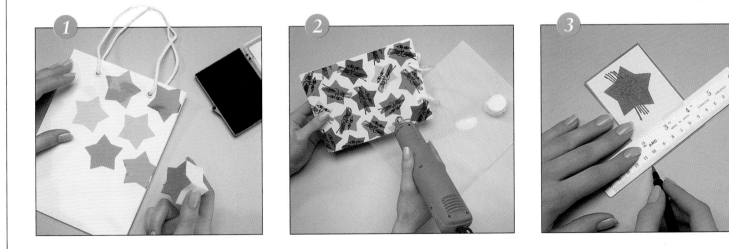

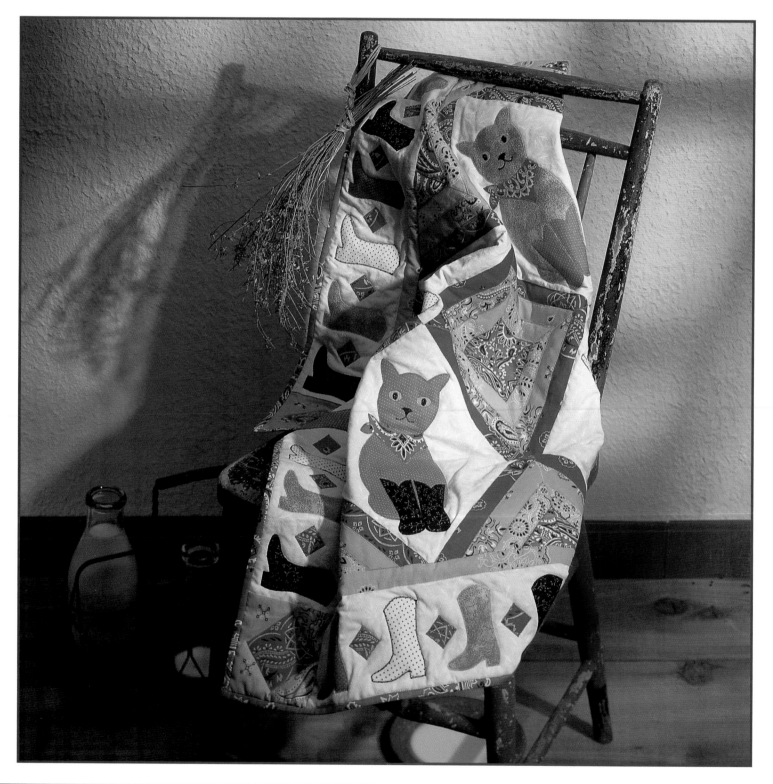

Puss-in-Boots Decorative Quilt

These cats have put on their cowboy boots and bandannas to make this 37½×37½-inch machine pieced, machine appliquéd quilt a great gift for a home with a Western theme.

What You'll Need

- 1¼ yards muslin or natural tone-on-tone fabric
- 1 bandanna each in purple, turquoise, gold, and rust (or substitute an 18×22-inch piece of fabric of each color)
- 2¼ yards fusible webbing
- ¼ yard each of black, gray, tan, and white small print or solid fabric
- 1⅛ yards fabric for backing
- 1⅛ yards low-loft polyester batting
- Clear plastic ruler with 45-degree angle marking
- Sewing machine, iron, pencil, scissors, straight pins, large basting needle and thread, thread to match each color bandanna and cat

1. See pages 14–17 for basic techniques for quilting. Wash and iron all fabrics before cutting. From muslin, cut 4 squares 10×10 inches and 4 squares 10½×10½ inches.

Cut each 10½-inch square in half diagonally twice, making 4 right triangles per square for a total of 16 triangles. Also cut 4 strips 5×28½ inches for borders.

2. Iron a 10×17-inch piece of fusible webbing to wrong side of purple bandanna, starting about 1 inch from bandanna edge. Remove paper backing. From bonded part, rotary-cut 16 strips 1×9¼ inches. Using ruler, cut each end at a 45-degree angle, making strip into a trapezoid with a 9¼-inch base. Repeat for all 16 strips.

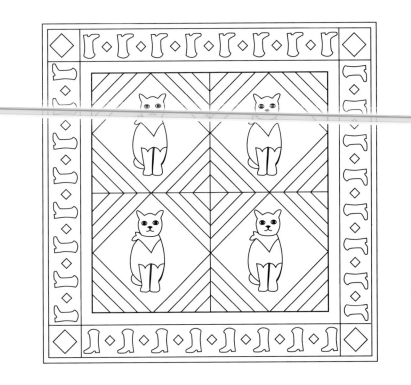

3. Follow directions on page 14 to trace and cut patterns on pages 125–126. Iron an additional 6×17-inch piece of fusible webbing to wrong side of purple bandanna. Place bandanna pattern piece right side down on paper backing; trace and cut out. Remove paper backing. Rotary-cut 4 squares 2½×2½ inches and 28 squares 1×1 inch.

4. Iron an 8×17-inch piece of fusible webbing to wrong side of turquoise bandanna, starting about 1 inch from bandanna edge. Following the instructions in step 2, cut 16 trapezoids 1 inch wide and with a 7¼-inch base. Iron an additional 3×10-inch piece of fusible webbing to wrong side of turquoise bandanna. Place bandanna and eye pattern piece right side down on paper backing. Trace and cut out 1 bandanna and 8 eyes. Remove paper backing. From remaining, unbonded bandanna, cut 4 squares 5×5 inches.

5. Iron a 6×17-inch piece of fusible webbing to wrong side of gold bandanna, starting about 1 inch from bandanna edge. Following the instructions in step 2, cut 16 trapezoids 1 inch wide and with a 5¼-inch base. Iron an additional 3×4-inch piece of fusible webbing to wrong side of gold bandanna. Place bandanna pattern piece right side down on paper backing. Trace

and cut out 1 bandanna. Remove paper backing. From the remaining, unbonded bandanna, cut 8 strips 1½ inches wide.

6. Iron a 4×17-inch piece of fusible webbing to wrong side of rust bandanna. Place bandanna pattern piece right side down on paper backing. Trace and cut out 1 bandanna. Remove paper backing. Cut 2 strips 1⅝ inches wide. Using ruler and rotary cutter, cut 45-degree-angle triangles from the strips until you have 16 triangles. From remaining, unbonded rust bandanna, cut 8 strips 2 inches wide for binding.

7. Iron a 9×17-inch piece of fusible webbing each to the wrong side of the black, gray, tan, and white fabrics. Place pattern pieces for cat, right and left cat boots, border boots, pupils, and noses right side down on paper backing on appropriate fabrics (see patterns). Trace around each piece and cut out. Remove paper backing.

8. Cut the batting and backing each to 40×40 inches.

9. Cover muslin triangles by laying purple, turquoise, gold, and rust trapezoids on them side by side ¼ inch from the raw edges. Iron into place.

10. Center each cat on a muslin square diagonally as shown in placement diagram on page 123 and iron into place. Iron coordinating boots, bandanna, and facial features onto each cat, referring to diagram on page 126 for placement. Transfer mouth and body markings with pencil.

11. Pin and stitch 4 triangles from step 9 to sides of each cat square, right sides together, forming a larger square. Stitch opposite corners first, then remaining opposite corners. Lightly press seams toward center. Stitch together the 4 squares to make the center square.

12. Stitch 2 gold strips together, right sides together, end to end; repeat with remaining strips to make 4 long strips. With right sides together and seams in strips matching center seam of cat section, stitch gold border strips to top and bottom of cat section. Trim off ends. Stitch remaining gold strips to sides. Lightly press seams toward gold border.

13. Line up 8 border boots on a muslin border strip in the following order left to right: gray, white, tan, black. Repeat order. Each boot is ¾ inch from top and bottom of strip. Boots are 1⅛ inches apart, and end boots are ⅝ inch from each side. Center a small purple square

placed diagonally between boots. When all pieces are in place, iron. Repeat for remaining border strips.

14. Center a large purple square diagonally on each turquoise square. Iron. With the right sides together, stitch a turquoise square to each end of 2 of the border strips. Lightly press seams toward the turquoise square.

15. With right sides together, pin the 2 border strips without turquoise squares to top and bottom of cat section. Boot bottoms face toward outer edge of quilt. Stitch. Press seams toward gold strip. Pin and stitch remaining border strips to sides of cat section. Press seams toward gold strip.

16. Place batting between top and backing; pin. Hand-baste vertically and horizontally and around the perimeter close to the edge. Set sewing machine for medium-warm zigzag stitch. Using matching thread, zigzag-stitch edges of cats, cat faces, cat bandannas, cat and border boots, border purple squares, and all bandanna fused edges that are not covered with stitching in a seam. When stitching is completed, remove all basting stitches except the perimeter.

17. Stitch rust bandanna binding strips together to make 1 very long

2-inch strip. Fold in half lengthwise with wrong sides together. Place raw edge of binding onto raw edge of quilt top, right sides together. Leaving 3 inches of binding free at the beginning, stitch binding to quilt, starting near a corner. Stop stitching ¼ inch from corner. Reposition binding onto next side and stitch. Continue around quilt. Stop stitching 2 or 3 inches from the start. Stitch together binding ends, trim excess fabric, and finish stitching binding to quilt top. Turn binding to back of quilt and blind-stitch in place.

Eye
Cut 8 turquoise

Pupil
Cut 8 black

Nose
Cut 3 black
1 white

Cut 1 purple
1 turquoise
1 gold
1 rust

Photocopy patterns at 125%

Cut 8 black

Cut 1 black
1 gray
1 tan
1 white

Cut 1 black
1 gray
1 tan
1 white

8 tan
8 white

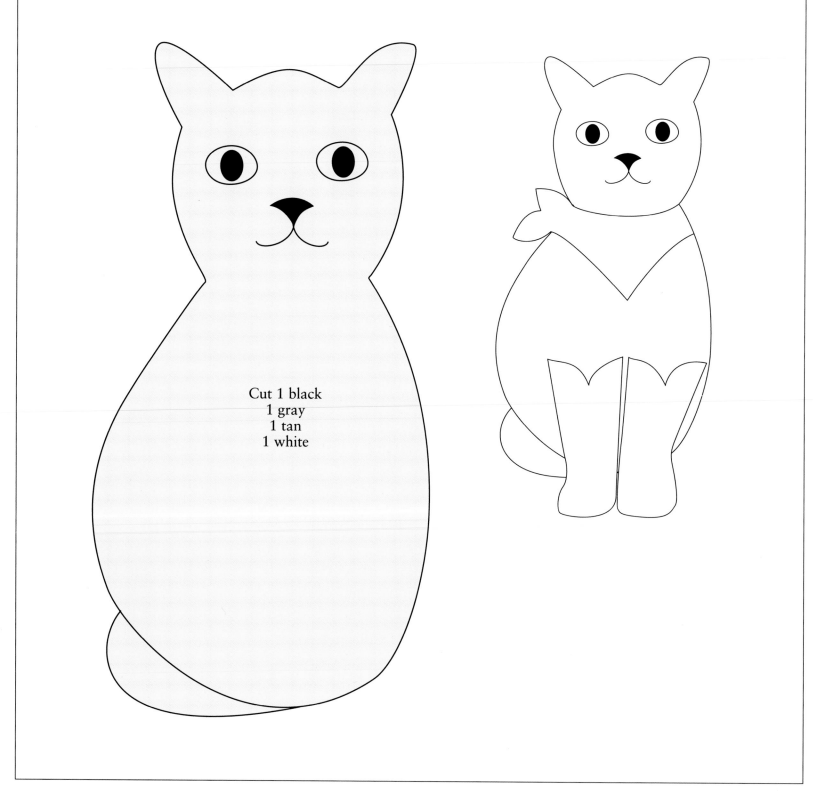

Cut 1 black
1 gray
1 tan
1 white

Kitten's Own Christmas Stocking

The family cat needs a stocking to hang on the mantel Christmas eve just as everyone else does. Santa needs a place to put those catnip treats and mouse toys that Fluffy loves.

What You'll Need

- Large red pin-dot prefinished stocking with Aida-cloth cuff
- 6-strand embroidery floss (see color key)
- #8 fine braid, 001 silver and 002 gold
- #24 tapestry needle
- Scissors

Stitch count: 49h×85w

Size: 3½×6 inches

Following the general cross-stitch directions on pages 9–11, stitch design, centered on stocking cuff with curved edge of cuff to left, according to chart. Use 2 strands of floss or 1 strand of braid for all cross-stitching. When all cross-stitching is done, backstitch where indicated with 1 strand black floss. Using cross-stitch alphabet provided, plot cat's name. Cross-stitch where indicated on chart with 2 strands medium Christmas red.

Color		DMC
■	Dark pistachio green	367
■	Light pistachio green	368
■	Ultra dark pistachio green	890
■	Medium rose	899
□	Ultra light beaver gray	3072
■	Ultra dark beaver gray	844
■	Light beaver gray	648
■	Dark beaver gray	646
■	Medium Christmas red	304
■	Bright Christmas red	666
■	Black	310
□	White	
■	Silver	
■	Gold	

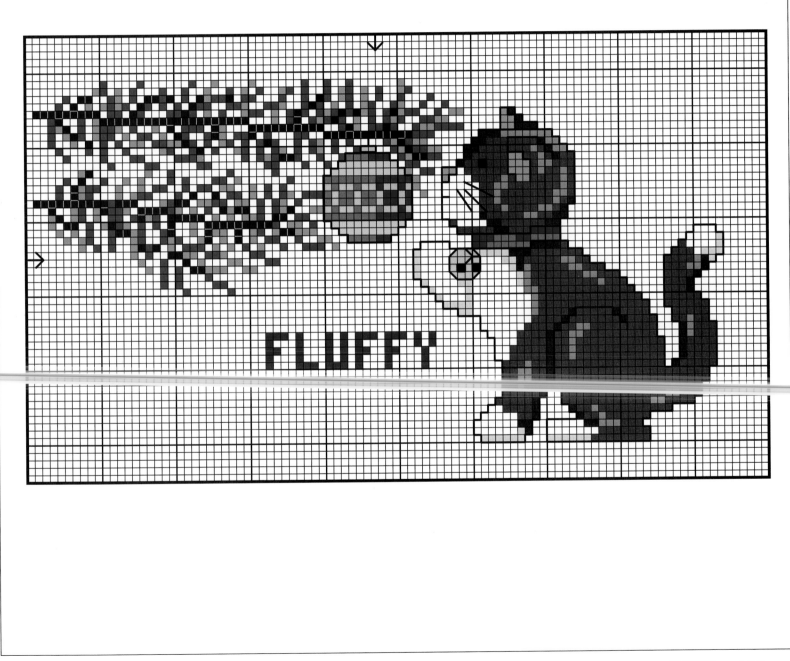

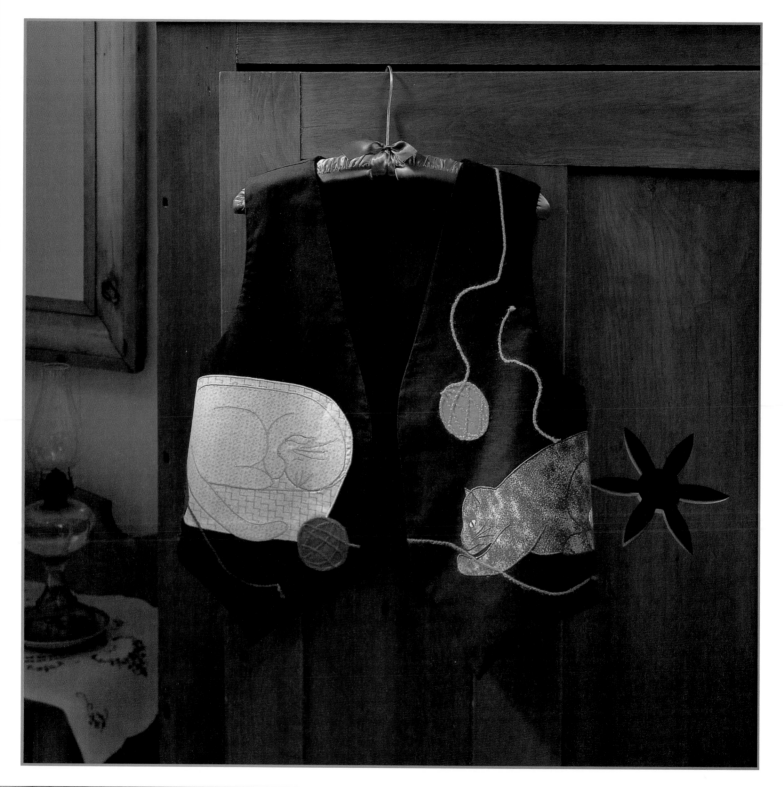

Yarn Nappers Cat Vest

Playful cats scamper across this striking vest, scattering yarn balls across the shoulder and around the back. This eye-catching accessory will form the nucleus of a striking outfit.

What You'll Need

- Ready-made vest, or fabric cut from your favorite vest pattern with only side seams sewn
- ½ yard each of 3 different fabrics (for cats)
- ⅜ yard each of 2 different fabrics (for cat and basket)
- 5×7-inch muslin scrap (for box)
- 7 scrap pieces (for yarn balls)
- Yarn to match each scrap piece
- 1 yard fusible webbing
- 1 yard tearable interfacing
- Threads to match each color of fabric
- Transfer pencil
- Acrylic paints: black, ivory, green, medium brown, golden yellow
- Brushes: #3 round, liner
- Sewing machine, iron, scissors, needle, pins, ruler

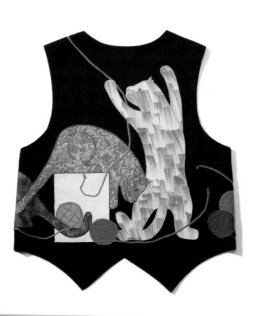

1. Follow directions on page 14 to trace and cut patterns on pages 133–135. Iron fusible webbing to wrong side of fabric following manufacturer's directions. Place pattern pieces right side down on paper backing. Trace around each piece and cut out.

2. Transfer all detail markings from pattern pieces to fabric pieces using transfer pencil. Remove paper backing and place pattern pieces on vest using placement diagram on page 132 as a guide. When all pieces are laid out appropriately, iron in place.

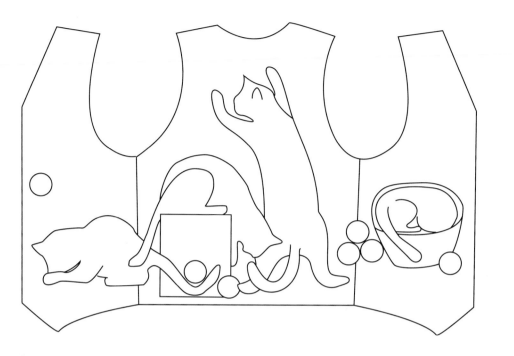

3. Pin tearable interfacing to wrong side of vest under areas to be appliquéd. Appliqué basket with a medium-width stitch. Appliqué cat #1 with a medium-width stitch. For cat noses, set stitch width to widest setting at top of nose marking and gradually narrow width setting while sewing to form nose shape. Appliqué cat #4, cat #3, box, and then cat #2 with a medium-width stitch. Tear away excess interfacing.

4. Zigzag-stitch around outside edge of each yarn ball. Lengthen zigzag stitch and, placing matching yarn in position, zigzag yarn around outside edge of yarn ball. Continue zigzagging yarn onto yarn ball as shown in photo. Using photographs of vest as a guide,

extend yarn ends and continue to zigzag in place. Tie a knot in the end of each yarn end and bar-tack in place. Do this for each yarn ball, using matching colors.

5. If you are using a pattern to make your vest, sew lining sides together, then sew lining to vest with right sides together, leaving shoulders open. Trim seams and clip curves. Turn right side out. Press. Match shoulder edges, right sides together, and pin only vest front to vest back, not lining. Stitch vest front and back together from armhole to neck. Sew as far as possible before removing fabric from sewing machine. Press shoulder seam toward back and slip-stitch lining shoulder seam.

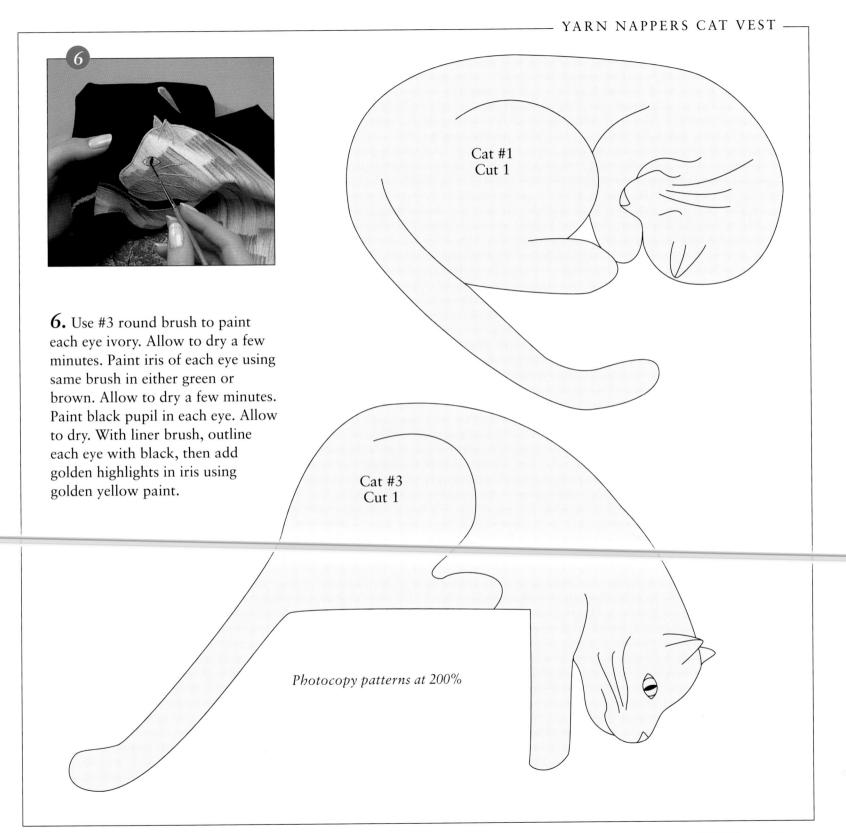

6. Use #3 round brush to paint each eye ivory. Allow to dry a few minutes. Paint iris of each eye using same brush in either green or brown. Allow to dry a few minutes. Paint black pupil in each eye. Allow to dry. With liner brush, outline each eye with black, then add golden highlights in iris using golden yellow paint.

Cat #1
Cut 1

Cat #3
Cut 1

Photocopy patterns at 200%

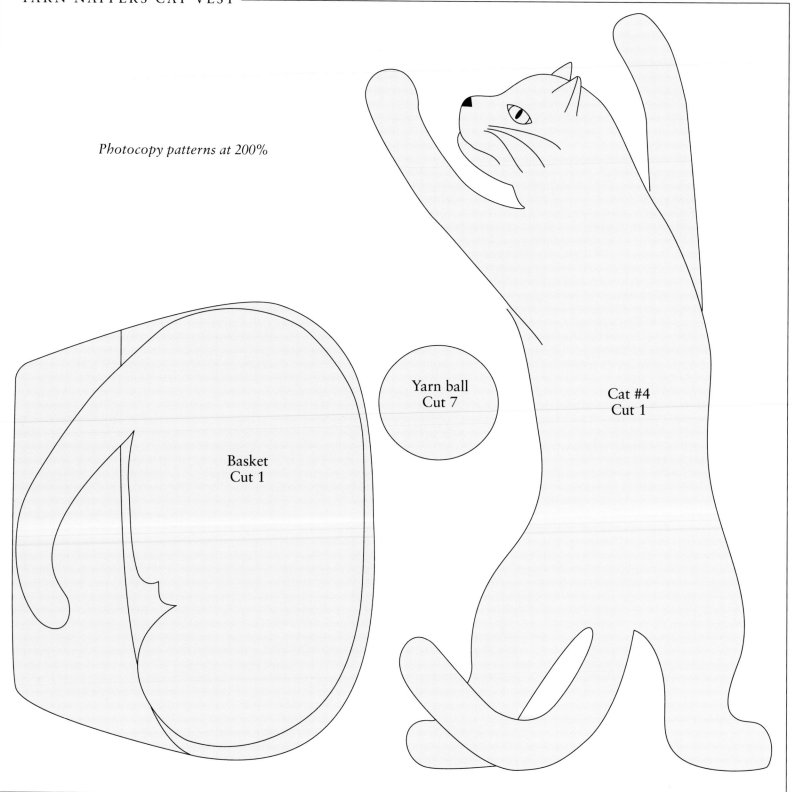

Photocopy patterns at 200%

Yarn ball
Cut 7

Basket
Cut 1

Cat #4
Cut 1

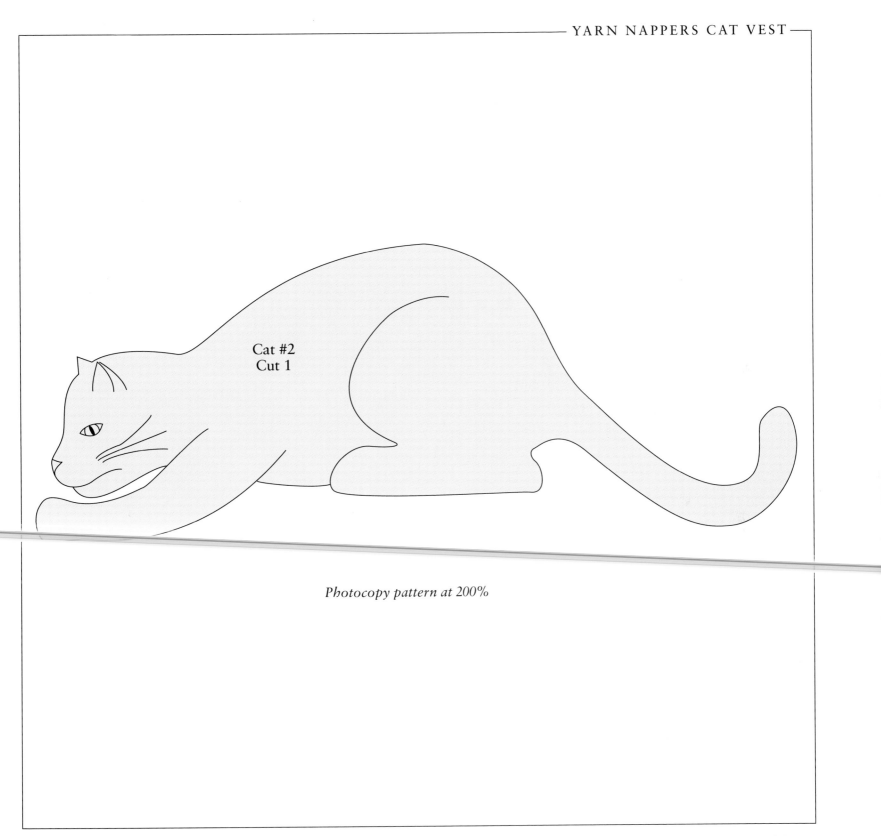

Cat #2
Cut 1

Photocopy pattern at 200%

Colorful Cat Toys

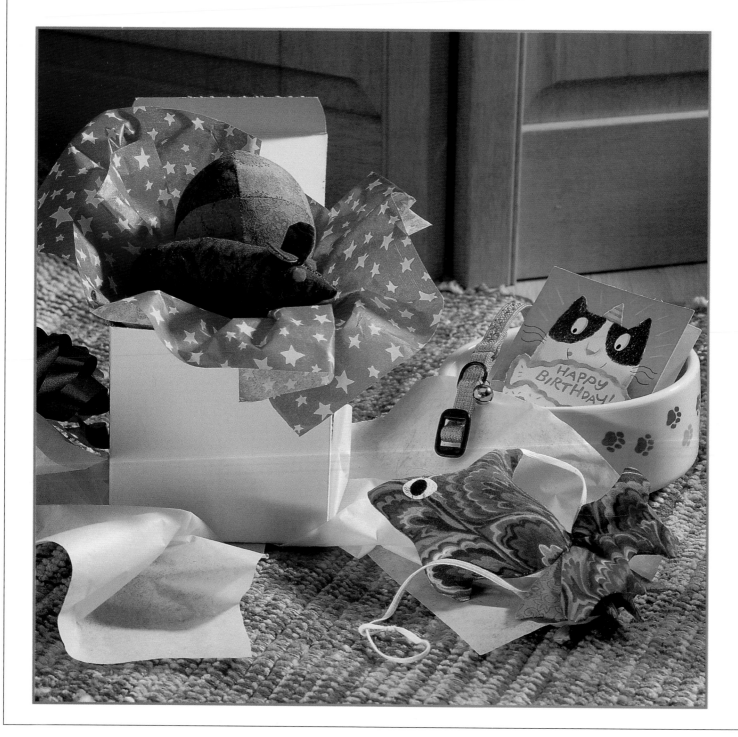

To please a favorite feline, present her with a catnip mouse to chase, a jingle ball to roll, and a bouncy fish hanging from a doorknob.

CATNIP MOUSE

What You'll Need

- ⅛ yard dark purple fabric
- Scraps of gold fabric
- Small package polyester stuffing
- Small package catnip
- 2 small red pom-poms
- Tacky glue
- Scissors, straight pins, sewing needle, purple and gold thread

1. Follow directions on page 14 to trace and cut patterns on page 140. Fold under raw edges on three sides of tail. Fold in half lengthwise and stitch the folded edges.

2. Pin gold ear piece to purple ear piece with right sides together; stitch curved edge A to B. Trim seam allowance to ⅛ inch; clip curve, turn, and press. Repeat for other ear.

3. With raw edges even, place gold side of ear against right side of body piece, matching A and B. Baste A to B. Repeat with other body piece and other ear, offsetting ear slightly so both ears show better.

4. Baste tail to one body piece at C. Place body pieces right sides

together and stitch long curve D to E. Trim seam.

5. Pin bottom piece to body, right sides together, matching D and E. Stitch, leaving 2 inches at the back open for turning. Turn.

6. Stuff with equal amounts of polyester stuffing and catnip. Blindstitch together the open edges. Use tacky glue to permanently affix the pom-poms for eyes.

BOUNCY FISH

What You'll Need

- ¼ yard multicolored print fabric
- ¼ yard aqua fabric
- ⅛ yard each or scraps of white and black fabric
- Fusible webbing
- Small package polyester stuffing
- 14 inches elastic, ⅛ inch wide
- Iron, scissors, straight pins and needle, thread to match the aqua

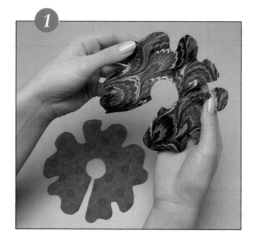

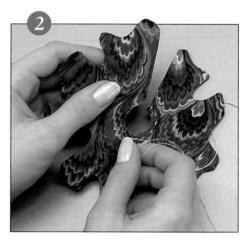

1. Follow directions on page 14 to trace and cut body and tail patterns on pages 140–141. For tail, place aqua fabric on print fabric with right sides together. Pin tail pattern to wrong side of the aqua. Cut both pieces, including slit and inner circle.

2. Stitch together along slit and outer edge from A to B. Clip curves, turn, and press. Using a long basting stitch, gather the inner circle.

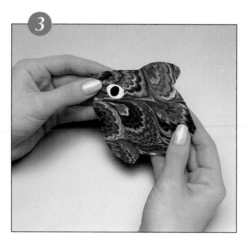

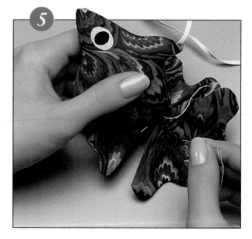

3. Iron fusible webbing to wrong side of white fabric following manufacturer's directions. Place pattern piece for eye right side down on paper backing. Trace around pattern piece twice, for two eyes, and cut out. Repeat with black fabric and pupil pattern piece. Remove paper backing. Iron an eye and pupil on each body piece as

shown on pattern. With raw edges even, baste end of elastic to right side of upper fin on one body piece.

4. Stitch body sides together from C to D, leaving the back open and taking care to leave length of elastic free. Clip curves, turn, and press, pressing under edges of opening at back.

5. Stuff fish firm but not hard. Slip tail under back body edge, matching the slit A and B to D. Blind-stitch into place. Be sure to completely close the back opening.

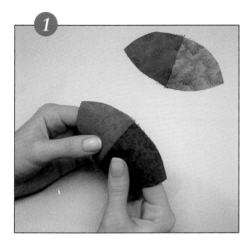

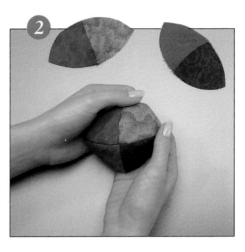

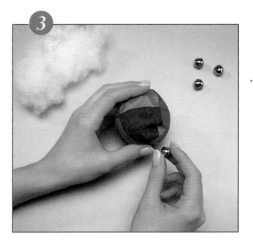

JINGLE BALL

What You'll Need

- ⅛ yard each of red, dark purple, gold, and turquoise fabric
- 4 round jingle bells (½-inch size)
- Small package polyester stuffing
- Scissors, straight pins, sewing needle, dark thread

1. Follow directions on page 14 to trace and cut pattern below. Place each turquoise piece on a gold piece, right sides together. Stitch seam A to B (the edge A to C is slightly more curved than the other two). Repeat with red pieces and purple pieces.

2. Place a gold and turquoise section on a red and purple section, right sides together, gold on purple and turquoise on red. Stitch seam C to B to C, leaving A to C open, forming a rounded circle. Repeat with remaining sections.

Photocopy pattern at 100%

3. With right sides together, pin the two circles, matching purple to gold and red to turquoise. Stitch together, leaving 2 inches open. Turn and stuff, spreading the bells evenly throughout. Invisibly stitch together the opening edges.

B

Ball
Cut 2 red
2 turquoise
2 purple
2 gold

• A

C •

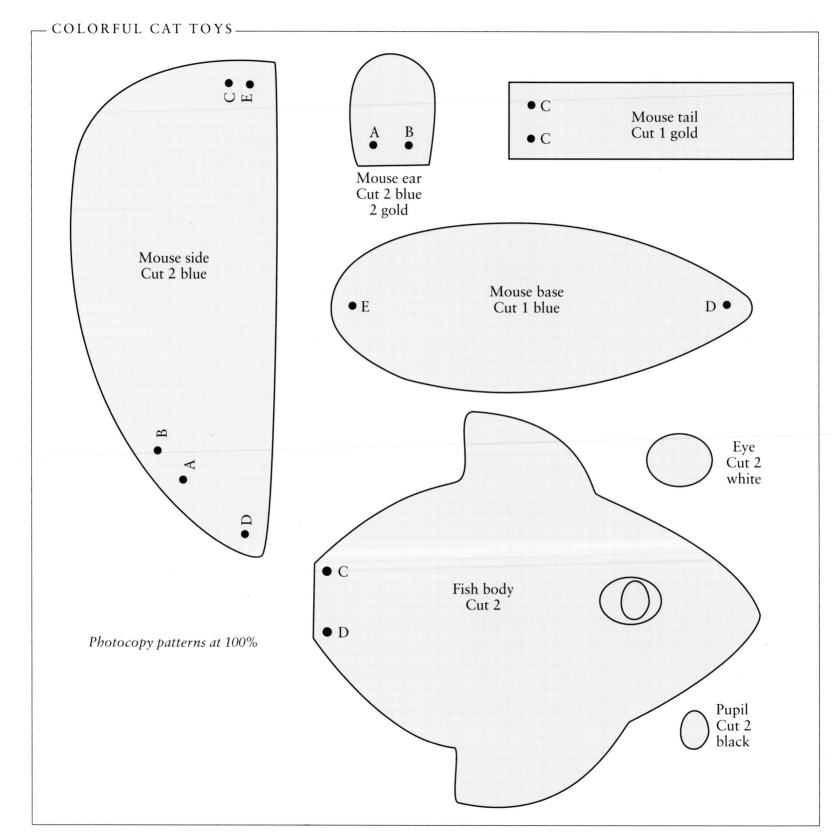

C
E

Mouse ear
Cut 2 blue
2 gold

A B

C
C
Mouse tail
Cut 1 gold

Mouse side
Cut 2 blue

Mouse base
Cut 1 blue

E

D

B

A

D

Photocopy patterns at 100%

Eye
Cut 2
white

C

D

Fish body
Cut 2

Pupil
Cut 2
black

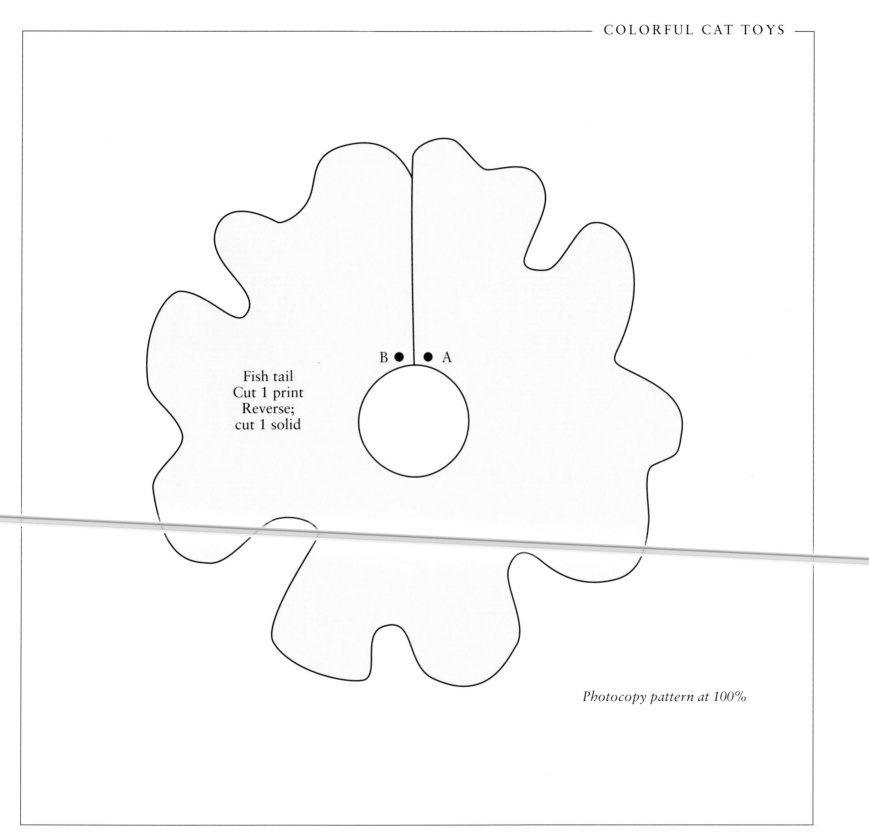

Fish tail
Cut 1 print
Reverse;
cut 1 solid

B ● | ● A

Photocopy pattern at 100%

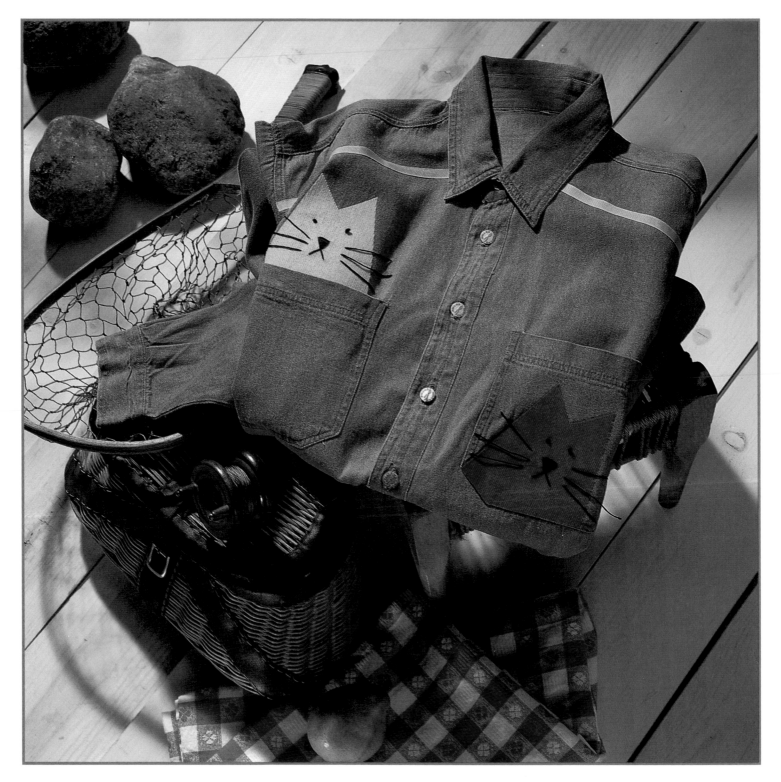

SPORTY CAT SHIRT

Modern, graphic cat shapes peek from the pockets and line up along the back yoke on this easy-to-make denim shirt. Create it for a cat-loving teenager.

— ❧ —

What You'll Need

— ❧ —

- Denim shirt
- Corduroy fabric: yellow, dark brown, red, light brown, rust
- 18 inches yellow grosgrain ribbon, ⅜ inch wide
- 20 inches red grosgrain ribbon, ⅜ inch wide
- Fusible webbing, sheet and ⅜ inch wide
- Disappearing-ink fabric marker
- Black embroidery floss
- Iron, scissors, embroidery needle, marker or pen

1. Wash and dry denim shirt. Cut 6-inch squares of corduroy fabric, 2 each yellow and red, 1 each dark brown, light brown, and rust.

2. Cut seven 6-inch squares of fusible webbing. Following manufacturer's directions, iron a square to wrong side of each corduroy square. Follow directions on page 14 to trace and cut cat patterns on pages 144–145. Place pattern pieces right side down on paper backing for indicated color, making sure nap

of corduroy goes in the same direction for each cat. Trace around each piece and cut out. Remove paper backing.

3. On front of shirt, place yellow cat coming out of left pocket and red cat on outside of right pocket. Iron into place. On back of shirt, place cats about 1 inch apart across yoke in this order: yellow, dark brown, red, light brown, and rust. Align bottoms of cats with yoke seam. Iron into place.

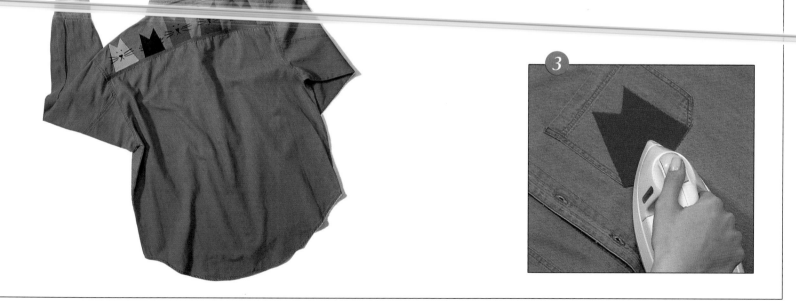

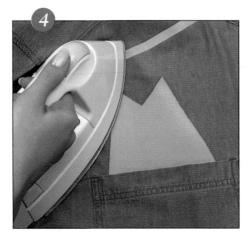

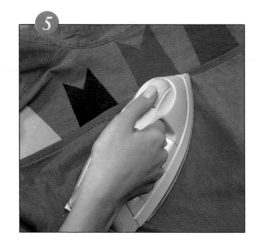

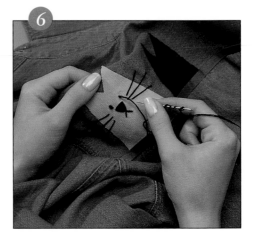

4. Cut yellow ribbon into 2 pieces approximately 9 inches long. Iron ³⁄₈-inch-wide fusible webbing to wrong side of each piece. Iron 1 piece onto left shirt front approximately 1½ inches below shoulder seams. Start at left sleeve seam and work toward collar seam. Trim excess. Repeat on right side.

5. Iron fusible webbing to 20-inch piece of red ribbon and iron in place across bottom of cats on back. Trim excess.

6. Draw details on cats' faces with disappearing-ink fabric pen. With 6 strands of black embroidery floss and embroidery needle, use straight stitches for noses and whiskers. Use French knots for eyes.

Photocopy patterns at 100%

Cut 1 rust

Cut 1 yellow

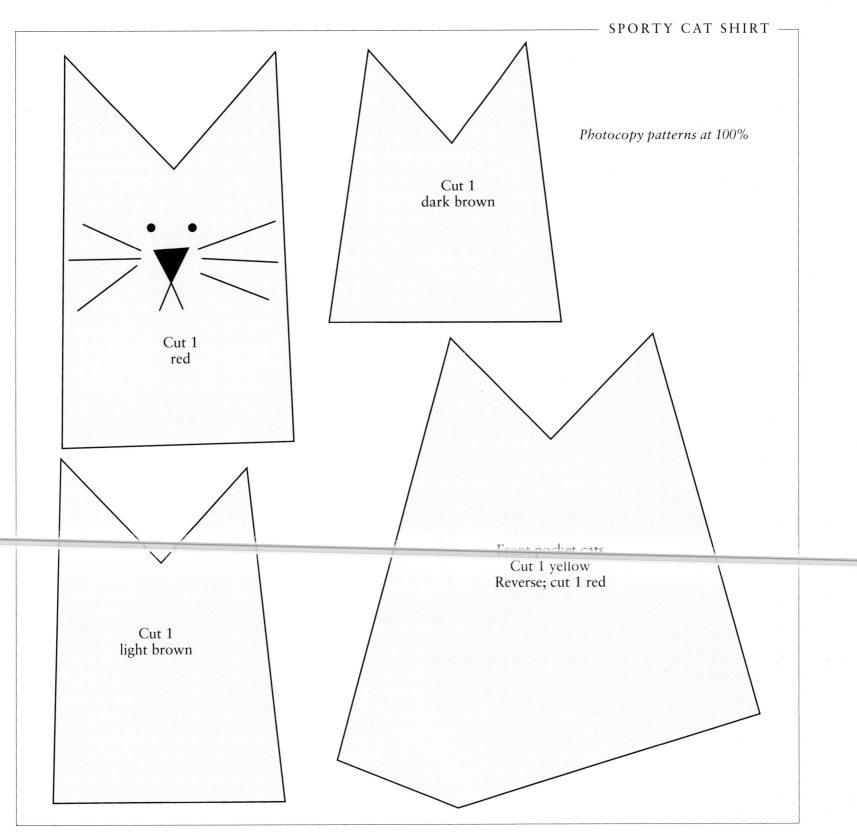

Cut 1
dark brown

Photocopy patterns at 100%

Cut 1
red

Cut 1
light brown

Front pocket cats
Cut 1 yellow
Reverse; cut 1 red

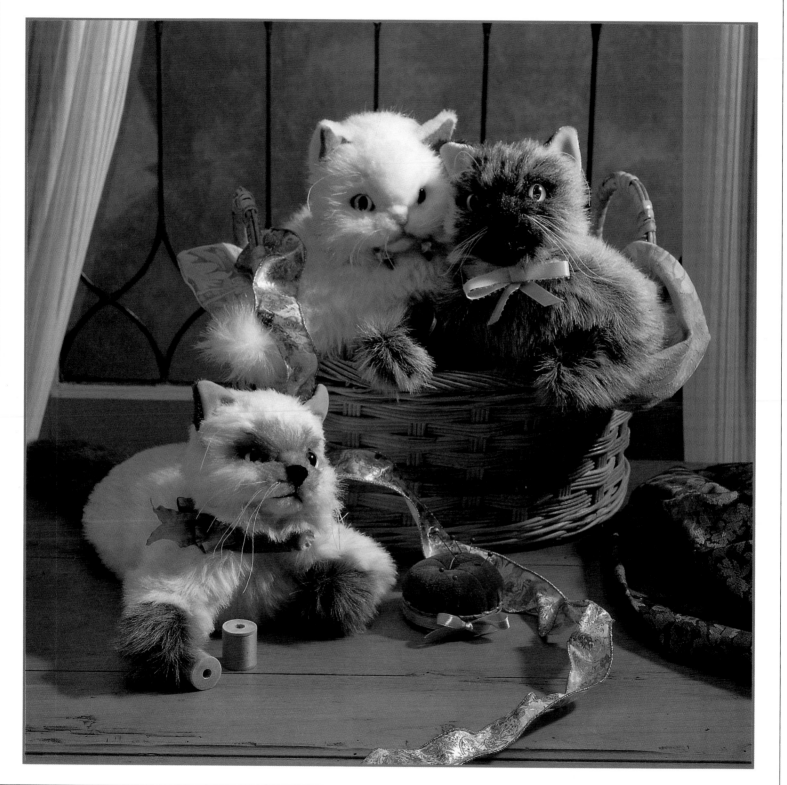

THREE LITTLE KITTEN PUPPETS

What You'll Need

- ⅓ yard each of medium-pile fur fabric in cream, white, and gray frost
- Medium-pile brown fabric 8 inches square (for Siamese kitten)
- Pink velvet, suede cloth, or suede, 3×6 inches (for ear fronts for gray kitten)
- Rose velvet, suede cloth, or suede, 3×6 inches (for ear fronts for white kitten)
- Light tan velvet, suede cloth, or suede, 3×6 inches (for ear fronts for Siamese kitten)
- 3 pieces black leather, 1×2 inches, for eye patches (use old leather gloves)
- 3 pairs 16mm cat eyes: gray, blue, and gold
- Pink and black embroidery yarn
- Thread to match fabrics
- Nylon pantyhose or stockings
- ½ yard rose garland ribbon
- ⅔ yard pink picot ribbon, ⅜ inch wide
- 26 inches double-ruffle blue ribbon, 1 inch wide
- Small package polyester stuffing
- Black, gray, and brown textile markers
- Needles: blunt, sewing, yarn, and doll (very long)
- Decorative stiffener
- Sewing machine, sharp scissors, seam ripper, ruler, ball-head pins, ⁵⁄₁₆ inch dowel stick

Though these clever hand puppets will bring bright smiles to children, our trio of furry kitties is decorative enough to appeal to the young-at-heart of any age.

1. Follow directions on page 14 to trace and cut patterns on pages 150–153. Pin pattern pieces to fur fabric with arrow direction the same as fabric nap, or how one would "pet" the fabric without ruffling the fur. Cut out, lifting the scissors and fabric so only the backing and not the fur is cut. Cut ear fronts and eye backings from suggested materials.

2. Trim the fur on areas marked on patterns for face pieces, all of ear backs, and along seam lines of upper tummy from G to G and from lower tummy from H to H. Fold over raw edges of upper and lower tummies along trimmed lines, with wrong sides together, and zigzag stitch to hold. Change machine to straight stitching.

3. Body: For Siamese only, stitch paws to body sides and upper tummy from A to B. For all cats,

Siamese leg pieces

3

4

Head pieces

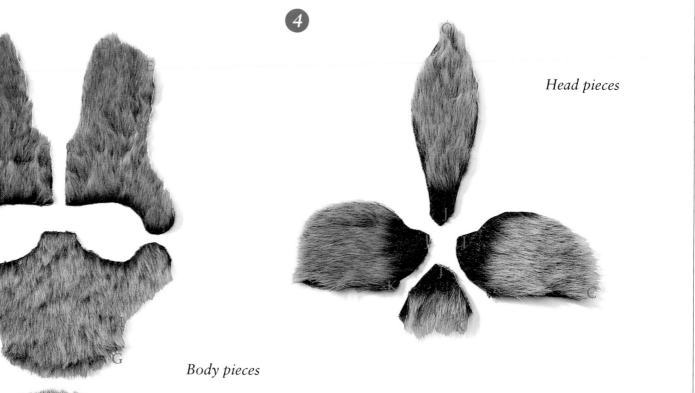

Body pieces

6

stitch body sides together from C to D. Stitch tail pieces together, leaving open from E to D to E. Use dowel stick to turn right side out. Stitch upper tummy to body sides from F, all around front legs to G, leaving neck edges F to C open. Sandwich tail base between lower tummy and body sides. Hand-sew from E to D to E. Sew sides of lower tummy to body sides, including wrong side of upper tummy from E to H.

4. Head: Stitch one head side to head gusset from J to C. Repeat with other head side. Seams should be slightly smaller than ¼ inch around nose area. Trim nose seams.

Sew chin to head side from K to J, easing chin to fit. Repeat with other side. Turn head right side out.

5. Temporarily stuff head. Poke pins into eye dots and check for accuracy, adjusting if necessary. They should be 1¾ inches from J. Remove stuffing. Use gray eyes for white kitten, blue for Siamese, and gold for gray kitten. Thread eye backings through eye shafts. Poke holes for eyes with seam ripper. Snap eyes in place.

6. Using pink for white kitten and black for the other two, embroider a satin-stitch nose and an upside-

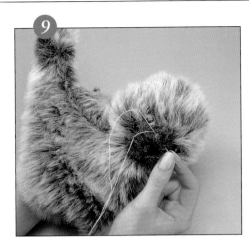

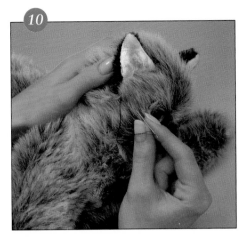

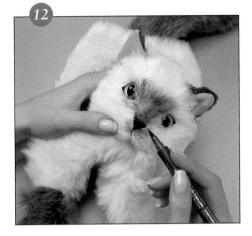

down Y mouth, following seam lines for mouth. Secure yarn end on inside.

7. Pin head into neck opening with Cs together and base of chin smooth at front, about ¼ inch past F. Ease rest of neck openings of head into neck openings of body sides. Hand-sew. Turn puppet right side out.

8. To sculpt face, stuff a piece of nylon with polyester stuffing to make a 2½-inch ball. Knot ends. Push into nose/mouth area. Double-thread a doll needle with about 18 inches in length. Knot end. Pull thread through from inside to outside, coming out at one mouth end. Make a tiny stitch and then run needle up to lower edge of eye, pulling so cheek puffs out. Repeat with other side.

9. Pinch nose bridge between fingers and run thread back and forth halfway between eyes and nose. Bring needle out at chin middle. Secure thread and cut off ends.

10. Make a 3-inch nylon ball as directed for 2½-inch ball. Sew ear fronts to ear backs, right sides together. Trim seams close to stitching. Turn right side out. Whipstitch raw edges together. Pin 3-inch ball in head top. Pin ears to head. Hand-sew ears on head with inside edges along seam line and 3 inches from nose. Secure ball with stitches while sewing on ears.

11. Slightly trim fur on forehead and head top if necessary. Pull fur out of seams by running blunt needle over seam lines.

12. For gray kitten use black marker to paint stripes on head, around legs, body, and tail. Run marker around ear fronts and backs at seam lines. For Siamese kitten paint mask brown, followed by gray, and run both markers along the ear seams.

13. Stuff lower tummy until rounded. Omit this if kitten is for a young child.

14. Decorate white kitten by tying garland ribbon around neck. Decorate Siamese kitten with blue ribbon, using ⅓ yard for collar, ⅓ yard for bow, and 2 inches gathered in center and sewn to bow. Decorate gray kitten with pink picot ribbon, using ⅓ yard for collar and ⅓ yard for bow and center, cutting off excess.

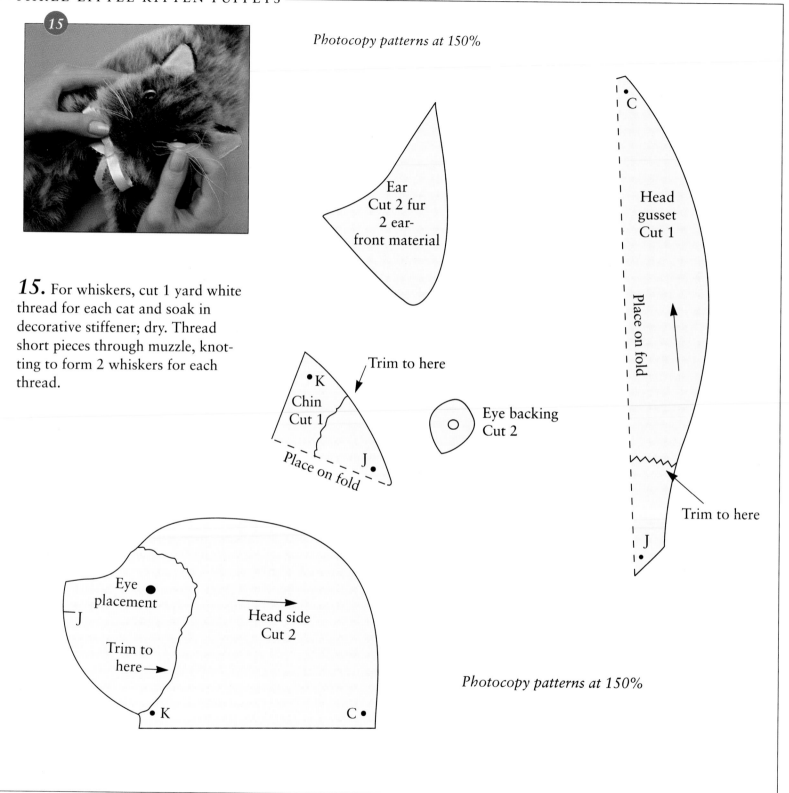

Photocopy patterns at 150%

Ear
Cut 2 fur
2 ear-
front material

C

Head
gusset
Cut 1

Place on fold

15. For whiskers, cut 1 yard white thread for each cat and soak in decorative stiffener; dry. Thread short pieces through muzzle, knotting to form 2 whiskers for each thread.

Trim to here

•K

Chin
Cut 1

Place on fold

J•

Eye backing
Cut 2

Trim to here

J•

Eye
placement

J

Trim to
here →

Head side
Cut 2

•K

C•

Photocopy patterns at 150%

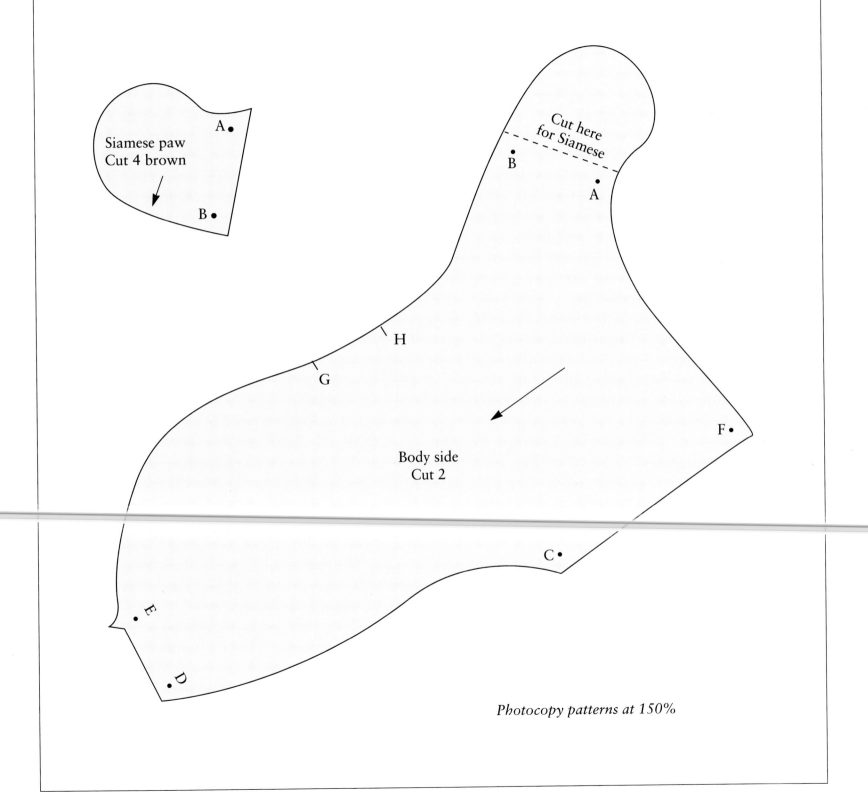

Siamese paw
Cut 4 brown

A•

B•

Cut here
for Siamese

B•

A•

H

G

F•

Body side
Cut 2

C•

E•

D•

Photocopy patterns at 150%

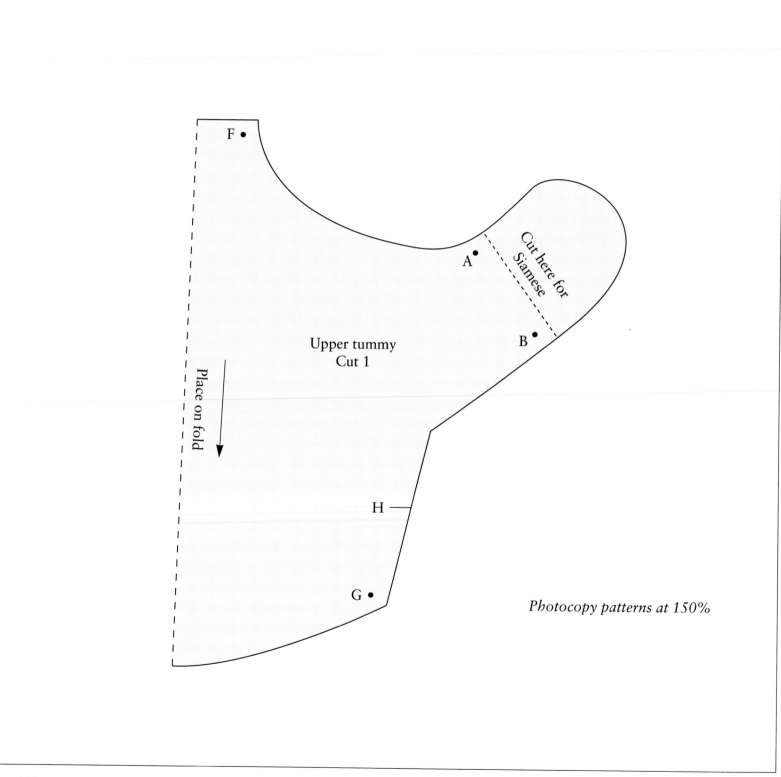

F •

Cut here for
Siamese

A •

B •

Upper tummy
Cut 1

Place on fold

H —

G •

Photocopy patterns at 150%

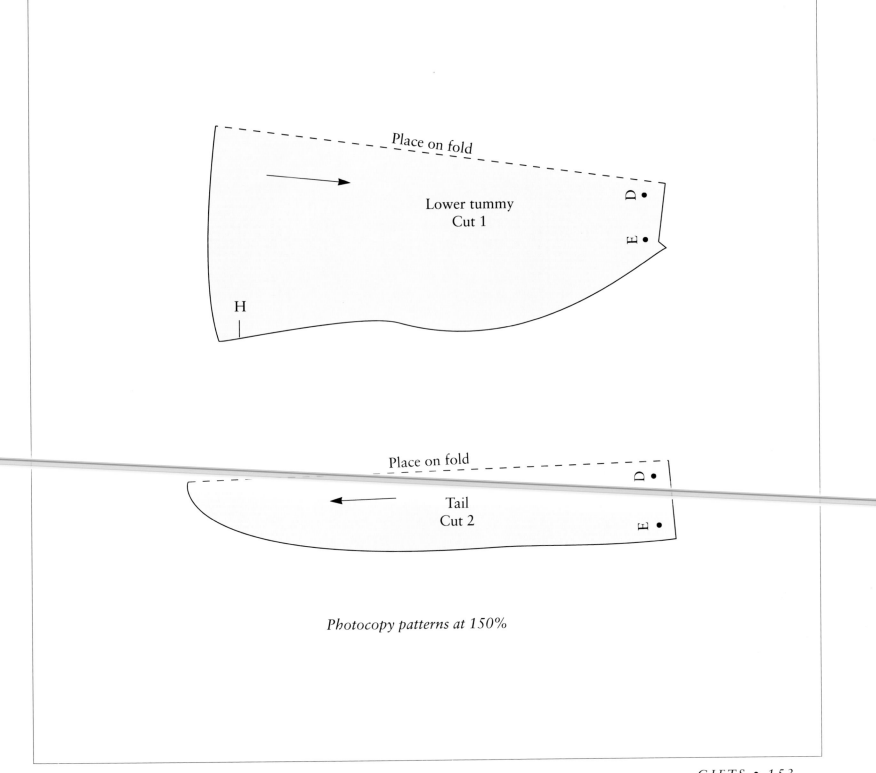

Place on fold

D

Lower tummy
Cut 1

E

H

Place on fold

D

Tail
Cut 2

E

Photocopy patterns at 150%

"Gotta Dance" Cross-Stitched Sweatshirt

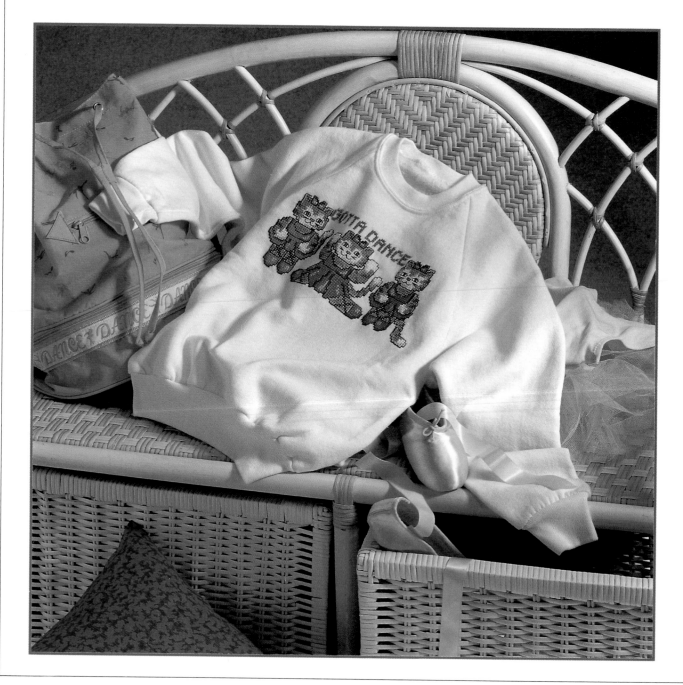

A special ballerina will dance for joy when she receives this sweatshirt with cross-stitched kittens capering across it.

What You'll Need

- 7×12-inch piece 10-count waste canvas
- 6-strand embroidery floss (see color key)
- Masking tape
- Embroidery needle
- Sewing needle and thread, scissors, tweezers

Stitch count: 42h×99w

Size: 4⅛×10 inches

Cover edges of waste canvas with masking tape. Baste waste canvas to front of sweatshirt, centered side to side and directly beneath neckline seam. Following the general cross-stitch directions on pages 9–11, stitch according to chart, stitching from large hole to large hole. Use 4 strands floss for all cross-stitching. When all cross-stitching is done, backstitch where indicated with 2 strands black floss. Trim canvas to within ¾ inch of stitched design. Wet with cold water to remove sizing. Canvas will go limp when sizing is washed out. Using tweezers, pull out canvas threads. Lay sweatshirt flat to dry.

Color	DMC
White	White
Black	310
Very light pearl gray	762
Medium rose	899
Medium jade	562
Medium steel gray	414
Silver	415
Light steel gray	318
Dark carnation	601
Very light cranberry	605
Light cranberry	603
Dark blue violet	333
Very light blue violet	3747
Medium blue violet	340
Medium plum	917
Ultra light plum	3609
Light plum	3607

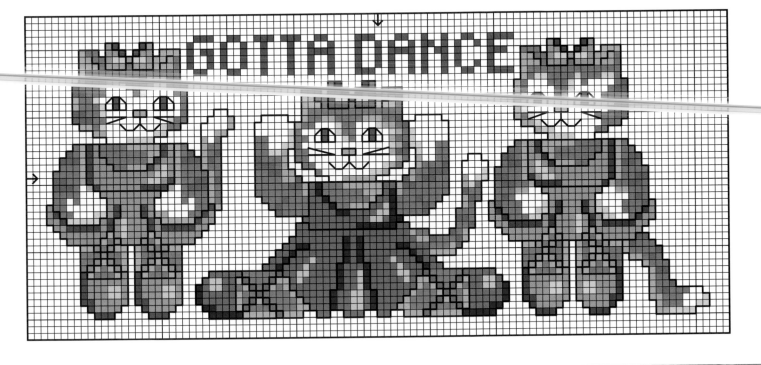

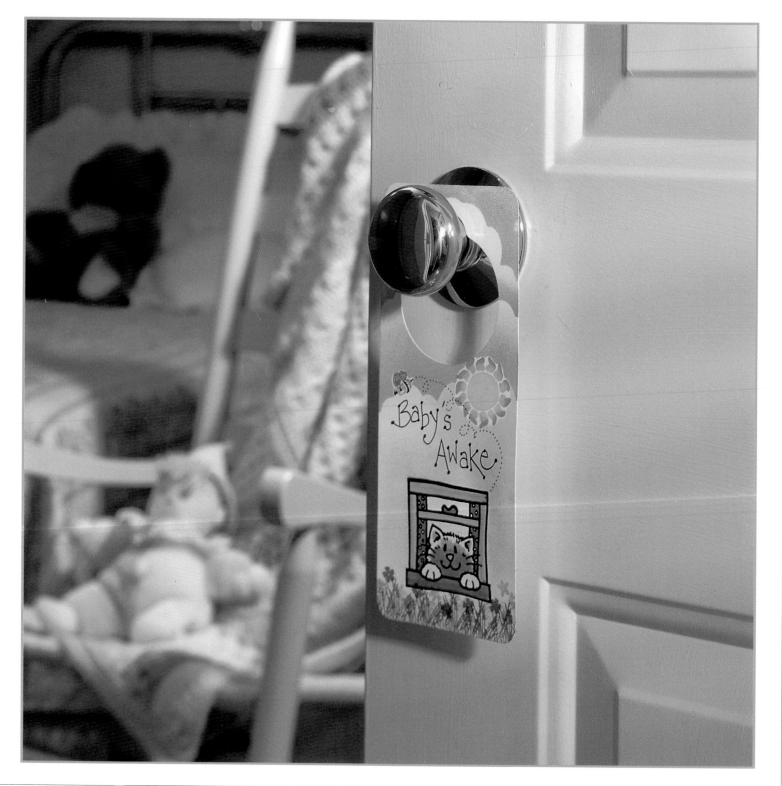

WATCHFUL KITTY DOORKNOB HANGER

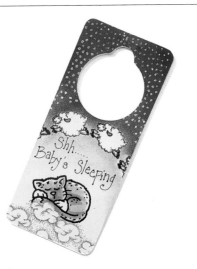

The vigilant cat on this doorknob hanger watches out for the new baby, letting family members know when to tiptoe. A fun baby-shower present.

What You'll Need

- White glossy doorknob hanger
- Kitty-sleeping stamp
- Jumping-sheep stamp
- Cloud stamp
- Star flakes stamp
- Kitty-awake stamp
- Sun stamp
- Bee stamp
- Scattered-flowers stamp
- Grass stamp
- Self-stick notes
- Embossing ink pad
- Embossing powder: clear and white
- Heat-embossing gun
- Plain white paper
- Wedge sponges
- Black pigment ink pad
- Felt-tip markers: navy, lilac, manganese blue, gray, pink, light blue, red, black, yellow, orange, violet, green

1. For "Baby's Sleeping" side, ink cloud stamp with manganese blue felt-tip marker directly onto rubber. Breathe moisture onto stamp and stamp clouds along bottom of doorknob hanger. Reink stamp after each image is stamped.

2. To create a mask, stamp cloud on self-stick note so that top of image is over self-stick part. Cut out image. Place over highest cloud stamped on card.

3. Ink kitty-sleeping stamp well with black ink pad. Stamp image about 1 inch from bottom of doorknob hanger, slightly covering cloud mask. Remove mask from cloud.

4. Sprinkle cat with clear embossing powder and tap off excess for future use. Heat with embossing gun until embossing powder melts.

7. Ink flat edge of wedge sponge with navy felt-tip marker. Blot excess ink on scrap paper. Sponge in navy sky, making it darkest at the top and fading to light around sheep.

8. Ink a second flat edge of wedge sponge with lilac marker. Blot excess ink on scrap paper. Sponge in lilac sky starting underneath sheep, being careful not to sponge on cat.

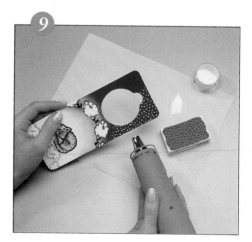

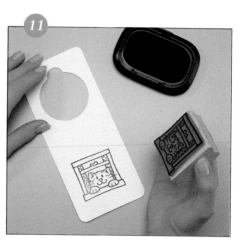

9. Stamp a few star flakes well on embossing ink pad. Stamp over navy sky. Sprinkle star flakes with white embossing powder and tap off excess for future use. Heat with embossing gun until embossing powder melts. Repeat to cover navy sky.

10. Color cat with gray marker, leaving paws and tip of tail white. Color insides of ears and nose with pink. With black marker, write "Sh . . . Baby's Sleeping" between sheep and cat.

5. Ink sheep stamp well with black ink pad. Stamp sheep in an arc above cat as shown in photograph on page 157. Emboss sheep following instructions in step 4.

6. Follow directions in step 2 to create 4 masks for sheep. (You can also stamp sheep on a stack of 4 self-stick notes and cut out all 4 layers at once.) Place a mask on each sheep on doorknob hanger.

11. For "Baby's Awake" side, ink kitty-awake stamp well with black ink pad. Stamp on reverse side of doorknob hanger ¾ inch from bottom. Sprinkle with clear embossing powder and tap off excess for future use. Heat with embossing gun until embossing powder melts.

12. Using yellow marker, color center of sun stamp directly onto rubber. Color outer edges of rays using orange marker. Breathe moisture onto stamp and stamp at right under hole, as pictured.

13. Using markers, color bee stamp directly onto rubber. Color body yellow with black stripe, stinger, and antennae; color wings light blue. Breathe moisture onto stamp and stamp bee to left of sun.

14. Stamp both bee and sun on self-stick note so that tops of images are over self-stick part. Cut out images. Place over images stamped on doorknob hanger.

15. Use green marker to color grass stamp directly onto rubber. Breathe moisture onto stamp and stamp to cover bottom of doorknob hanger under windowsill. Reink stamp after each use.

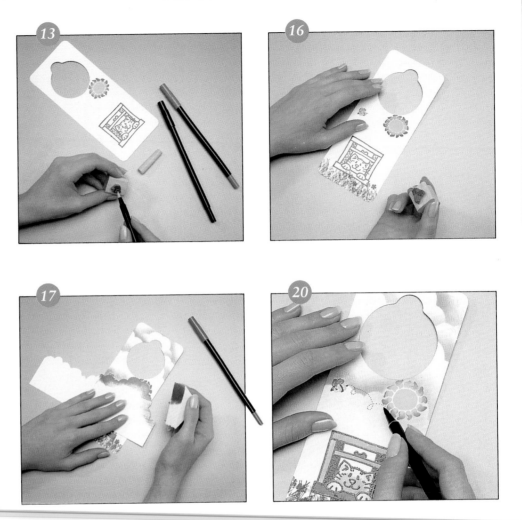

16. Use red, violet, and yellow markers to color flowers of floral stamp. Breathe moisture onto stamp and stamp flowers in grass. Reink stamp after each use.

17. Draw random cloud shapes on paper and cut out to make cloud template. Ink flat edge of wedge sponge with light blue marker. Blot excess on scrap paper. Place cloud template near top of doorknob hanger and sponge over template. Move template down and repeat, alternating cloud shapes.

18. Ink flat edge of wedge sponge with yellow marker. Sponge lightly around masked sun.

19. Ink flat edge of wedge sponge with green marker. Sponge lightly over grass.

20. Use gray marker to color kitten, leaving paws white. Color insides of ears and nose pink. Color window frame light blue and windowsill manganese blue. Color curtains red, leaving dots white. Use black marker to make dotted line for bee's flight path and to write "Baby's Awake" over window.

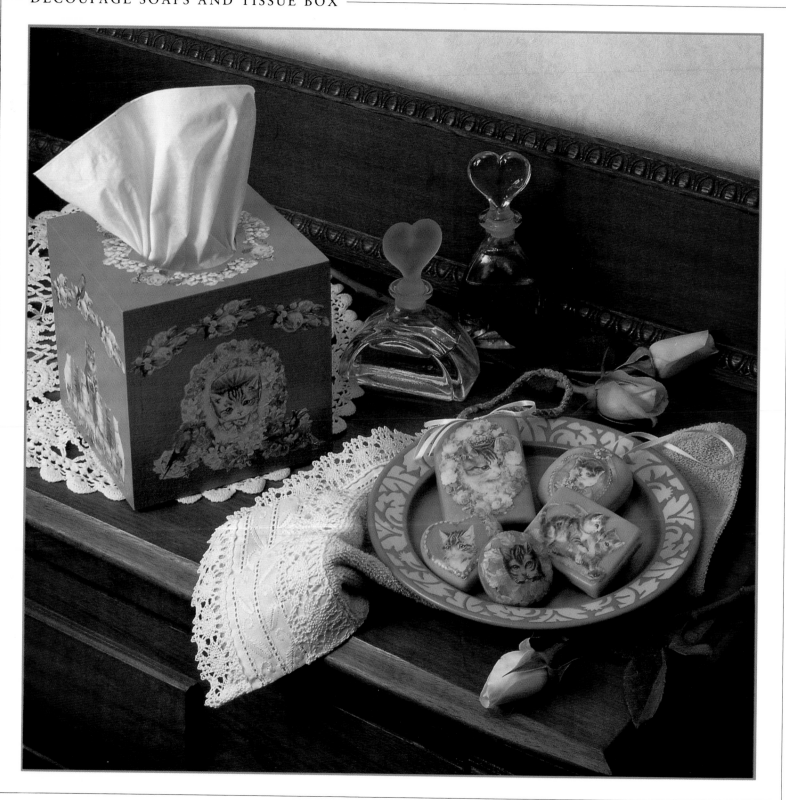

Decoupage Soaps and Tissue Box

Sweet Victorian kittens and garden motifs decorate these enchanting guest soaps and tissue box. They'd make a thoughtful housewarming present for someone who loves old-fashioned charm.

SOAPS

What You'll Need

- 1 pound white craft soap
- Geometric and heart-shaped soap molds
- Victorian cat wrapping paper
- Soap colorants (we used green, blue, and red)
- Soap fragrances
- Paraffin
- 27 inches pink satin ribbon, ⅛ inch wide
- 9 inches dusky green cord, 3mm
- White tacky glue
- Small foam brush
- Double boiler, small scissors, stirring sticks or spoons, straight pin, paring knife

1. Cut kitten shapes from wrapping paper, matching cat shapes with desired soap shapes. Use more than one motif, if necessary, to fill space. To make paper lie flat on curved soap surfaces, such as the round blue soap, cut slits in shapes at edges so they can overlap.

2. Pink soaps are made from red colorant mixed with craft soap; light blue is made from blue colorant mixed with soap. Dusky green is a mix of a small amount of red added to the green, and aqua is a mixture of blue and green. Follow manufacturer's directions for melting soap. Add color and stir until melted. Add fragrance last so it does not cook away. If soap is to be used as an air freshener, add more fragrance.

3. Pour soap into mold. To embed ribbons or cords for air fresheners, press knotted end of cord or ribbon into melted soap and hold for a few seconds until secure. Use 8 inches pink ribbon and 9 inches green cord for air fresheners. Let soap harden.

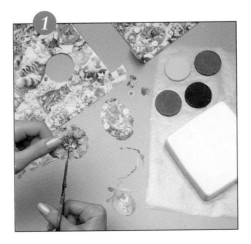
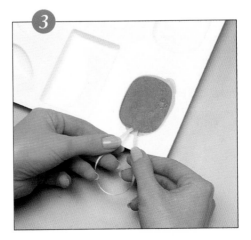

4. Remove soap from mold. Trim away excess.

5. To make the other half of soap, pour more soap in mold. While still warm carefully place top layer on it. Allow to cool. Remove soap from mold. Trim edges. Smooth with fingers.

6. Apply glue to backs of kitten designs and place onto soaps. Use ample glue to secure cat designs to soap, pressing firmly. Let dry. If areas pop away, apply more glue and press. Allow to dry several hours.

7. In double boiler with pan large enough to hold soap with fingers, melt enough paraffin for a layer of about ¼ inch. Leaving the rest of soap unwaxed, quickly dip the cat design in the wax and remove. Allow to dry. Smooth away excess wax with fingers. Tie and pin pink bow to larger air freshener soap.

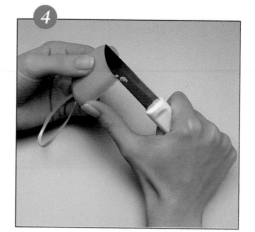

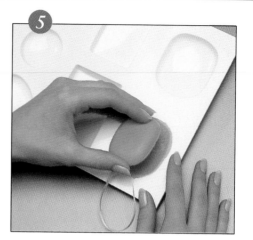

TISSUE BOX

What You'll Need

- Unfinished wood tissue-box cover
- Wood sealer
- Acrylic paint: jade green and deep teal
- Brushes: ¾-inch flat and #3 shader
- Decoupage sealer/glue/finish
- 3 packages Victorian cat wrapping paper
- Fine sandpaper
- Brayer
- Plain white paper
- Waxed paper
- Acrylic matte-finish spray
- Small scissors, small mixing container and stir stick, tablespoon, pin

1. Sand box with sandpaper. Brush off sand dust. Apply wood sealer to outside and top of box, then to inside and bottom, allowing box to dry after each application.

2. Mix 1 tablespoon each jade green and deep teal paint in mixing container. Stir until well blended. Use ¾-inch flat brush to paint box, applying strokes in center and working to edges so coat is even.

3. Cut out your choice of cat and flower motifs. Arrange them to your liking on box sides and top.

4. Place a motif piece face down on waxed paper. Using #3 shader brush, apply sealer/glue/finish all over the back. Place motif in position on box, patting it down. Place a clean sheet of paper over motif and run brayer over surface. If more glue is needed, apply and press down again. If air bubbles make lumps under the motif, prick with a pin and press until smooth. Don't worry if glue shows around the motif. Continue until all pieces are glued in place. Allow to dry thoroughly.

5. Follow manufacturer's directions to apply sealer/glue/finish over box with large brush. Allow to dry between coats. Varnish with acrylic matte-finish spray. Allow to dry.

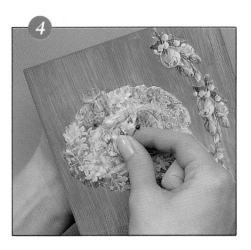

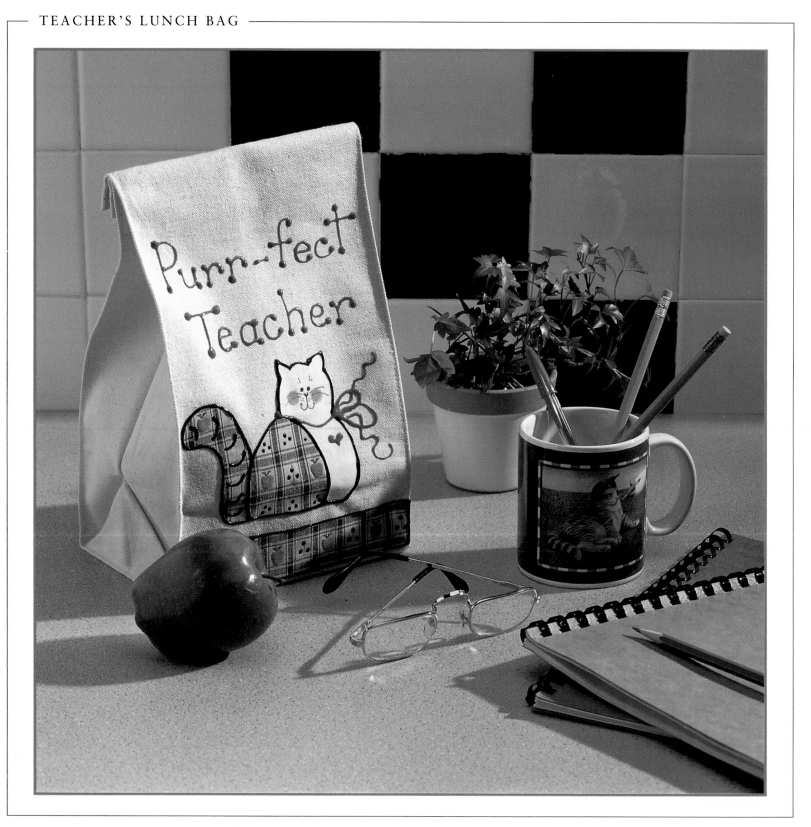

TEACHER'S LUNCH BAG

Here's a cute and cheerful way to carry a lunch or snack to school. This apple-gingham kitty decorates the purr-fect gift for a brown-bagging teacher—who might forgive the CAT-astrophic pun!

What You'll Need

- Premade lunch bag
- Scrap of muslin fabric
- Scrap of plaid apple gingham fabric
- Shiny dimensional fabric paint: navy, red
- ¼ yard fusible webbing
- Water-erasable transfer paper
- Black thin-line permanent marker
- Tracing paper
- Scissors, pencil, iron

1. Follow directions on pages 4–5 to trace patterns on page 166. Iron fusible webbing to wrong side of both fabric pieces. Place cat face pattern piece right side down on paper backing on muslin fabric. Place body and tail pattern piece right side down on paper backing on gingham fabric. Trace around each piece and cut out. Cut out a strip of plaid apple fabric the width of the lunch bag. Remove paper backing from fabric pieces.

2. Arrange pieces on bag as shown in photograph. Iron in place.

3. Using transfer paper, transfer face pattern to cat head. Using pencil, draw in "Purr-fect Teacher" lettering in center of bag above cat.

4. Paint letters in red. Dip finger in a puddle of red paint and dot cheeks on cat face.

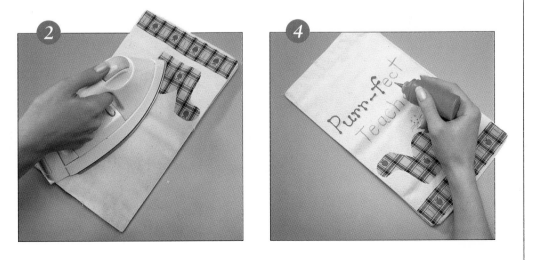

 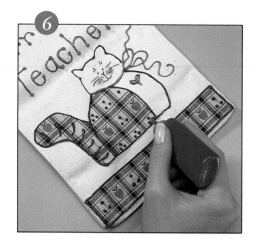

5. Draw face on cat with thin-line black marker.

6. Using navy paint, paint stripes on cat's tail and outline cat and bottom strip. Add dots to plaid fabric pieces. Paint bow around neck and heart on chest with red. Allow to dry overnight. Bag can be gentle-washed and line dried after 72 hours.

Photocopy patterns at 150%

SOURCES FOR PRODUCTS

Most of the crafts materials used in the projects in this book, such as brushes, paints, fusible webbing, or tapes, are available at craft, hobby, or fabric stores nationwide. Other products may give equally good results. Specialized products that are specific to a project are listed below by page number; these products are also widely available. For further information, contact the manufacturers at the addresses given at the bottom of the page.

Page 21: Aunt Lydia's craft and rug yarn #125, Wild Rose: Caron International. **Page 23:** "French Lace" linen fabric: Wichelt Imports, Inc. Jacquard textile paints: Rupert, Gibbon & Spider. **Page 33:** Mantle clock #53206, clockworks #TQ700P: Walnut Hollow Farm, Inc. Cozy Cat stencil #28451: Plaid Enterprises, Inc. Americana acrylic paints: DecoArt. **Page 35:** Americana acrylic paints: DecoArt. **Page 42:** Prefinished Heatherfield pillow: Wichelt Imports, Inc. Embroidery floss: The DMC Corp. Special Edition pillow form:

Putnam Company. **Page 60:** Wooden cat: J.B. Wood Products. Americana acrylic paints: DecoArt. **Page 63:** Poinsettia embossed felt: Kunin Felt. Tulip Treasure See-Thru stones, Tulip Treasures fabric paint, Tulip Puffy paint: Tulip Productions. **Page 70:** Kitchen Mates towel and pot holders: Charles Craft. Embroidery floss: The DMC Corp. **Page 73:** Americana acrylic paints: DecoArt. **Page 77:** Teacup stamp PR241-K: Stamp Francisco. Sugar stamp #S261: Graphistamp. **Page 79:** Etching Creme glass etching cream: B & B Products. Dr. Ph. Martin's "Soft Tack" Frisket masking film: Salis International, Inc. **Page 83:** Medium diamond birdhouse #11108: Walnut Hollow Farm, Inc. Americana acrylic paints: DecoArt. **Page 86:** Metallic ribbon and gold braid: Kreinik Mfg. Co. Plastic canvas yarn: Spinrite Yarns Limited. **Page 89:** Americana acrylic paints: DecoArt. **Page 93:** Aleene's Opake Shrink-It plastic film: Aleene's, Division of Artis, Inc. **Page 96:** Pearl cotton #3: The DMC Corp. **Page 99:** Rounded trunk basswood box #3220: Walnut Hollow Farm, Inc. Mrs. Grossman's

stickers: Mrs. Grossman's Paper Company. Ceramcoat acrylic paint: Delta Technical Coatings, Inc. **Page 101:** Lucky kitten stamp #226D, cat paw stamp #221C: All Night Media. **Page 104:** Oval plaque #14021: Walnut Hollow Farm, Inc. Americana acrylic paints: DecoArt. **Page 109:** Kitten stamp #A875E: Rubber Stampede. **Page 115:** Silk paints, silk, and supplies: Rubert, Gibbon & Spider. **Page 121:** Cat face stamp #A414-C: Rubber Stampede. **Page 123:** X-ACTO Craft Rotary Cutter and Craft Self-Healing Mat: Hunt Manufacturing Company. Bandannas: Carolina Manufacturing Company. **Page 128:** Stocking: Charles Craft. #8 fine braid: Kreinik Mfg. Co. Embroidery floss: The DMC Corp. **Page 155:** Embroidery floss: The DMC Corp. **Page 157:** Zzzzzz stamp #A201-E, Jumping Sheep stamp #735-C, Cloud stamp #Z327-C, Starflakes stamp #Z044-E, "Hello Kitty!" stamp #A202-E, Sunsational stamp #Z365-C, Buzzy Bee stamp #Z319-A, Scattered Flowers stamp #Z033-A, Wild Grass stamp #Z310-A: Rubber Stampede. **Page 161:** Complete soap-craft supplies: Environmental Technology, Inc. Cat wrapping paper: Hallmark. **Page 163:** Americana acrylic paints: DecoArt. **Page 165:** Scribbles Shiny Dimensional paint: Duncan. Premade lunch bag: Bagworks.

The following companies' products are listed above:

Aleene's
Division of Artis, Inc.
Buellton, CA 93472

All Night Media
Box 10607

B & B Products
18700 North 10th Avenue #9
Sun City, AZ 88373

Bagworks
3933 California Parkway East
Fort Worth, TX 76119

Carolina Manufacturing Company
P.O. Box 9138
7025 Augusta Road
Greenville, SC 29604

Caron International
140 Avenue E
Rochelle, IL 61068

Charles Craft
P.O. Box 1049
Laurinburg, NC 28353

DecoArt
Box 360
Stanford, KY 40484

Delta Technical Coatings, Inc.
2550 Pellissier Place
Whittier, CA 90601

The DMC Corp.
South Kearny, NJ 07032

Duncan
5673 East Shields Avenue
Fresno, CA 93727

Environmental Technology, Inc.
South Bay Depot Road
Fields Landing, CA 95537

Graphistamp
Box 3658
Carmel, CA 93921

Hallmark Cards Co.
2501 McGee Street
Kansas City, MO 64108

Hunt Manufacturing Company
230 South Broad Street
Philadelphia, PA 19102

J.B. Wood Products
P.O. Box 3084
South Attleboro, MA 02703

Kreinik Mfg. Co.
9199 Reisterstown Road Suite 209B
Owings Mills, MD 21117

Kunin Felt
A Foss Manufacturing Company
P.O. Box 5000
Hampton, NH 03843

Mrs. Grossman's Paper Company
77 Digital Drive
Novato, CA 94949

Plaid Enterprises, Inc.
1649 International Boulevard
Norcross, GA 30093

Putnam Company
P.O. Box 310
Walworth, WI 53184

Rubber Stampede
967 Stanford Avenue
Oakland, CA 94608

Rubert, Gibbon & Spider
P.O. Box 425
Healdsburg, CA 95448

Salis International, Inc.
4093 North 28th Way
Hollywood, FL 33020

Spinrite Yarns Limited
Box 40
Listowel, Ontario
Canada N4W 3H3

Stamp Francisco
466 8th Street
San Francisco, CA 94103

Tulip Productions
A Division of Polymerics, Inc.
24 Prime Park Way
Natick, MA 01760

Walnut Hollow Farm, Inc.
Route 1
Hwy 23 North
Dodgeville, WI 53533

Wichelt Imports, Inc.
Box 139–Hwy 35
Stoddard, WI 54658

\mathscr{I}NDEX